H. Gordon Selfridge

THE WORLD OF

MR SELFRIDGE

THE GLAMOUR AND ROMANCE

ALISON MALONEY

WILLIAM MORROW
An Imprint of *HarperCollins*Publishers

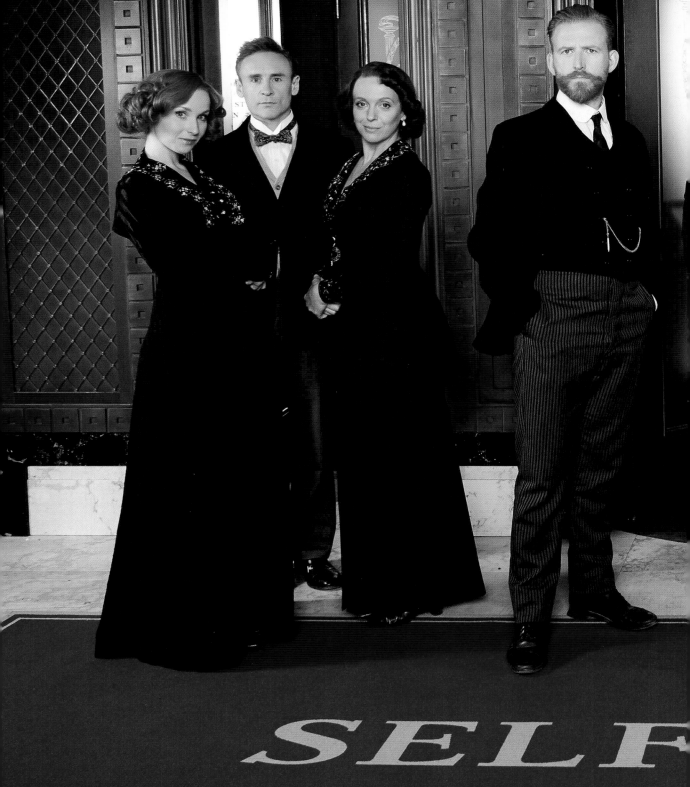

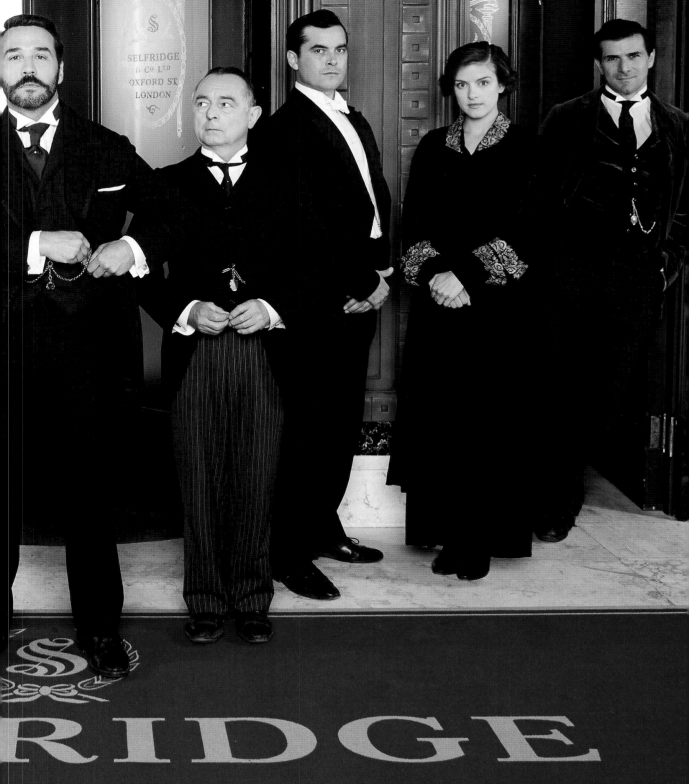

FIRST U.S. EDITION

Library of Congress Cataloging-in-Publication Data has been applied for.

ISBN 978-0-06-242224-8

15 16 17 18 19 /L.E.G.O. SpA 10 9 8 7 6 5 4 3 2 1

Images: Marshall Field's dining room (p.26) courtesy of Mary Evans Picture Library;
Back to School (p.88) courtesy of The Advertising Archives; The Narcissus Hall at
Leighton House (p.51) and *The Marchesa Luisa* by Giovanni Boldini (p.128) courtesy
of Bridgeman Images; *The Blue Hat* by John Duncan Fergusson (p.148) courtesy of
Bridgeman Images and © The Fergusson Gallery, Perth & Kinross Council, Scotland.
Images on pages 20, 22, 23, 24, 38, 40, 44, 50, 56, 58, 60 all with kind permission
of Selfridges archives. All other images courtesy of John Rogers and
Christian Black and © ITV Studios.

Designed in the UK by Smith & Gilmour
Printed and bound in Italy by L.E.G.O. SpA

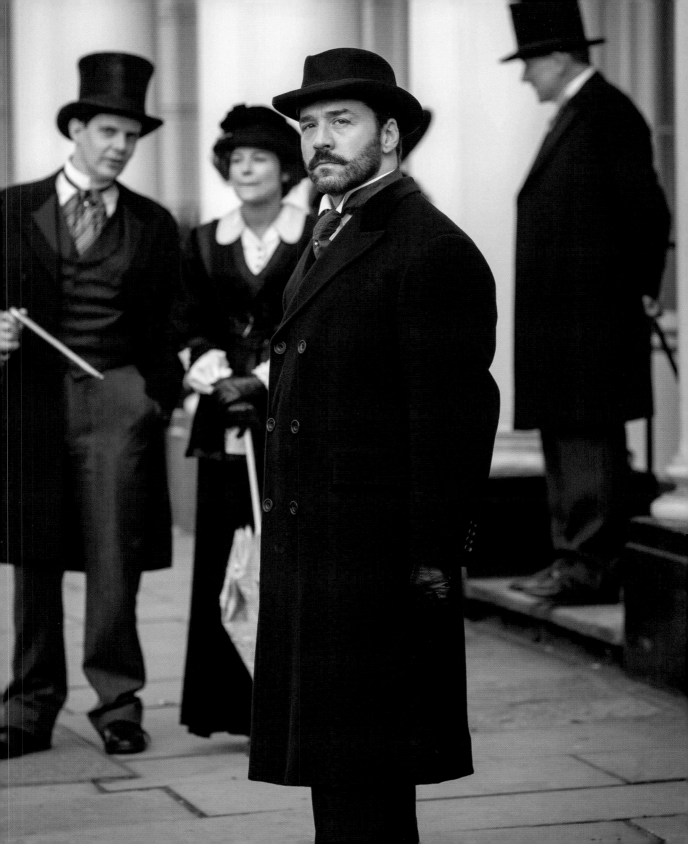

CONTENTS

FOREWORD

BY WRITERS ANDREW DAVIES AND KATE BROOKE

Andrew Davies: When executive producer Kate Lewis first approached me about *Mr Selfridge*, I have to confess I was reluctant. As far as I could see, she and script executive Siobhan Finnigan were getting excited over a book about shopping – and I don't do shopping! But after reading Lindy Woodhead's fascinating biography *Shopping, Seduction and Mr Selfridge*, the book on which the series is based, I found Harry Selfridge to be a fascinating character and the notion of a series that was both a family series and a workplace series seemed very attractive.

Harry was interesting because of his background – a self-made man with a very powerful mother behind him and a wife he absolutely adored, yet was never faithful to. But also because he set out to be an ideal father and employer, and he achieved so much.

But who would play Harry? I didn't have anyone in mind when I began working on the script and by the time Jeremy Piven came on board, I'd already written two episodes. Kate and I were in Cannes, publicising the show, and somebody mentioned Jeremy, so I sat in my hotel room watching a box set of *Entourage* and trying to imagine Jeremy in the part of Selfridge. He definitely had the kind of cheeky charm and chutzpah that would fit very well, plus it was a bit of a thrill to have a genuine American. Then, when we met him, it turned out he actually came from Chicago, as did Harry, and he knew the store that Harry had worked in, which was a happy coincidence.

Once we had him on board, it was great to write for him. He has this tremendous energy and charm, though I soon discovered that he is perhaps at his strongest in the quiet, intimate interactions. So we started to write more emotional scenes for him with Rose, and with Lois and the children.

Having been drawn in by Harry's personality, we started thinking about all the other people who were going to be in the story. Some of the real-life

characters, such as Rose and the children and Lois, obviously had to be there because we know a reasonable amount about them. Beyond that we know there were staff in the shop and we know what their jobs were, but there's not much recorded about them, so one by one we started conceiving of them. The first character I created was Agnes, because I thought it was interesting for the audience to identify with somebody who has really come from the lowest strata of society, and we decided that she would gradually make her way up in the firm. Originally, we toyed with the idea that she was romantically involved with Selfridge but that didn't fit with his biography, as he never dallied with his staff and, anyway, it would be more interesting for her to rise professionally in a time when it was difficult for women to do so.

Lady Mae was conceived fairly early on, because she acted as a bridge for Harry into London society. As someone who had been a Gaiety Girl, who had married into the aristocracy, she wasn't silver spoon herself, so I thought she'd be an intriguing character.

Many of the other characters evolved during the writing and casting process. For instance Miss Mardle, at first, was just a bit of a battle-axe, someone who the young girls would have been in awe of and scared of, and she would be very strict and maintain very high standards. But we had a series of meetings and, one day, as we were just settling down to write over a cup of coffee, Siobhan said, 'Did you know that Miss Mardle and Mr Grove are having an affair?'

'Good God,' I said. 'They're not!'

'Yes,' said Siobhan. 'She's desperately in love with him and she's followed him from store to store.' I thought that was a wonderful idea because these two are so upright and strict with the young assistants, and yet they are having this illicit affair and are desperate not to be discovered.

Kate Brooke: As the great-great-granddaughter of a very successful, self-made engineer, I've always been interested in entrepreneurs, especially of the pre-war era. Those first-generation plutocrats with the visionary ideas fascinate me, so I was instantly drawn to Harry's story. Harry was 100 years ahead of himself and even now his ideas feel modern. He was American, which meant he seems classless in a class-conscious society, and he was the epitome of that wonderful American 'can do' attitude, which is incredibly refreshing. What I love about him as a character is that he's a brilliant manager of people and he understands how to get the best out of his staff.

He's a very optimistic character and a lovely one to write because he's at the heart of the show, a bit like a magician, but he's much better at making things right for the characters around him than he is at making it right himself.

As the show's creator, Andrew laid out a marvellous spread of characters, who were all there and waiting when I arrived. Myself and Kate O'Riordan, my fellow writer, then worked with him to move them on and give them stories.

For example, we always imagined the Victor and Agnes relationship, and Andrew set that up quite early. Then there was a scene in episode one, when Henri gives Agnes a rose, and Aisling Loftus and Grégory Fitoussi played so beautifully together that we decided to create a love triangle. There have been lots of arguments along the way about who Agnes should end up with – the safe, traditional Victor, who would make a lovely husband, or the creative, dashing Henri. Oddly enough, men always want her to end up with Victor, and women always want her to choose Henri.

For series two we brought in some new characters, but we do a lot of research and we do like to have some kind of factual basis to them. Delphine, for instance, was very much taken from Elinor Glyn, a racy lady from that era who had lots of lovers and was very naughty, and we thought she was marvellous.

In the second series, we also met Lord Loxley for the first time. For the first series, he was always in the country and Lady Loxley was always in town, and when he came to town, she went to the country to avoid him. But for series two, we brought him back as a problem for Lady Mae, and inadvertently created a nemesis for Harry. And that feud is set to get even more dramatic in series three.

Andrew Davies: Character and casting is half of the show. The stories all come out of the characters and their reaction to each other. And they can be a revelation, even to us writers. For example, the dramas Mr Grove went through in series one were really quite surprising. I can't remember where we got the idea that Grove was going to dump Miss Mardle but, after his wife died, he had this sudden piercing sense of his own mortality and decided he had to leave some mark of himself behind on the earth. So Miss Mardle, who had tragically given him her child-bearing years, was cruelly pushed aside for little Doris. Amanda Abbington played that with such wounded dignity and their story is not over yet.

Kate Brooke: The early part of the twentieth century is an era I have always found interesting, especially in terms of women's rights. There's so much going on and it's the beginning of a world that we still recognise now, so it's a lovely period to be writing in and it helps us make characters feel very modern. In the first series we saw women being liberated by shopping and in the second, women were further liberated by the war. In series three, we move on to 1919, looking at what happened in the post-war period, because there was an assumption that women were just going to get back into their boxes after four years of working in the store, once the men returned from the front and took back the jobs.

The show has such a wide breadth of characters, in terms of class and what they bring to the show. It is wonderful to write for all of them – American, French, cockney, upper class – they all have such different voices. And, as filming on series three gets underway, I can assure *Mr Selfridge* fans that there is a lot more drama on the way for each and every one of them.

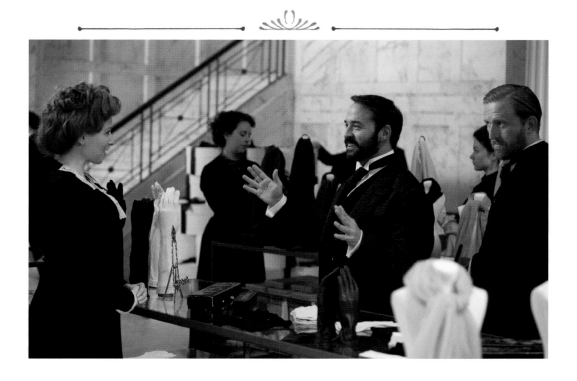

INTRODUCTION

Strong ideas for returning series are frustratingly elusive and when you happen upon one that you think might have legs, it feels like winning the lottery.

I was in a meeting back in 2010 with Laura Mackie and Sally Haynes, the commissioners at ITV at the time, and mentioned a book I'd just read by Lindy Woodhead, about the man who founded Selfridges. I'd pretty much dismissed the story as being too ambitious to realise on a television budget – period department store on Oxford Street! – but Sally jumped on the idea. Being an enthusiastic shopper herself, she loved the book and saw the potential. I rang Lindy's agent that afternoon and secured the rights.

Like many producers, I've always found real people and true stories the source of the richest drama. My first producing job was adapting Alan Clark's witty and poignant political diaries, and this spurred me to look around at other larger-than-life real people for inspiration.

Harry Gordon Selfridge's story immediately grabbed me, as he came from such humble roots to become one of the richest men in London, only to lose everything again. He dazzled London society with his revolutionary vision for shopping and his lavish store on Oxford Street. There were many department stores, like Harrods, Debenham & Freebody and Liberty, but what marked Selfridges out was that Harry was a real showman. He wanted to make his store one of the city's attractions, one that you would go to see along with the Houses of Parliament and Buckingham Palace. But he also had this really strong urge to self-destruct, and blew every penny he made on gambling and women, to die in poverty and obscurity.

It felt to me that the shop itself was also a prism through which to take a look at the beginning of the twentieth century. It was a time of great change and this is reflected in a fascinating way through retail. The history of the humble lipstick alone tells you much about the sexual revolution that was underway for women.

So the hunt was on for a writer with the vision and experience to bring this story to life for television. I had worked with Andrew Davies for many years and sensed that this might be a rather intriguing challenge for him. I'd been his script editor on productions such as his award-winning adaptation of Trollope's novel *The Way We Live Now* and later as a producer on his adaptation of Alan Hollinghurst's *The Line of Beauty*, so we had a good shorthand to embark on a project of this scale. Andrew's great skill is to make stories from the past relevant to today's audience. He has an almost uncanny ability to see what an audience will enjoy, what will make them laugh and cry.

Andrew read about Harry's story and loved it, but he was clear that he wanted the freedom to create a fictional set of characters around the store that we could use as the platform for a long-running series. At quite an early stage we mapped out the trajectory for the entire run of the series, framed by Harry's own rise to fame and fall from grace. The joy of working within television as opposed to film is the opportunity to follow characters in detail. We wanted to exploit this and tell really strong character-driven stories.

Andrew is hugely generous towards other writers, something that is probably borne of his experience in teaching creative writing. From an early stage, we discussed creating the series with a team and, taking inspiration from writing rooms in the US, we brought two other writers, Kate Brooke and Kate O'Riordan, on board. Together with them and our two script editors, Siobhan Finnigan and Ben Morris, we set up our own peculiar and very British system of working, which involves endless days of story lining, arguing about what our characters would or would not do, interspersed by lavish lunches and drunken evenings.

After the first series, Andrew passed the lead writer baton on to Kate Brooke and the writers' room has been topped up with exciting new writing talent. We all get to know each other pretty well. We have an office within the studio set up in north London and this ensures that writers stay at the heart of the creative process. We spend a lot of time there and pop down to set to grab a coffee and chat with the cast and crew.

The studio was once a carpet warehouse which over the past three years we've slowly tailored and spruced up to suit our needs. We have three stages which now house seven sets, and alongside this runs a set of production offices and editing suites. In the full flow of production, we have a producer, a co-producer, a production office, four directors at work (at various different stages of production), as well as busy production design, costume

and make-up departments, a filming crew and a support team of caterers and the facility crew. On a busy filming day, we might have a hundred extras and another hundred cast and crew on site, which makes simple daily events such as lunch a military operation.

It has been very rewarding for everyone involved in making the show to see how the stories have touched audiences both here in the UK and in the other 150 countries where the show is broadcast. It's also a great responsibility. We continue to move on five years between each series, something that brings fresh stories and social and historical context to each new run. Our cast seems to get bigger, as do our studio sets, and the stories continue to get richer.

It's a privilege to revisit our characters again and again, to see how life has changed from 1909 to 1914, and now to 1919. You can't help but fall in love with them and root for them as they encounter their trials and tribulations. The plan is to finish it all – at some point – with Harry's fall from grace. It'll be sad to say goodbye but it will have been a roller-coaster ride.

Kate Lewis
Executive Producer
June 2014

SELFRIDGE & Cᵒ Lᵀᴰ

THE STAFF ROOM

Honest endeavour together

The customer is always right

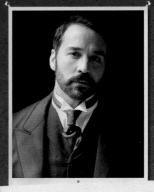

THE CHIEF

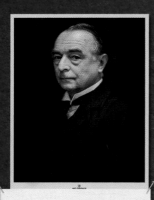

MR CRABB
Director of Finance

MISS MARDLE
Head of Accessories

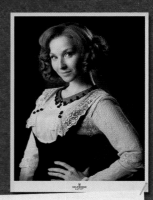

KITTY HAWKINS
Head of Beauty and Cosmetics

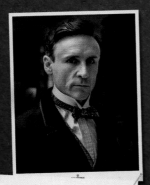

MR THACKERAY
Head of Fashion

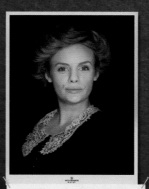

MRS DORIS GROVE
(Former) Accessories Assistant

GEORGE TOWLER
Manager of the Loading Bay

FRANCO COLLEANO
Waiter, Palm Court

AGNES TOWLER
Head of Display

HENRI LECLAIR
Creative Director

MR GROVE
Chief of Staff

VICTOR COLLEANO
Manager of Palm Court

MISS PLUNKETT
Secretary to Mr Selfridge

MISS BLENKINSOP
Social Secretary to Mr Selfridge

GRACE CALTHORPE
Accessories Assistant

JESSIE PERTREE
Accessories Assistant

GORDON SELFRIDGE
Manager of the Tea Emporium

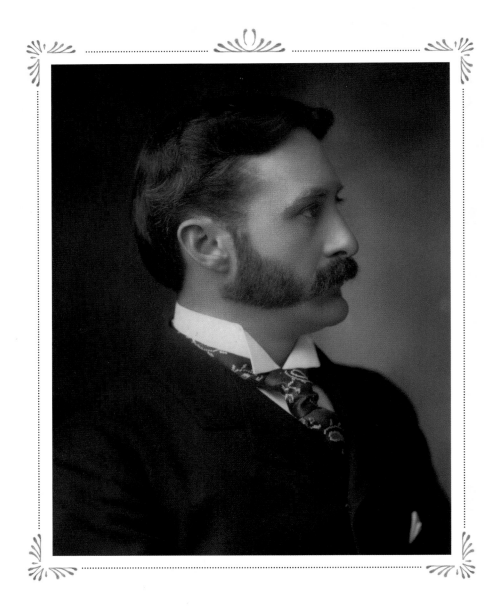

THE REAL
MR SELFRIDGE

THE EARLY YEARS

The ambitious entrepreneur who opened the doors to the iconic Oxford Street emporium in 1909 was a trail-blazer, a showman and a brilliant visionary. His ground-breaking flagship store and his revolutionary ideas were to change the face of shopping forever. But it was a humble beginning and a tragic past that proved the driving force in his life.

Harry was just five when his father enlisted to fight in the American Civil War.

Harry Gordon Selfridge was born to Lois and Robert Selfridge in 1856, in Ripon, Wisconsin, where his father ran a general store. The youngest of three sons, Harry was just five when the American Civil War broke out and his father joined up to fight. He was never to see him again.

As a child, Harry was told his father had died a war hero, but that was in fact far from the truth. When Robert Selfridge was honourably discharged at the end of the conflict, in 1865, he chose not to return to his family, vanishing without word. Eight years later, he died after being hit by a train in Minnesota.

'I don't think Lois rammed down his throat what a war hero his father was but I think she would have had a mixture of shame and pride,' explains Lindy Woodhead. 'The American Civil War was a ghastly war, really vicious, and to later discover that his father hadn't died a war hero, but had been discharged honourably and then had vanished, must have had a shattering effect on Harry. He must have become a driven man.'

Further tragedy struck the family shortly after the war, when Harry's two older brothers, Robert and Charles, died, leaving Lois and Harry alone. Mother

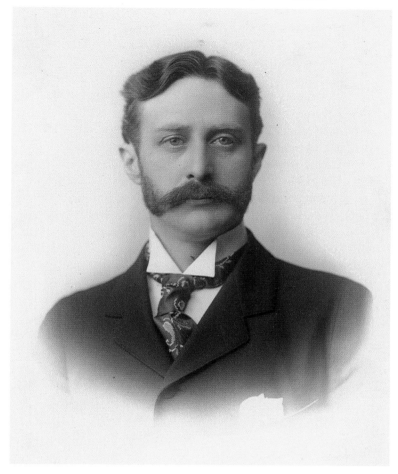

Being the only son of a 'widowed' mother had a profound effect on him. He strived to be the male of the family, the protector and the provider, and all his life, Harry was protective of women, especially his mother.

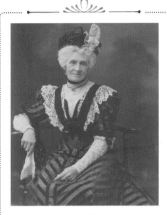

*A portrait of Lois,
and Lois with Rose
and Beatrice Selfridge.*

and son moved to Jackson, Michigan, where Lois took up a job as a primary school teacher. Although they were not in the absolute depths of poverty, Lois had to struggle to make ends meet on her salary of $30 a month (the equivalent of $440 today, or £260). She stopped short of taking in other people's laundry, but in order to subsidise her wages from teaching, she would also embroider Valentine's cards for pin money. She was a very proud, hard-working woman, with a huge work ethic.

'Being the only son of a "widowed" mother had a profound effect on him,' says Lindy. 'He strived to be the male of the family, the protector and the provider, and all his life, Harry was protective of women, especially his mother.'

The bond between Harry and his mother – who he later described as 'brave, upstanding and with indomitable courage' – was unbreakable, and they were to live together until the day she died. Lois's work ethic also rubbed off on her son and, as the man of the house, Harry was eager to contribute to the household income as soon as he could. At the age of ten, he got his first paper round, then a bread round and a holiday job carrying parcels – handing every penny of his earnings to his mother. At fourteen, he took on a full-time job as a book-keeper in a small local bank, where he earned $20 a month ($326 today, or £190).

But it wasn't just an industrious nature that Lois instilled in her bright young boy. Harry was always beautifully turned out, with a crisp white shirt, an immaculate suit and polished shoes. A smart haircut and scrupulously clean fingernails were also a must.

'Lois was an enormous influence on him,' reveals Lindy. 'She was actually a very relaxed mother, but she instilled in him a sense of duty and of pride, especially in his appearance. He was fastidiously dressed, and from a young age clothes were of immense importance to him. He had a monumental ego. He wore lifts in his shoes, and often a top hat, because he was quite short. His mother would check his fingernails and clothes before he went out in the morning – not in an *Oliver Twist*-style line-up, but more, "Everything all right Harry? Let's just check. Then off you go…"'

Harry was very short-sighted and wore glasses for reading and writing – but this would later provide an unwitting advantage in his business affairs. His startling blue eyes would fix on to those he met with a flattering and often disconcerting intensity, merely because he found it hard to read faces without his glasses.

Following on from his job at the bank, Harry became a book-keeper at a furniture firm, but when that company soon folded, the industrious teenager decided to take up an insurance job in the town of Big Rapids, a few hundred miles away. He returned to Jackson in 1876, at the age of twenty and with $500 of 'savings from his earnings' (though this could easily have been winnings from his frequent poker games), full of ambition and keen to make his mark on the world. He persuaded local store owner Leonard Field – who had employed him to deliver parcels as a boy – to write a letter of introduction to his cousin, Marshall Field, a partner in the Chicago department store Field, Leiter & Co. After a ten-minute interview, Harry was hired as a stock boy. It was the start of a 25-year career at the store that would see him rise to the top and sow the seeds of his retail revolution.

After four years in the wholesale division, first as a store boy then selling lace from suitcases on the road, Harry requested a transfer

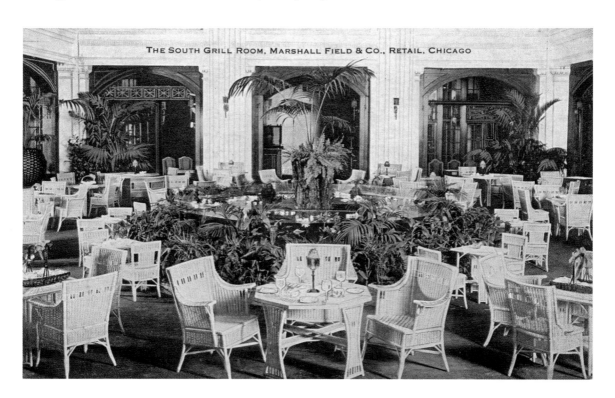

THE SOUTH GRILL ROOM, MARSHALL FIELD & CO., RETAIL, CHICAGO

to the retail store, which stood on State Street. According to his son Gordon, however, he never worked on the shop floor. Instead, his innate talent for publicity was put to good use in the advertising department, writing copy to entice the fashionable women of Chicago through the doors of the store, which had been renamed Marshall Field & Co, Levi Leiter having been bought out by his partner.

In 1885, Harry became personal assistant to general manager J. M. Fleming, though he was effectively now Marshall Field's 'ideas man', tasked with coming up with and implementing innovations for the store – and the role suited the pioneering 29-year-old to a tee.

The first thing he did was brighten the gloomy shop floor, by quadrupling the number of hanging lights; then, he created the concept of window shopping after dark, by lighting the window displays after closing; next, he added more telephone lines and a central switchboard. But perhaps the most significant change came when he altered the way the customer saw the goods. As Lindy Woodhead writes, 'Shopping, he reasoned, should be both a visual and tactile experience, one best enjoyed in a moment of self-indulgence and enjoyment and not requiring a sales clerk to unlock a cabinet.' For the first time in the history of high-end retailing, the goods were put on display on tables, allowing the discerning shopper to examine and feel the gloves, cashmere shawls and lace handkerchiefs before buying. The counters were lowered to allow staff to place goods on them for the customers' perusal and drawers were added, so that stock was immediately to hand. Behind-the-counter storage was added lower down, to avoid staff having to clamber up ladders. Harry also instigated the twice-yearly sale so ingrained in modern shopping habits.

Thanks to Harry, Marshall Field & Co were the first store to have a 'bargain basement', which offered 'even better value' for less affluent customers. Opening in 1885, the lower ground floor department was turning over $3 million by 1890 and was being copied in rival stores across the country.

Despite his successful innovations, Harry didn't always see eye to eye with his boss, described by Lindy as 'dry, humourless and puritanical'. Though he admired Harry's public relations skills and his visual merchandising ability, Marshall Field felt Harry was a bit of a showman and less skilled as a buyer. Field was motivated by money and in Harry he saw somebody who was in tune with the

LINDY
WOODHEAD
Author, Shopping, Seduction
and Mr Selfridge

' *When Field was on one of his many trips to Europe, Harry went behind his back and opened a tea shop.* '

HARRY'S HOMILIES

*'To do the right thing at the
right time in the right way.'*

*'To do some things better than
they were ever done before.'*

*'To know both sides
of the question.'*

*'To be courteous, to be
a good example, to anticipate
requirements.'*

*'To be satisfied with nothing
short of perfection.'*

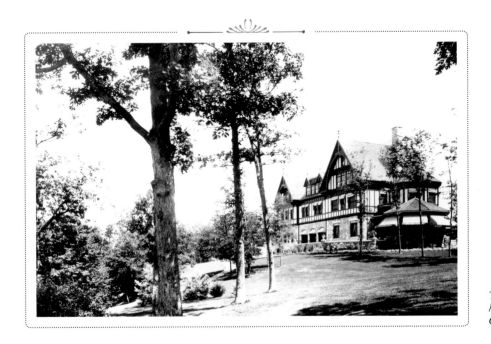

*The Selfridges'
house at Lake
Geneva.*

future, someone who could create magical departments that would make money for the store. Marshall recognised that Harry brought an energy and a synergy to the store. He utilised his keen manager's talents and tolerated Harry's extravagances – most of them at least. It didn't mean they always got on, however. In fact, the multi-millionaire magnate often vetoed Harry's ideas – but Harry didn't take no for an answer, as Lindy reveals:

'He forbade Harry from opening an in-store restaurant. "We're a department store," he said. "I'm not having cups of tea and cake crumbs all over the carpet." So when Field was on one of his many trips to Europe, Harry went behind his back and opened a tea shop. By the time he came back it was so successful that Marshall Field would go round the store saying, "It was such a good idea. I had been talking to Selfridge about it. They have them in Europe..." The hypocrisy of it!'

At least Marshall respected Harry enough to make him a junior partner meaning, with share packages, he was raking in the modern equivalent of $435,000 (£250,000) a year. One characteristic of Harry's tenure at Marshall Field & Co, which he later brought to London, were his motivational messages, pinned to the wall of the staff canteen in State Street, setting daily targets.

In fact, Harry is credited with creating some of the familiar retailing maxims still in common currency today. He came up with the well-worn phrase, 'Only X shopping days until Christmas', and adopted as his own mantra Marshall Field's adage: 'The customer is always right.'

In 1904, feeling he had gone as far as he could at Marshall Field, Harry decided to strike out on his own. He bought the lease for a new store that was being built just up the street from his old store and opened the doors to the loud fanfare of brass bands in June that year. But the eternal optimist found his new venture sent him into a deep depression. 'I was extremely miserable competing with my own people – the people with whom I had spent so many happy and glorious years,' he told the *Saturday Evening Post* in 1935. 'I tried to beat down the feeling but my unhappiness increased.'

After three months, Harry put the business up for sale and retired, with his family, to Harrose Hall, a house in Lake Geneva.

MR SELFRIDGE

PLAYED BY JEREMY PIVEN

As a boy growing up in Illinois, Jeremy Piven was a frequent visitor to Marshall Field & Co, where he gazed in admiration at the fabulous architecture that dominated Chicago's State Street. Razed to the ground in the Great Chicago Fire of 1871, the store was rebuilt, under Harry's influence, as an impressive twelve-storey building with huge display windows, a grand entrance and an inner atrium that stretched from floor to ceiling – which later became the largest Tiffany glass roof in the world.

'I remember the whole store as being like a piece of art,' recalls Jeremy. 'In the States we don't have as much history as you do in the UK and visually, after the Chicago fire, these landmark buildings really changed the skyline.

'Marshall Field had been there for so long, and I remember that the metalwork was so impressive and the big windows were always fun to see. It was a real destination as opposed to running in and grabbing something to buy in a mall. It was like a museum, and in that way it had real impact.'

The childhood memories of his favourite department store came flooding back to him when he arrived in London and visited the Oxford Street store, as well as on the set of *Mr Selfridge*.

'In both Selfridges and the set I saw that influence everywhere,' he says. 'You see it in the structure itself, and the way it's laid out. On the set, all of the designers have been meticulous in getting it right and the work that has been done to the structure itself reminds me of Marshall Field. Being from the Midwest, I do have a connection with Marshall Field so there's a great tie in and it makes me feel at home.'

HARRY
SELFRIDGE

' *To work is elevating. To accomplish is superb.* '

Although the American actor knew very little about Harry Selfridge when he first read the script, he was instantly taken with his larger-than-life character and keen to learn more about the magnanimous millionaire.

'I like that he cared so much about everyone that worked for him, and he treated everyone with the dignity that he would want to be treated with himself,' he says. 'It's like the old saying, "Do unto others as you would have done unto you." I don't think that was all talk. He walked the walk with that, and that's evidenced by all the people who spent their entire professional careers with him. It meant a lot to him to be in a position to help people.'

Jeremy admits he also admires the flamboyant businessman for his incredible ambition, even if some of his more outrageous ideas failed to get off the drawing board.

'Not many people know but his original plans for Selfridges were almost identical to the White House,' he laughs. 'So there's something very grandiose about Harry Selfridge – he basically wanted to recreate the White House. How many Brits would say, "You know what, I want to recreate Buckingham Palace … in Detroit." He was a very ambitious, flamboyant, passionate, driven guy.

'He was also incredibly innovative. He was the guy that came up with the idea of announcing the number of days until Christmas, the bargain basement, and even the idea of a sale. "The customer's always right", "Treat them as guests" – these are all his credos.

'His heroes were P. T. Barnum, who invented the three-ring circus, and that informed my performance. He wanted to create an event in his store, and he did. He essentially transformed shopping and the way we think of it. He loved to empower women – and he loved women, obviously – but they could come to his store and feel comfortable to be whoever they wanted to be.'

For Jeremy, working on a period drama in the UK is a new experience and he admits he is impressed by the authenticity of the costume, the set and the many props used in the production.

'It's a pleasure and an honour to work on a period drama and they are meticulous about getting it right so you're lucky enough to feel like you're genuinely a part of that time. I'm in awe of their attention to detail. Everything looks so real and so authentic and it just blows my mind because even people in the States say, "It must be such a huge budget." The reality is that they make it look like so much more

'Treat them as guests.'
HARRY SELFRIDGE

than what they are working with. That's a tribute to them and their creativity and ingenuity.'

In order to film the series, Jeremy decamps to London for seven months each year, and says he is often recognised from his role in the show and addressed as Harry. One woman even asked him to have a word with his staff because she was unhappy with a manicure she received at Selfridges.

'After the second season it's gone to a whole new level, and it's really nice,' says Jeremy. 'Whenever I hear recognition of the show, I feel so connected to it that it makes me happy.

'I think the character is continuing to evolve and I am still very much learning, but I am thrilled to be working around all these brilliant people who raise my game because they are the best actors I've ever worked with.

'Here we are in a carpet warehouse in north-west London, grinding it out for seven months and I couldn't feel more lucky. I'm having the best time of my life and I'm really proud of this show.'

> *'The customer's always right.'*
> HARRY SELFRIDGE

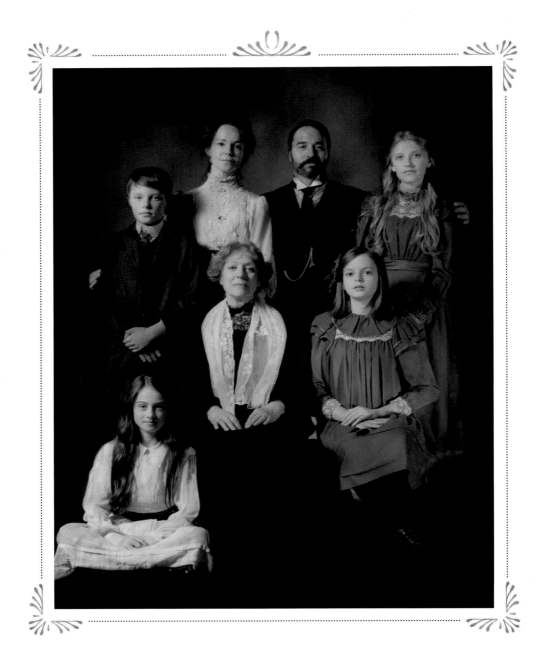

MEET THE FAMILY

**LOIS
SELFRIDGE**

 Married to

**HARRY
SELFRIDGE**

**ROSE
SELFRIDGE**

ROSALIE

GORDON

VIOLETTE

BEATRICE

FRIENDS AND LOVERS

LADY MAE LOXLEY
FRIEND

LORD LOXLEY
LADY MAE'S HUSBAND

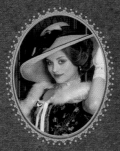

ELLEN LOVE
HARRY'S LOVER

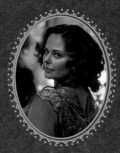

DELPHINE DAY
FRIEND

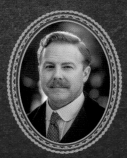

FRANK EDWARDS
JOURNALIST AND FRIEND

MEET THE FAMILY

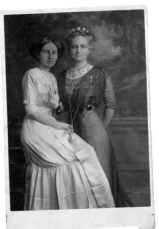

SELFRIDGE & CO LTD
OXFORD STREET, LONDON W.1

Dearest Rose,

I have been called away on urgent business. I am travelling to Paris immediately, an important supplier wishes to meet me there.

Please explain to the staff that I will return soon, a few days at most.

All my love,

Harry

HARRY AND ROSE

In 1890, at the age of thirty-four, Harry married Rosalie Buckingham, a property heiress from a hugely wealthy Chicago family. A talented linguist and harpist, she travelled through Europe with her mother between the ages of thirteen and nineteen, studying languages, and had become a cultured young woman.

In a 1949 book, *Strange to Say,* Chicago socialite Mrs Carter H. Harrison recalled the sophisticated and generous young lady she had become: 'Rose Buckingham, belonging to a distinguished family, was as lovely in mind as she was in body. I think when she stood beside the harp, which she played beautifully, she was an inspiration to those who saw her. A great favourite in society, she was generous in contributing her skill on the harp for charitable purposes. She loved her art and was always willing to help others.' In fact, she had received a *Légion d'honneur* from the French government for her work in Anglo-American-French art and letters.

In her twenties, Rose extended her travels to Russia and the Middle East, but found plenty to do at home as well. She was a successful property developer in her own right by the time she married Harry at the age of thirty (this at a time when it was common for women to marry at seventeen or eighteen), having bought land in the city's Hyde Park area with money inherited from her father, and built forty-two artisan villas and cottages in a beautiful landscaped garden, along with a café, restaurant and an inn called The Red Roses.

'I love my wife. I've failed her many times, but if you really want to know what drives me, it's Rose. Everything I've done in this store, every brick, every counter, it's for her.'

HARRY SELFRIDGE, MR SELFRIDGE

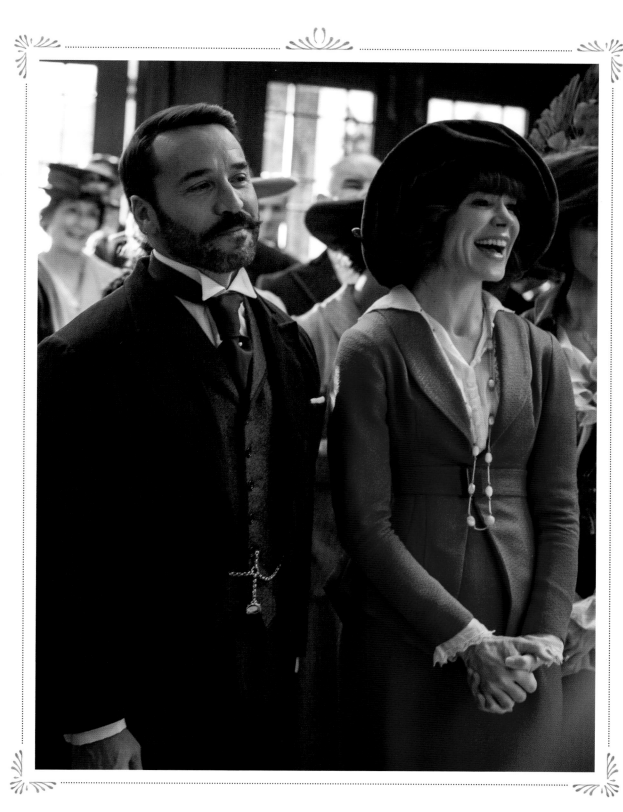

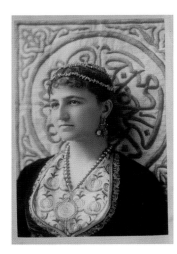

LINDY
WOODHEAD
Author, Shopping, Seduction
and Mr Selfridge

*' They absolutely
adored each
other. She was his
prop, and he was
her prop. When
they married he
was in his mid-
thirties, with a
reputation as a
man about town,
so she must have
known he had
a lot of lovers. '*

For the couple's wedding on 11 November 1890, Harry poured all his skills as a showman into the planning. Fittingly, the ceremony was held at Chicago's Central Music Hall, a venue big enough to house the 1,000 invited guests. The central aisle and roof had been turned into an exact replica of Ely Cathedral – a reference to the bride's Cambridgeshire ancestry – and the hall was decorated with 5,000 roses. Music was provided by a choir of fifty singing to the booming sound of the hall's large organ. Harry's wedding gift to his bride was an exquisite necklace of blue diamonds, which she wore to walk down the aisle.

Such was the bond between Harry and his mother that Lois not only accompanied the newlyweds on their honeymoon, but would go on to live with them for the rest of their married lives. Fortunately, Rosalie got on famously with her mother-in-law and thought nothing of sharing her honeymoon and her home with her.

Initially, the newlyweds lived with Rose's mother on Rush Street, Chicago, before moving to their own home in Lake Shore Drive. Harry also had his house on Lake Geneva, Harrose Hall, which was built in mock-Tudor style, complete with large greenhouses and extensive rose gardens.

Despite their lavish wedding, it wasn't all roses and diamonds for the couple. Tragically, their first child died at just a few months old. They went on to have four children (all featured in the series): Rosalie, Violette, Beatrice and Gordon.

Then there were the affairs. Harry had always had an eye for the ladies and was particularly fond of actresses and showgirls, whom he showered with gifts and flattered with his attention. But Lindy Woodhead insists his love for Rose was genuine: 'They absolutely adored each other. She was his prop, and he was her prop. When they married he was in his mid-thirties, with a reputation as a man about town, so she must have known he had a lot of lovers. Of course, she knew. But she wasn't going to give up on the man she loved. She had her children, her home and they had a very independent existence.'

After her marriage, Rose turned her
hand to growing orchids and became
an expert in the field. An article in
a 1903 edition of the *Chicago Tribune*
praised her accomplishments and
asserted that she had 2,000 different
varieties of the flower.

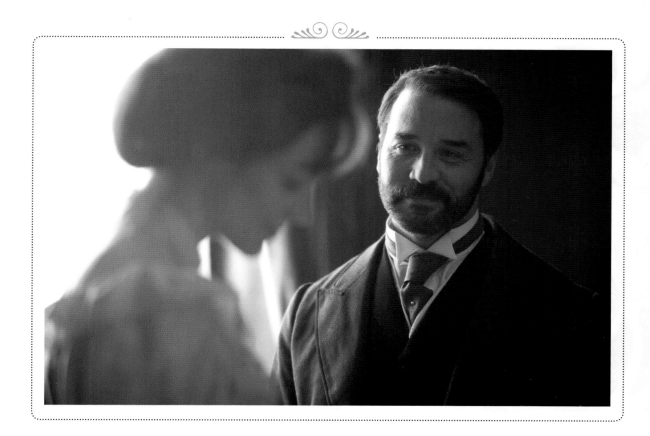

ROSE SELFRIDGE

PLAYED BY FRANCES O'CONNOR

As Harry's wife Rose, Frances O'Connor is the true love of Harry's life but his womanising ways have almost driven her away. At the end of the first series, after finding out about his fling with showgirl Ellen Love, Rose fled home to Chicago. For series two, she decided to stand by her man – but only on her terms.

'It was five years on and I think Rose had grown up a lot,' says the Australian actress. 'She decided that she couldn't get back with Harry so she was going back and forth from Chicago to London. But she was really just in London in a public capacity as his wife, to be Mrs Selfridge to the outside world. But that's as much as she could do.

'The relationship was not frosty but perfunctory in a way. Harry had a lot of work to do to try and win her back and he still had lovers on the side.

'Underneath it all Rose was still totally in love with him but she became a lot stronger and surer of herself. She was still the same person but had worked out what she wanted from life. Rose knew what she was prepared to put up with and what she was not.'

As one of the wealthiest characters, and the wife of a fashion store magnate, Rose boasted an exquisite wardrobe which was more subtle in tone than Lady Mae's but equally eye-catching – and frighteningly expensive.

'Some of my evening dresses are amazing,' laughs Frances. 'A few of them are actually 100 years old and you have to be quite careful when you're wearing them. Inevitably they get caught on a chair or something, and people freak out.

Zoë Tapper plays Ellen Love, a showgirl who has a fling with Harry.

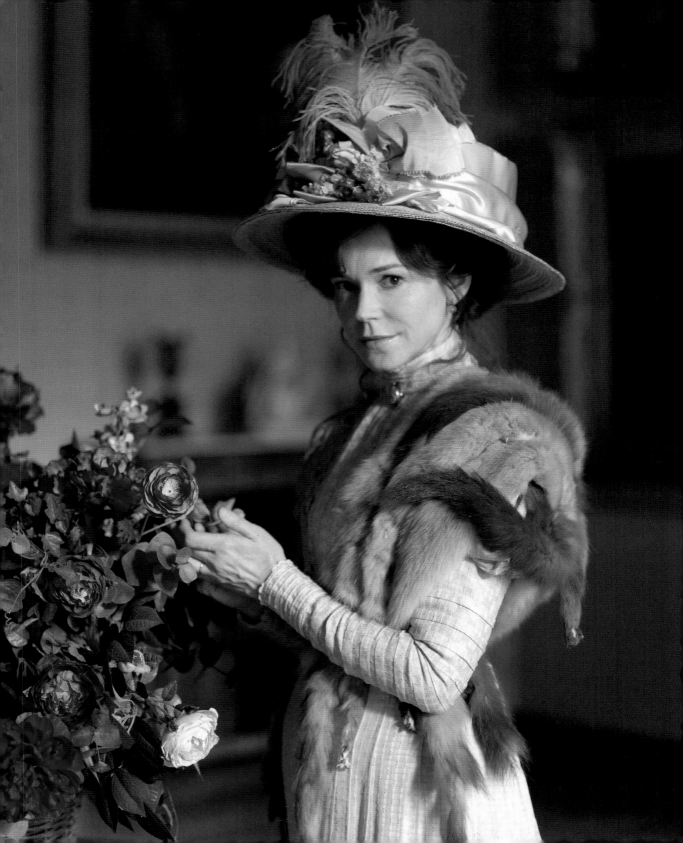

FRANCES
O'CONNOR
Rose Selfridge

' *She was tested
and challenged,
which was very
satisfying to play.
And women
identified with
her, although they
understood both
Rose's and Harry's
perspectives.* '

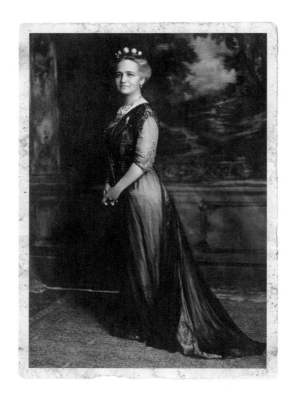

'In the second series, Rose's look is different from before. It's a little softer than the Edwardian look and slightly less structured. So it's got more flow to it. I think it's very pretty in what was quite a glamorous era.

'They've also done a really great job this series in terms of how they've dressed the sets. The decor in all of the sets is really beautiful and they are so detailed. It helps you believe in the world.'

The relationship between Harry and Rose did thaw throughout the second series but Rose's tragic demise, set up in the final episode, means Frances will not be returning to the fold for the next run.

The actress admits that she is sad to leave such a popular character behind her.

'People seemed to really like Rose as a character,' she says. 'I don't think I've ever played anyone quite that gentle. She was tested and challenged, which was very satisfying to play. And women identified with her, although they understood both Rose's and Harry's perspectives.'

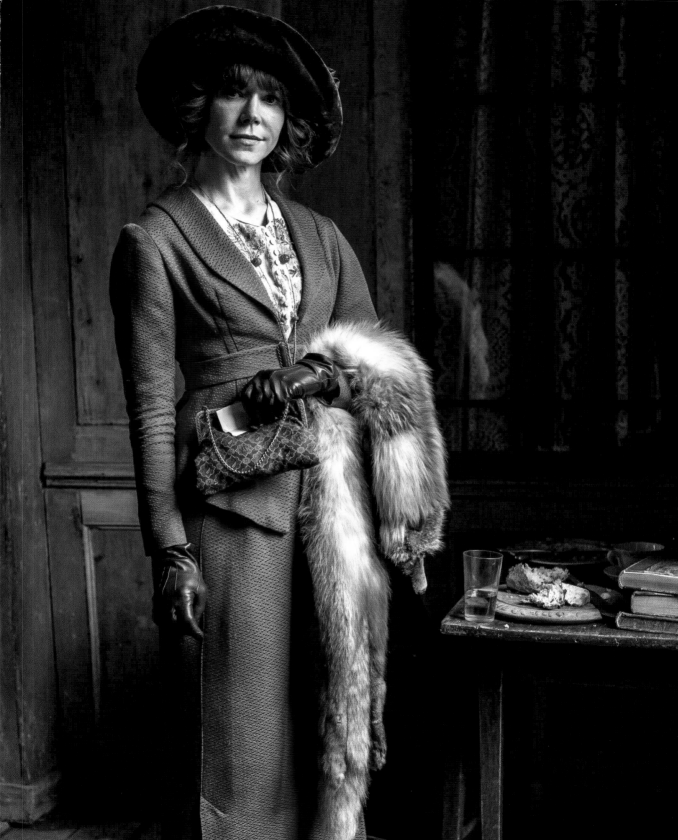

THE FAMILY HOUSE

THE CHILDREN

Rosalie was born in 1893 and was followed by three siblings – Violette, born in 1897, Gordon, in 1900, and finally Beatrice, in 1901. Rosalie was a quiet and loving girl while Violette, the free spirit of the family, was prone to playing pranks and organising 'unexpected amusements' for the rest of the family. Gordon, marked as his father's successor from day one, was schooled in the ways of the business from a young age, spending school holidays in private tuition or with Harry at the store. He had his own desk in his father's office at the age of sixteen, despite still being in full-time education.

Harry and Rose were indulgent, engaged parents in an era when most children in wealthy families were raised by armies of nannies. Each morning the family breakfasted together, discussing items from the newspaper picked out by Lois. The children – sixteen, twelve, nine and eight when Selfridges opened – were often then asked to make three suggestions to tempt customers into the store before they left the breakfast table.

A family friend, Grace Lovat Fraser, once said the atmosphere of the home of the Selfridges was 'lively and informal, with the house always full of young people of whom gentle Mrs Selfridge was very fond'.

THE SELFRIDGES MOVE TO LONDON

Harry first visited Britain on a business trip for Marshall Field in 1888. As well as enjoying the restaurants and theatres of London, he visited several stately homes and developed a passion for the aristocratic way of life of their inhabitants.

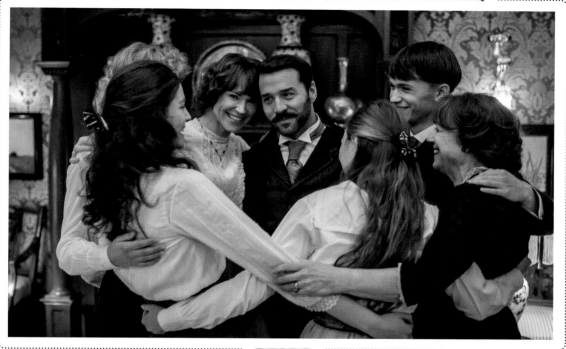

'It was the most powerful city in the world,' observes Lindy, 'and Great Britain ruled half the globe, so if you could conquer London you could conquer the world.'

Arriving to set up the store in 1906, he was joined by Rose, Lois and the four children a year later, renting both Foots Cray House in Sidcup and the palatial house at 17 Arlington Street, just round the corner from the store. Rosalie, Violette and Beatrice attended Miss Douglas's School in Queen's Gate, while Gordon was sent away to prep school. Harry set about impressing London's aristocracy – such as Lady Victoria Sackville and the Duchess of Rutland – but as an American in a rather anti-American era, he wasn't exactly welcomed into society with open arms. A number of financial scandals, most notably that involving Charles Yerkes and his falsification of accounts while financing the building of the London Underground, had tainted the reputation of Harry's countrymen, and the British were very wary of flash new money from America as a result.

'However, Harry was very popular with a certain strand of society, even among the duchesses, because he was always doing his best in the store to help these ladies with various committees,' explains Lindy. 'His neighbour in Arlington Street was the Duchess of Rutland and she absolutely adored him because he was very generous to her charities.'

While Rose dutifully attended the social functions that helped promote her husband's interests, and enjoyed theatre outings, she was not as happy with London life as Harry was and would return to Chicago to visit her sister, Anna, three or four times a year.

17 ARLINGTON STREET

The Selfridges' London home, at 17 Arlington Street, was in the heart of upper-class Mayfair, overlooking Green Park. However, when it came to filming the series, the real thing was no longer a viable option. Having been bombed in the war, the opulent address now forms part of an apartment hotel.

'His real house is quite bland and boring,' reveals Nic Pallace, the art director of the second series. 'It's been modernised beyond the point where it could be used.'

As a stand-in, the fabulous exterior of the former Royal College of Organists, close to the Royal Albert Hall, was chosen. Now a privately owned house, the maroon and cream building, designed by H. H. Cole and built in 1876, boasts hundreds of intricate carvings of musicians, drawn by artist F. W. Moody and executed by his art students. The perfectly preserved façade lent itself to Harry's extroverted personality and, according to set designer Rob Harris, reflected his love of circus legend Phileas T. Barnum.

'We decided not to go for a typical Edwardian house because we wanted to give it the Barnum & Bailey feel, make it slightly different so that it wasn't like a *Downton Abbey* house, but the house of an American in London,' he recalls. 'We gave it a flamboyant exterior, put a lot of tiles on the wall, a lot of colours – so it is more about his character than the exact period. We wanted to reflect the showmanship of the man.'

AT HOME WITH THE SELFRIDGES

For the interior of Harry's house, Rob originally took inspiration from the home of Lord Frederic Leighton. The Victorian artist owned a large property in Holland Park, which he embellished in his own

Harry was keen to run his household in the opulent style of the wealthy English gentleman. The 1911 census shows that the Arlington Street house had eleven servants, including a cook, a kitchen maid, four housemaids, a scullery maid and three footmen. The household was run by the butler and cook – a Scottish couple named Mr and Mrs Fraser, who stayed with the family until 1924.

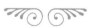

unique and grandiose style over a period of thirty years, and the dark blue tiles of the hallway in Harry's house are an homage to that style.

The set, built alongside the store interiors at the north London warehouse where much of the filming takes place, comprised the living rooms and dining room, a functional staircase and bedrooms which actually came off the upstairs corridor – an unusual luxury on a set build. 'We built it as a composite set,' explains Rob, 'so you could actually walk around it, walk upstairs into the bedrooms, into the dining room and we could just move the cameras through the rooms.'

For Frances O'Connor, who plays Rose Selfridge, the first time on set was just like seeing it through the eyes of Harry's newly arrived wife. 'When Rose and the children first come to the country, Harry has found the house, designed it and made it amazing, and then we as a family turn up and we're exploring,' she remembers. 'When we filmed the scene it was actually us, as actors, thinking, "Wow, what a great set," because it is beautiful.'

Series two set designer Sonja Klaus brought in a more exotic feel for the 1914 house, in a move that reflected the more accessible world that better transport and more pioneering adventurers were opening up to the well-to-do Londoner. 'With the second series, we're at the start of the First World War, which was a horrendous period in history,' she says. 'The other side of that is the Roaring Twenties, when everyone went a bit bonkers, with music and parties. It was a fast-changing world and the Edwardians were at the beginning of that.

'The Victorian Orientalists were still popular at the time and many contemporary painters were influenced by the Orient. Artists such as David Roberts had gone to Egypt and were doing wonderful paintings of sphinxes and pyramids, and the adventurous were saying, "Ooh, fancy that. I think I might go for a little trip down the Nile." People were becoming more inventive and progressive, and being more daring. It was easier to get on a boat and go to America than it had ever been.

'It's important to show that Harry's house was keeping up with the times, and that he was moving with the new things that were coming in – the new designers, the new look, the new feel, the experiences that people were having.'

To keep up with the trends, the interiors were given an overhaul, starting with the vast entrance hall and those famous blue tiles.

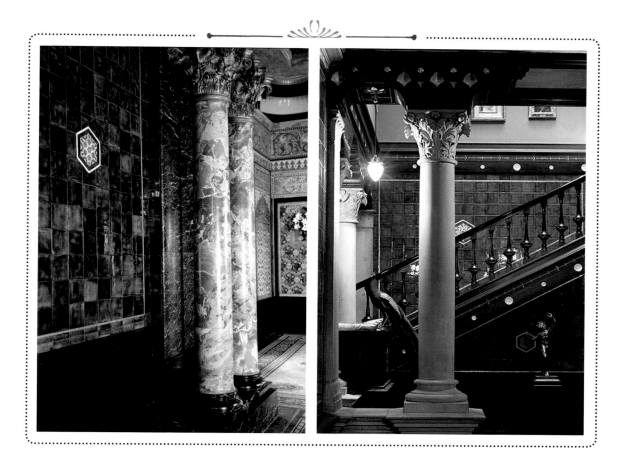

Above: Narcissus Hall at Leighton House (left) is the inspiration for Harry's house in the series (right).

'We built an internal garden with a fountain and a seating area, which was Moorish in style, a little bit Persian,' says Sonja. 'I felt the hallway needed a bit of light so I changed the colour palette to give it a more golden look.

'I added a lot of large paintings to cover up a lot of the blue tiling, and I removed a whole wall of it and added an enormous fireplace. I put the piano in the hallway so they could have concerts and gatherings in this large space. Then I created a seating arrangement to serve as an "interim receiving area", which many houses had, so that if the guest wasn't well known to the family, they could be seated in the hall, as opposed to being shown straight into the inner sanctum.'

Another seating area was added upstairs, in a large open space which was previously unused, and this one served a dual purpose

– in some places on set the lighting rigs tend to take over and get in the way, so having this area was a good way of masking the huge structure that the lighting department had built.

DINING IN STYLE

The dining room is the heart of the house, where Harry surrounds himself with his family at breakfast and dinner, or entertains influential guests at dinner parties. For series two, it moved from the front to the back, closer to the kitchen, and was refurnished.

Big pieces of furniture were added in both the living room and dining room to give a sense of scale, and quite a lot of money was spent on beautiful Moroccan lights and huge chandeliers. Sonja added palm trees in Chinese containers and Edwardian cupboards to display the china.

Whether Harry is having Thanksgiving dinner with the family, or entertaining the likes of Lady Mae and F. W. Woolworth, the sumptuous table is always heaving with the finest china and the best silverware that money could buy. Production buyer Belinda Cusmano sourced Royal Crown Derby designs for the crockery and cut-crystal wine glasses and vases from Waterford. The silverware was provided by William Turner, who have been manufacturing cutlery in Sheffield since 1887. 'They actually made us special cutlery,' says Belinda, 'which took them seven weeks.'

Sonja adds: 'Everything is new – they are all replicas of original designs, because everything in Harry's house would have been new. You don't want it to look like it's been bashed around in a props house for twenty-five years. Many of the Waterford Crystal designs haven't really changed since 1914 and all these companies – the glass, china and silverware companies – still produce goods that are based on designs from that time.'

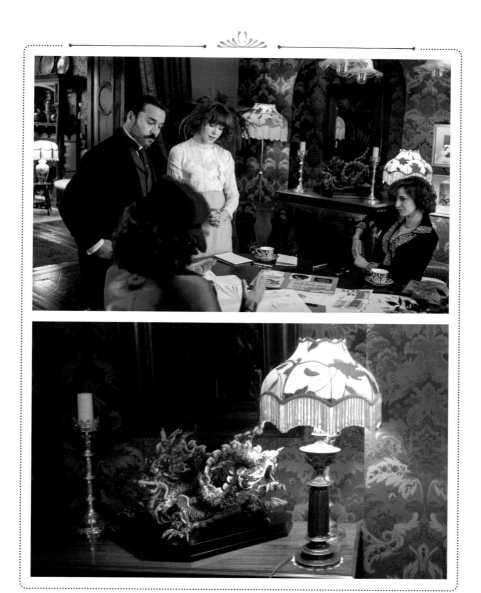

Visitors to Harry's dining room could hardly fail to notice the two enormous green Chinese dragons, a major focus of the room. These beautiful china beasts, borrowed from Lladro, are worth £18,000 each.

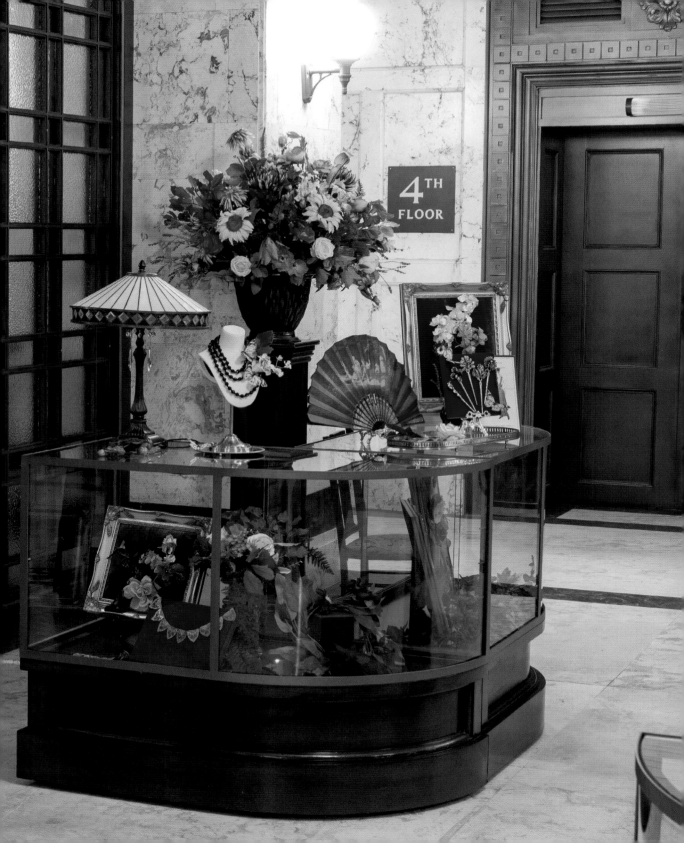

FLORAL TRIBUTE

Along with the tableware, the dining room table often required an impressive centrepiece. Unlike today, however, the florists of 1914 would have been restricted to the blooms that were in their natural season, and not all of the varieties we are used to seeing would have been available.

Luckily, London-based florist Jayne Copperwaite was on hand throughout the series to make sure her stunning arrangements stayed true to the era. 'I've worked on many period dramas over the past fifteen years,' says Jayne. 'So I have done extensive research in my historical gardening and cook books, as well as the "language of flowers", which was a popular conceit with the Victorians and Edwardians. Once I have established what was grown in England, both historically and seasonally, I can then match that to which flowers and plants are still available now to purchase. The most popular flowers and plants would have been carnations, roses and lilies, and those with more exotic tastes would have chosen hothouse-grown orchids.'

The frequent scene swaps meant that Jayne and her assistants were kept busy on set.

'In total, in series two, there were eighteen regular arrangements, which were changed over when the script changed dates, to mark a new scene. Over six months of filming we visited the studio at least twice a week, sometimes more. For one block of scenes in Harry's house, we had to dress then redress the set three times in one day, so myself and a member of my team were on standby all day. We were also going out to different locations at least once a week as well.'

For the Selfridge house, as well as Lady Mae's reception rooms, Jayne used a mixture of real and silk flowers. 'We used real flowers for some of the dining table arrangements, such as the Thanksgiving dinner, but the majority were silk flowers and plants.'

As Sonja explains, interior sets make poor habitats for plant life.

'We used a lot of silk flowers because in a studio situation there is no daylight and things die,' she says. 'We did have some real plants and real flowers, if we were shooting something for a short enough period of time, but if a scene was shot over a longer period of time, they would have to be synthetic, and silk was best for that.'

A floral arrangement to complement the lavender soaps is among Jayne's many stunning creations.

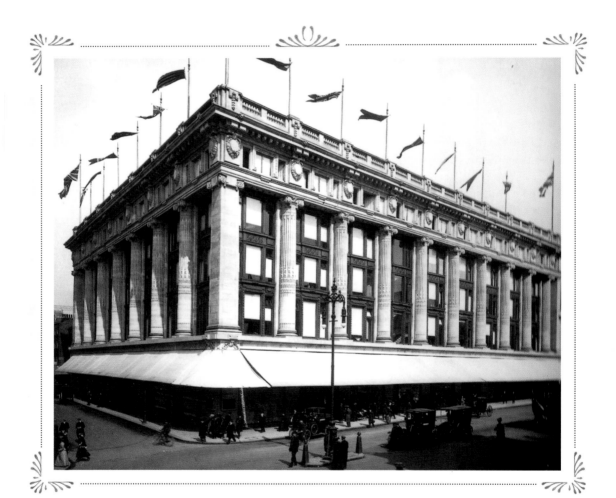

A SHOPPING REVOLUTION

A SHOPPING REVOLUTION

'*Give the lady what she wants.*'

HARRY
SELFRIDGE

Although Harry had made the decision to sell his Chicago store and move his family to Lake Geneva in 1904, his early retirement was short-lived. For a man as dynamic as Harry, life without work proved far too dull, and within a year a fruitless venture into gold-mining had cost him a $60,000 (£36,000) – the equivalent of $1.2 million (£726,000) today. In 1906, he travelled to London with a new business idea – to open his dream store in the West End.

Harry's grand plan was to teach the English that shopping could be fun, with a spacious, purpose-built emporium that would sell everything 'from an aeroplane to a cigar'. The first drawings, which showed a huge six-storey building with a mansard roof were rejected due to London planning laws, but with Marshall Field & Co architect Daniel Burnham at the helm, he forged ahead with a five-storey building, with three basement levels and a roof garden.

Disaster struck in 1907 when, frustrated by the constant delays and spiralling costs of the entrepreneur's grandiose plans, Harry's business partner Sam Waring pulled out of the deal, leaving Harry with an expensive excavation the press dubbed, 'the largest building site London has ever seen'. However, rescue came in the form of tea tycoon John Musker, who was happy to back the new store and, in 1908, Selfridge & Co was formed, with a capital of £900,000 (around £80 million today).

When it threw open its doors in March 1909, 'London's first custom-built department store' stretched over 50,000 sq foot. It would revolutionise shopping forever.

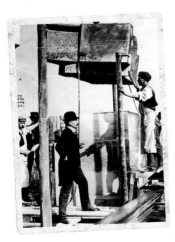

Harry's grand plans were thwarted when Sam Waring pulled out, but he was undaunted and building work carried on.

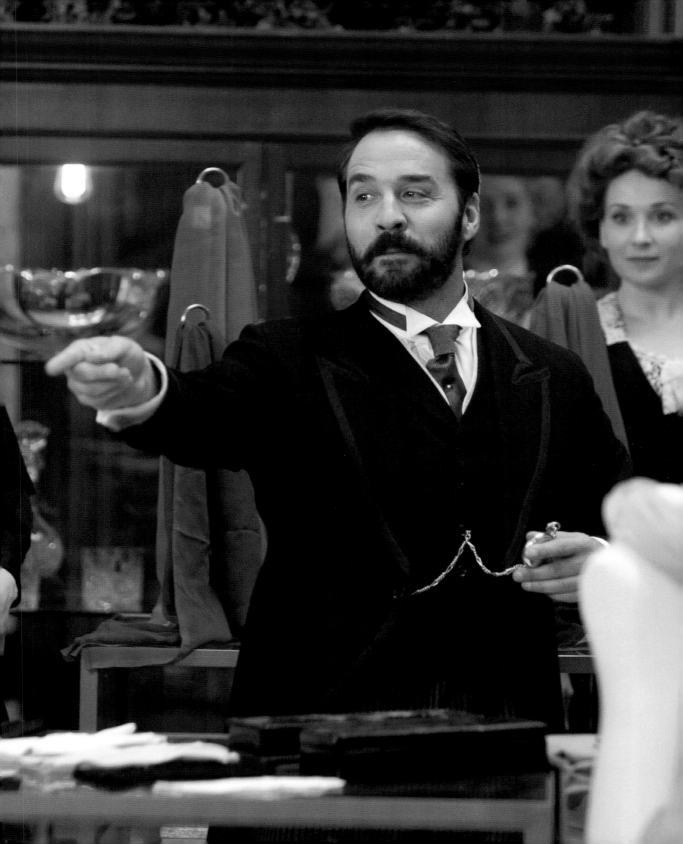

'Selfridges was built from scratch and all the other stores had evolved from being rather small, elegant little buildings,' says Lindy Woodhead. 'Imagine an old manor house, where someone adds an extension to the top, and more on the side, then another on the back, so it becomes much larger but it's higgledy-piggledy. This also happened to department stores. They built a very smart elegant, small store, but as consumerism became more important throughout the nineteenth century, they bought out next door, they bought out the back, so they became like rabbit warrens, with small interlinked departments.

'Harry got a modern architect, with a vision for space, to plan a building that was straight lines, so you have walkways that are twice as wide as some actual departments in existing London stores. At Selfridges, each department was a series of showcases within an area, but that area was maybe ten times larger than any other comparable area in a London department store.'

Harry wanted wide vistas, not claustrophobic spaces; he wanted the shopper to look through from books into china, or from fashion hats to fashion accessories, and starting from scratch meant being able to utilise the most up-to-date innovations.

Among those innovations were a library, a silence room – where customers could take a rest from their arduous shopping tasks – a first aid room with uniformed nurses, a barber's shop, a ladies' hairdresser and manicurist, a bureau de change, a post office, and a staff dedicated to concierge duties, booking theatre tickets, hotel rooms or anything the well-heeled shopper required.

The Palm Court restaurant served lunch and afternoon tea while an orchestra serenaded diners and, in perhaps the biggest boon to female shoppers, the store boasted the first ladies' toilets in a department store to be accessible to everyone, both to those who had spent money and to those who had been 'just looking'.

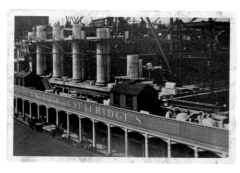

The Doric columns were a huge feature of the original store and can be seen here, rising from the construction works.

'In the past, if a lady wanted to go to the toilet, she had to go home which was a real problem,' says Samuel West, who plays journalist Frank Edwards in the series. 'Women had so many petticoats on and everything else, and when nature called they had nowhere to go. It made shopping a very different experience if you didn't have to go home.

'Selfridges was also a respectable destination to go with your female friends, rather than having to go with a chaperone. In Edwardian Britain, it was considered deeply improper for a lady to go out without an escort, but if you were going to Selfridges, you could go with a girlfriend.'

As well as the many services available, the new store provided a blueprint for the way we shop today. The acres of floor were brightly lit and scented with flowers, goods were on show, to be looked at and touched, and the biggest shop windows in the country displayed the fashions of the day, the latest crockery, mountains of scented soap or a special display to mark a patriotic occasion, such as the coronation of George V in 1910.

On the day of the grand opening, staff looked on in horror as the stunning fashion windows created by designer Edward Goldsman were soaked by the new sprinkler system, just hours before the first customers arrived. The doors opened regardless and 90,000 curious customers filed through into the store.

Harry introduced a bonus system to ensure all staff had an interest in performing well. A young employee in the accounting department earned just 5 shillings a week (£21.40 in today's terms), with a monthly bonus of 10 shillings (£42.80) if their figures were not out by more than a ha'penny. Three months' accuracy meant a bonus of 30 shillings (£128.40).

Junior sales staff were paid around £1 a week (approximately £85 today) but were rewarded with a sales commission of 3d in every pound (1.25 per cent).

dressing the window and he lights a cigarette, and the water sprinklers go off,' says Lindy. 'I don't know if it was a cigarette or a pipe that set the sprinklers off in 1909, but they did go off. Mr Crabb then blames it on "all these innovations, Mr Selfridge". That sums it up. Harry's vision was so huge that people often found it hard to cope with.'

THE CHIEF

When it came to choosing his staff, Harry had some strange stipulations. Men who were too tall or had a skinny neck were rejected, as were those without polished shoes or spotlessly clean and well-clilpped nails. Once in the fold, however, Harry proved a fair and inspirational employer, providing staff with unprecedented facilities, thorough training and a higher salary than many of his rivals. He was a great modernist and egalitarian in the way he ran the staff. As he had at Marshall Field & Co, Harry posted motivational messages on the staff-room notice board, such as 'Merit will win' and 'There's no fun like work'. As he explained during an interview on business practice, he believed the way to get the best productivity from staff was to take them 'as far as possible into mental partnership with you. Make them feel a real interest in the business.' A good businessman, he felt, should 'make their life as happy as possible. Feed and pay them well. Make them contented.' He even set up staff councils, where employees could air their grievances. In return, they adhered to a strict dress and punctuality code, and any hint of dishonesty meant instant dismissal.

Harry's own day at the store ran like clockwork. Every morning, he arrived at the store at 8.30am, went through his post and the day's diary with his secretary, and had a breakfast of fruit and China tea in his office. At 9.30am on the dot, he would appear for his morning round, visiting each department on the six acres of shop floor and chatting to as many of the 3,000 staff as possible. He would ask which lines were selling, and the staff's opinion on certain lines, and would scribble comments on his shirt cuffs in pencil.

He urged all employees to address him as Mr Selfridge, rather than the more formal 'Sir' favoured at the time, but most referred to him as 'The Chief'. One employee, who worked in the store for thirty years and who was quoted in interviews in the Selfridges archives, said, 'There was a feeling of kindness pervading the store right from the start – it was always a happy place.'

ORGANISATION CHART
SELFRIDGE & C⁰ Lᵀᴰ

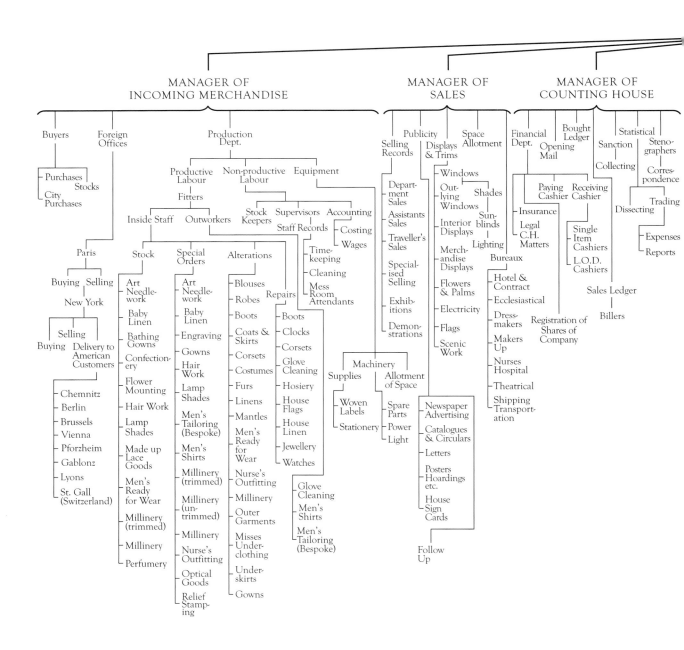

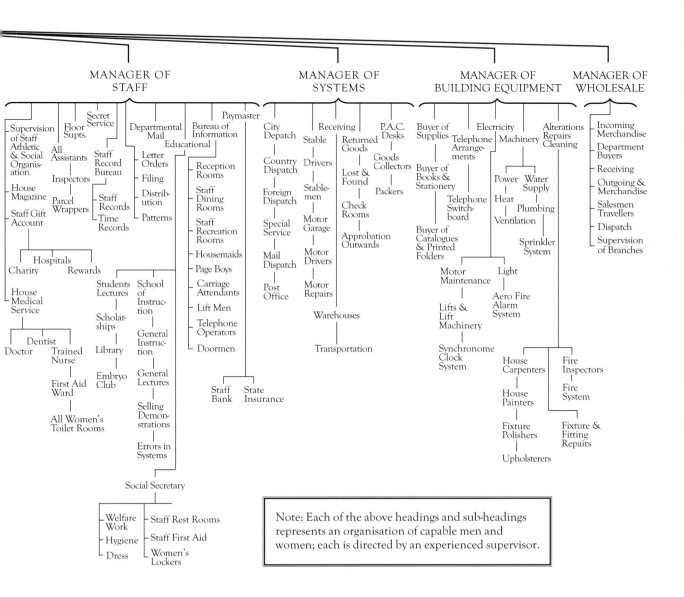

MANAGER OF
STAFF

MANAGER OF
SYSTEMS

MANAGER OF
BUILDING EQUIPMENT

MANAGER OF
WHOLESALE

Supervision of Staff Athletic & Social Organisation
House Magazine
Staff Gift Account

Floor Supts.
All Assistants
Inspectors
Parcel Wrappers

Secret Service
Staff Record Bureau
Staff Records
Time Records

Departmental Mail
Letter Orders
Filing
Distribution
Patterns

Educational

Paymaster

Bureau of Information
Reception Rooms
Staff Dining Rooms
Staff Recreation Rooms
Housemaids
Page Boys
Carriage Attendants
Lift Men
Telephone Operators
Doormen

Charity
Hospitals
House Medical Service
Doctor
Dentist
Trained Nurse
First Aid Ward
All Women's Toilet Rooms

Rewards

Students Lectures
Scholarships
Library
Embryo Club

School of Instruction
General Instruction
General Lectures
Selling Demonstrations
Errors in Systems

Social Secretary
Welfare Work
Hygiene
Dress
Staff Rest Rooms
Staff First Aid
Women's Lockers

Staff Bank
State Insurance

City Depatch
Country Dispatch
Foreign Dispatch
Special Service
Mail Dispatch
Post Office

Receiving
Stable
Drivers
Stablemen
Motor Garage
Motor Drivers
Motor Repairs
Warehouses
Transportation

Returned Goods
Lost & Found
Check Rooms
Approbation Outwards

P.A.C. Desks
Goods Collectors
Packers

Buyer of Supplies
Buyer of Books & Stationery
Buyer of Catalogues & Printed Folders
Motor Maintenance
Lifts & Lift Machinery
Synchronome Clock System

Electricity
Telephone Arrangements
Telephone Switchboard
Light
Aero Fire Alarm System

Machinery
Power
Heat
Ventilation
Water Supply
Plumbing
Sprinkler System

Alterations Repairs Cleaning
House Carpenters
House Painters
Fixture Polishers
Upholsterers
Fire Inspectors
Fire System
Fixture & Fitting Repairs

Incoming Merchandise
Department Buyers
Receiving
Outgoing & Merchandise
Salesmen Travellers
Dispatch
Supervision of Branches

Note: Each of the above headings and sub-headings represents an organisation of capable men and women; each is directed by an experienced supervisor.

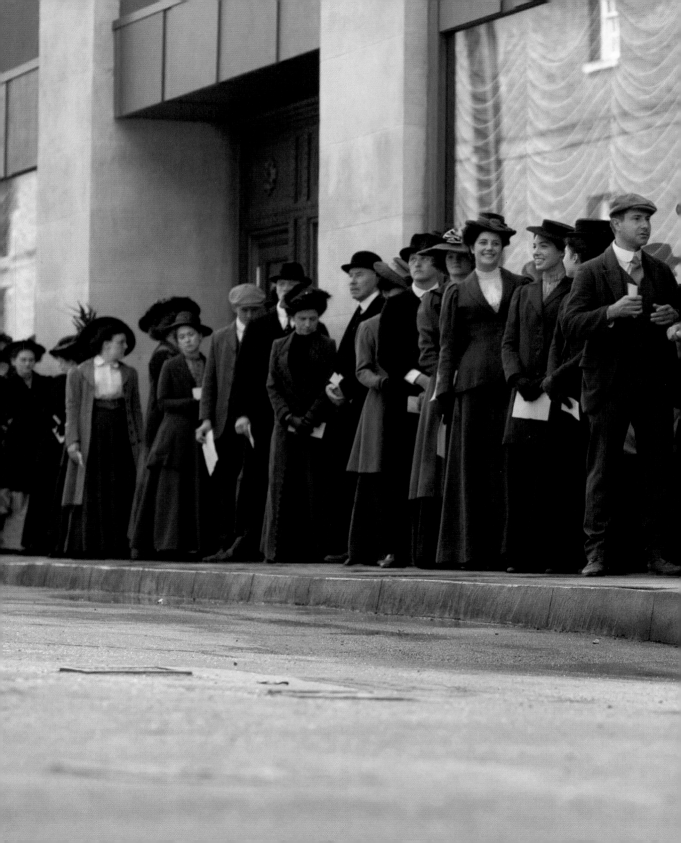

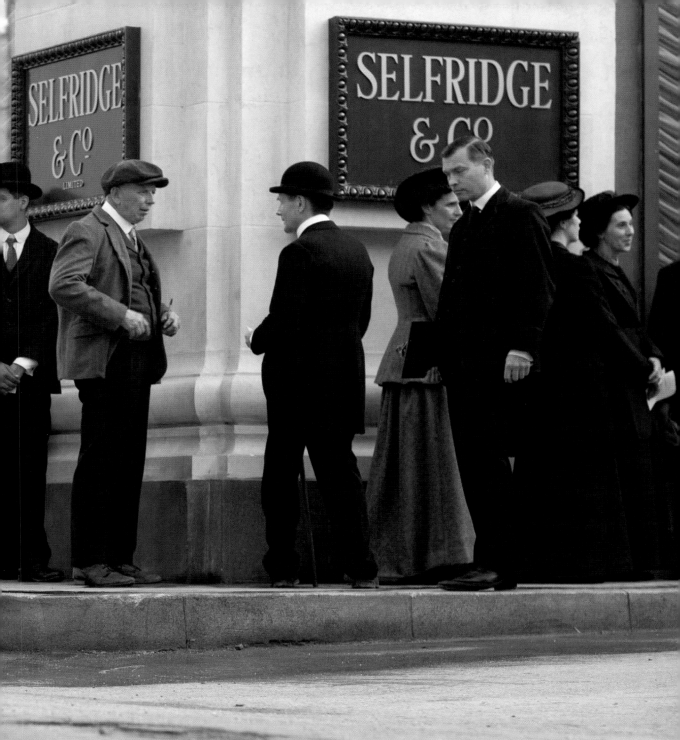

THE STORE AT WAR

The outbreak of war with Germany in August 1914 changed the face of the store, at least in terms of staffing. Half of the 1,000 men employed joined up immediately, sent on their way with a promise from Harry of a guaranteed job on their return. The remaining men formed a House Corps, taking part in regular rifle drills on the roof of the store; female employees were also offered rifle and self-defence classes.

With so many men away, women stepped up to the mark to take over their jobs, manning the doors as commissionaires, working in the warehouse, driving the delivery vans and even stoking the boilers.

'I think the women loved driving the trucks and making deliveries,' reflects Lindy. 'It gave them freedom, and Selfridges wasn't the only store doing this. Harrods had female commissionaires, as did Dickens and Jones. Everybody had to make do and mend with their personnel just as with their clothes.'

The store, like the rest of the UK, faced the war with a spirit of renewed patriotism, with the Palm Court Orchestra striking up a rousing rendition of 'Rule Britannia' twice a day, discounts being offered to war-work charities who were knitting blankets, and free afternoon tea for those ladies busy sewing for the war effort.

Despite the patriotism displayed in his shopping empire, opinion about Harry himself was coloured by the conflict, at least at first.

'The war didn't intrude that much on day-to-day life, other than men going off to war,' says author and series advisor Juliet Gardiner. 'But people were afraid of invaders, in the beginning, and people with German names. Mr Selfridge was regarded with

'Business as usual.'
HARRY SELFRIDGE

'The minute I heard about clothing problems I figured corsets had to be an issue. These skirts are much too long. The overalls are too heavy. How about lighter overalls, with a belt. Forget about corsets altogether. Shorter skirts. I'll speak with the seamstresses. We should get these made up right away, Mr Grove.'

ROSE SELFRIDGE,
MR SELFRIDGE

SELFRIDGE'S

WOMEN WANTED!

SELFRIDGE'S DEPARTMENT STORE
REQUIRES NEW STAFF

To fill a variety of roles, including -

Lorry Drivers	Clerks
Warehousemen	Sales Assistants
Storemen	Cleaners
Packers & Pickers	Signwriters
Loaders	Accounts Assistants
Kitchen Assistants	Mailroom Staff

Selfridge & Co. Ltd.　·　Oxford Street　·　W1

suspicion because he was American. It was thought he would be unpatriotic, unreliable, because America refused to join the war until 1917.'

However, Harry proved his commitment to the country by making his own contribution through charitable work. He helped build homes for unmarried mothers in Stepney and was a member of the Stoll Foundation, which built flats for disabled soldiers. He also gave generously to the charitable causes of aristocratic friends like Lady Diana Cooper, winning friends in very high places.

The store's famous windows, which had lit up the London sky at night before the war, were now darkened as a result of the Defence of the Realm Act. But little changed in the way London society shopped, initially, especially in the hallowed emporium of Selfridges. It was not until direct attacks on London, by Zeppelins in 1915 and later by Gotha aircraft, that people felt threatened in the capital, as Juliet explains:

'Travel wasn't quite so easy because there was petrol rationing and a lot of the trains were taken over by troops and to move supplies, but Londoners would still come in to shop,' she says. 'People still had days out in London, until about 1915, and it was considered patriotic to come up to London because troops came in to Waterloo and Victoria, so crowds came to welcome them.'

As the First World War rumbled on, the most notable change in-store, apart from the army of female employees, would have been the stock.

'An awful lot of things were difficult to buy, because many factories were turned over to war production and tailors were making army uniforms. And of course, imports were restricted. Germany made a lot of toys, teddy bears and mechanical toys, so there was a shortage of toys because there was a German U-boat blockade, so goods couldn't get through. Rationing came in later, but that didn't extend to clothes in the First World War, only food.'

But, while the former parlour maids now working in munitions factories had a little more spending power, the majority were finding wartime a tough economic challenge.

'Prices rose and people's incomes didn't rise proportionately, so they didn't have as much money to spend as they would have done. A lot of women had to rely on their husband's soldier's wage, which was quite low, and of course, army pensions because a lot of

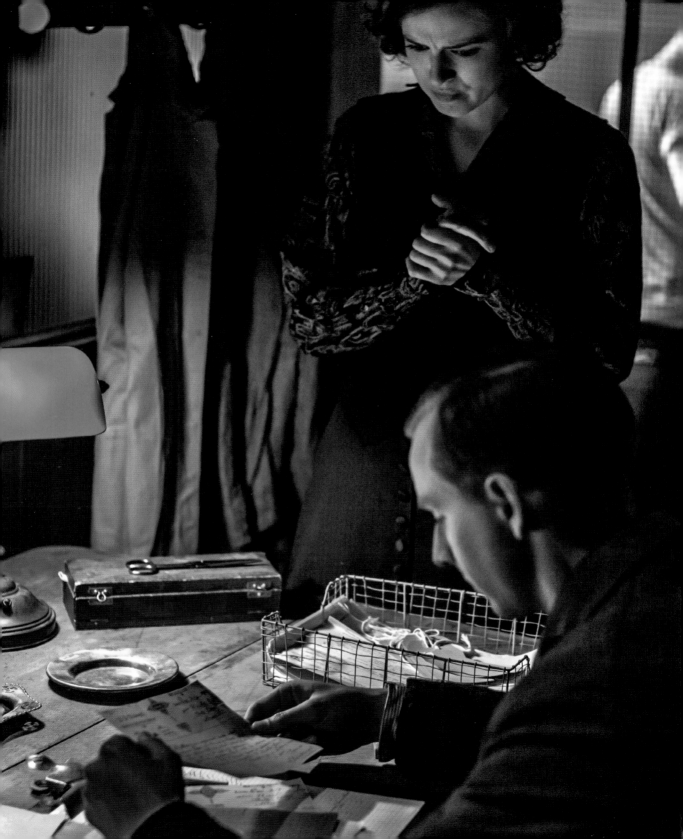

husbands were killed in the war, or were wounded, and the pensions were poor. The overall picture was rising prices and falling or static income, so people who might have treated themselves on an occasional day in London would have spent less.'

The watchwords were 'Waste Not, Want Not' and posters urged those left behind at home to be make sacrifices in order to maximise the resources needed on the front. 'It was unpatriotic to be wasteful, or buy new clothes,' says Juliet. 'Looking shabby was patriotic because all resources needed to go to our fighting boys.'

Selfridges rose to the challenge, with cheaper clothing and household goods taking over from luxury items as the bestsellers. In 1917, the store reported profits of £258,000 (£10 million today).

ROSE'S WAR EFFORT

In 1916, when the German attacks began in London, Harry decided to move the family away out of the city. Highcliffe Castle, on the Hampshire coast, was available to rent for the princely annual sum of £5,000 (£270,000 today), and served the dual purpose of keeping his wife and children safe from the Zeppelins, and keeping them far away from his burgeoning affair with French showgirl Gaby Deslys.

It was H. E. Morgan – the advertising controller of W. H. Smith, and himself an advisor to H. G. Selfridge – who came up with the phrase 'business as usual', but Harry seized on it and used it frequently. It was also adopted by Winston Churchill, who declared in November 1914, 'The maxim of the British people is business as usual.'

Rose and her two eldest daughters, Rosalie and Violette, joined the Red Cross and worked at the nearby Christchurch Hospital. In 1917, after the US entered the war, Rose opened a convalescent home for wounded American soldiers in the castle grounds. She threw herself into the work with enthusiasm and US reporter Hayden Church, who visited Highcliffe, reported in the *Detroit Free Press*:

The Christmas gift of this American business man to his wife was a perfectly equipped convalescent camp. The former cricket pavilion with thatched roof, that must be over a century in age, has been transformed into an office for the commandant and into a kitchen and cheerful dining room, in which the convalescent 'Sammies' take their meals. The huts in which they live number 12, with quarters for two men in each, and each of these huts whose open side is protected against the elements by a thick rubber curtain, which is mounted on an axis in such a way so that it may always face the sun. Then there is a recreation hut provided with a gramophone, games, books, maps, writing material and other things to make the men who use it comfortable. Lastly, there is another building known as the 'Medical Ward', which provides quarters for the permanent American non-commissioned officer who is responsible for the discipline of the camp and which also houses the linen room and the men's bathroom.

Sadly, Rose was not to see the end of the war. In May 1918, during the Spanish Influenza pandemic, she contracted pneumonia and died. She was buried at St Mark's Church, close to the castle. The local paper reported: 'The pretty village of Highcliffe and its vicinity has, in the death on Sunday of Mrs H. Gordon Selfridge, lost a valued friend, whose kindness of thought for others, and abounding charity, will be much missed.'

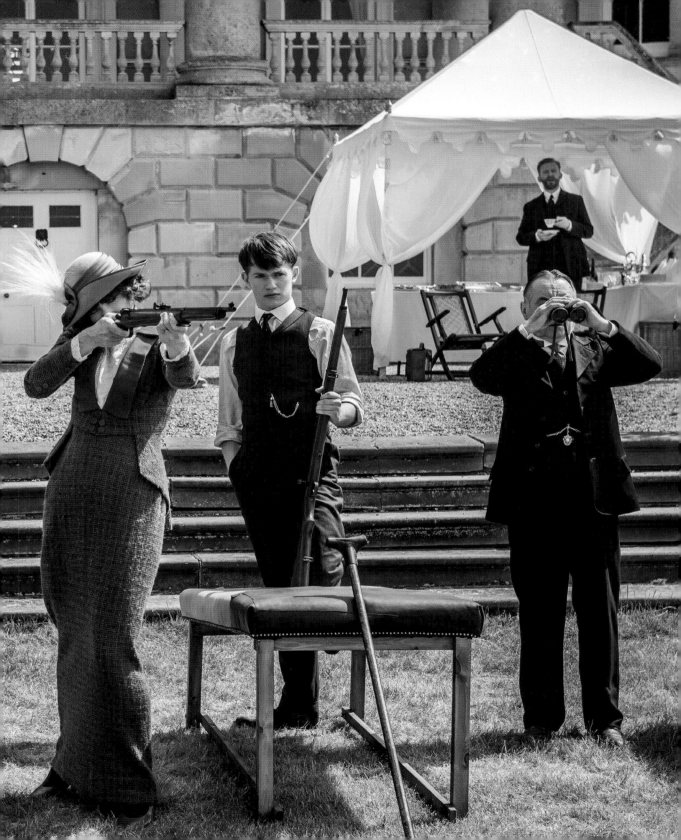

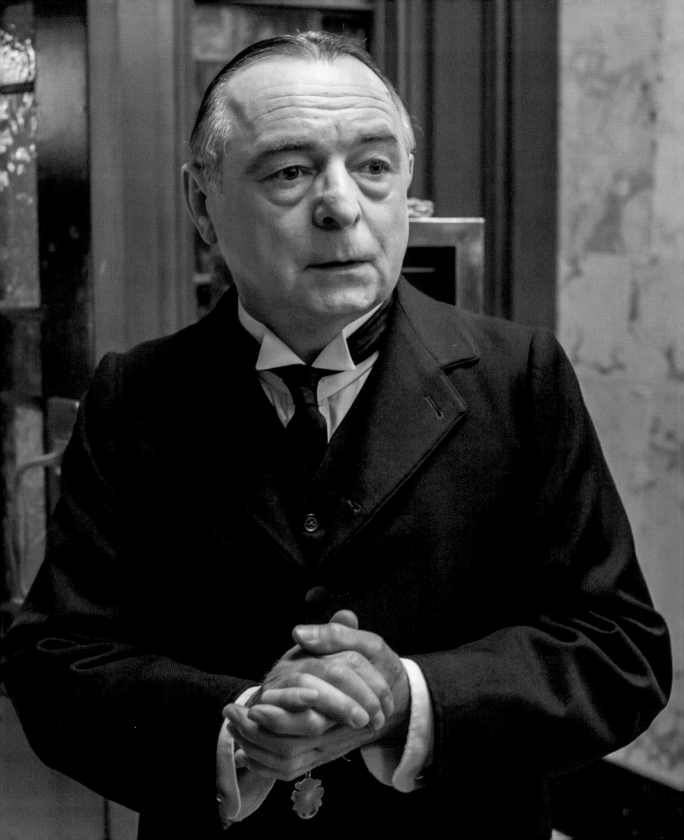

MR CRABB

As an older member of staff, Mr Crabb is unable to enlist to serve his country when war breaks out – but he makes his own special contribution.

'Crabb's too old to go to war, although he tries to teach the staff some drill,' says Ron Cook, who plays the store's accounts manager. 'That's a funny scene. Then he comes up with the idea of shooting practice.'

Having done intensive research into the wartime store as part of his preparation for the role, Ron found the 1914 setting of the second series fascinating.

'Series two tackles the repercussions of war on the shop,' he says. 'Just the simple fact that eighty per cent of the men who worked in Selfridges were eligible to be called up changed the whole dynamic. They suddenly found that they had no men to do all the carrying, to work in the loading bay and all of those things that were done by men, so they took the women on.'

Mr Crabb is the antithesis of 'Mile-a-Minute Harry', as some colleagues referred to Selfridge. Cautious, prudent and strait-laced, wild changes make him nervous, and Harry's extravagance undoubtedly gives him sleepless nights.

'He's from a different generation,' comments Ron. 'He is a Victorian, really, in an Edwardian world. He's very uptight and tightly buttoned and a stickler for doing his work properly. Initially, Mr Selfridge hired him because he was obviously very good at his job, but he was a huge surprise and had a lot of disagreements about the way in which Harry was handling the business. But he's come to be very loyal. Mr Selfridge has won him over.

'Harry's way of doing things puts Mr Crabb out of his comfort zone really, which upsets him but at the same time it sort of excites him, too.

'Jon Jones, our first director, gave me a lovely analogy. He said that he imagined if it was nowadays and Selfridges had gone on a day trip to Alton Towers, Mr Crabb would hate the idea of going, but would go on the rides twice. It's that conundrum of being uptight and out of his comfort zone but at the same time loving the thrill of it.'

With Mr Crabb staying largely in store throughout the series, Ron invented a home life for the character, based on his frequent mentions of his wife.

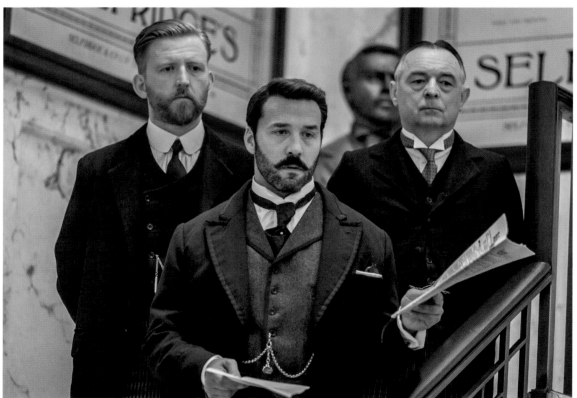

'We were always joking about Mrs Crabb because he is always saying, "Mrs Crabb wouldn't like this" or "Mrs Crabb wouldn't like that",' he reveals. 'She was a bit like Captain Mainwaring's wife in *Dad's Army*, who you never see. I was fantasising about what Mrs Crabb would be like. You could go for something extraordinary, that she would be 6 feet tall. In the end they put her in a scene in the store and the actress turned out to be Wendy Nottingham, who I had worked with before. I was amazed, because if anyone had asked me who would make a great Mrs Crabb, I would have said Wendy!'

Another unknown in series one was Crabb's first name, but the veteran actor had his own ideas about that, too.

'He was always called Mr Crabb,' laughs Ron. 'Then, in one of the episodes in series two it was his birthday and they called him Percy. I went to the executive producer, Kate Lewis, and said, "He's not Percy, he's Arthur!" I think she was taken aback but delighted that in my head I had made up something about him, which was that his name was Arthur Crabb. So that's what he became.'

Mr Crabb's resistance to change is especially evident when it comes to fashion. As the action leapt forward five years between the first series and the second, and the younger members of staff updated their wardrobe, Crabb's stiff, starchy look remained unwavering.

'I'm very envious of the women because I have one costume that I've worn throughout!' admits Ron. 'He's still Victorian. He's from a different era. So while some of the men – like Grégory [Leclair] and Tom [Mr Grove] – are going into soft collars, my character keeps with his starched collar. The ladies had to put up with wearing corsets and we men had to put up with hard collars which cut your neck in two, and I can't get rid of mine.'

Working hard on the number crunching for Harry, Crabb spends much of his time in the wood-panelled offices at the top of the store, rather than on the spacious shop floor. While he doesn't get to choose new clothes for each season, Ron does enjoy choosing the period props for his little domain, which are authentic down to the very last detail.

'The props team come in with a load of bags and ask, "Which one is Mr Crabb?" so I can pick one out,' reveals Ron. 'Even with tiny things like a pencil, they will ask which one suits him best.

'In the offices, the set designers are brilliant because they just put little things in that you can latch onto when doing the scene.

MR CRABB
Mr Selfridge

'*I do find rampant innovation a little trying.*'

For example, on my desk is an original counting machine which counts up pounds, shillings and pence, and I said, "Does this work?" And they said, "Yes." So I used it in the scene.'

Ron is a huge admirer of Harry Selfridge, and read several books about the retailer and the story of the department store before starting on the series.

'It's a wonderful story. He did some extraordinary things. He changed consumerism. He changed shops. He was the first person to put restaurants in the store. He once said, "It's not a trading store, it's a social centre." And he appealed to women, in what was a much more restrictive society. He targeted women and made them welcome to come into the store, and they could have their hair done, they could go and have a meal, they could meet their friends at the same time. He said, "I want them to fulfil their dreams within the store." He was an incredible innovator but a convoluted man, because he was a terrible gambler and womaniser outside of the store. He was a larger-than-life character.'

The British actor also admires co-star Jeremy Piven, who he believes is a perfect fit for the flamboyant American.

'Jeremy has got huge energy and enthusiasm. Our working relationship is very similar, in a way, to Mr Crabb and Mr Selfridge. He will sometimes throw things at you – not literally – but he will come out with another way of doing something, which will surprise you. It wakes you up a bit, keeps you on your toes but it's great fun.'

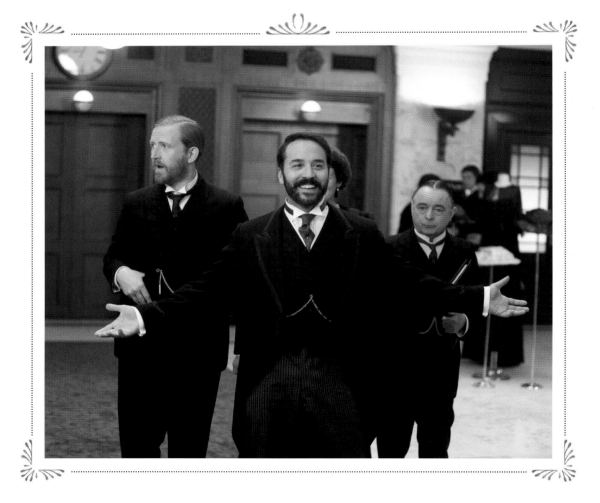

HARRY THE SHOWMAN

From his early career days at Marshall Field – where he had succeeded in quadrupling the advertising budget – Harry had always put faith in the value of marketing and publicity. For the opening of the store in 1909, he unleashed a barrage of advertising of a nature previously unseen in the UK, with thirty-eight illustrated adverts, filling 104 pages in eighteen national newspapers, at a cost of £36,000 – £2.35 million nowadays.

Unlike the punchy slogans of today, or the wild promises of some contemporary retailers, Harry sought to lure his customers in with gentle persuasion and long, homely invitations. One ad for the opening read:

'Entertainment, customer service and value for money: the first will get them in, while the second and third will keep them there.'

HARRY SELFRIDGE

SELFRIDGE & Cº Lᵀᴰ

'We wish it to be clearly understood that our invitation is to the whole British public and visitors overseas – that no cards of admittance are required – that all are welcome – and that the pleasures of shopping, as those of sight-seeing, begin from the opening hour.'

Another long and involved advertorial was headed with the phrase 'Back to School', frequently used in marketing today, and began, 'Remember that for the next thirteen weeks – save for a possible flying visit at "half" – your boy is out of your sight. His wardrobe must suffice for all contingencies: frost, snow, storms and fogs; for the church, the schoolroom and the playing fields.'

Actor Samuel West, who plays journalist Frank Edwards, believes the character of Harry came across in the advertising campaigns.

'As a Christmas present last year, my father bought me a lovely original Selfridges poster, which I'm having framed, and it is an important part of the store's history and a crucial part of the show,' he says. 'The access the graphic designers had to the archives made such a difference because all those Selfridges adverts and posters, a lot of which Selfridge himself wrote, were revolutionary in terms of the way they sold a shop. A lot of Harry's energy comes across in that advertising.'

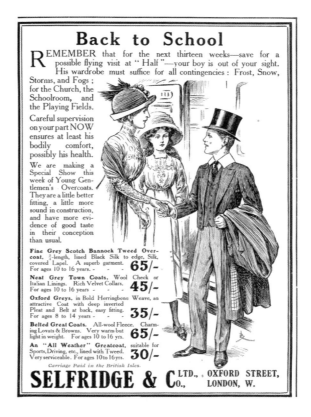

UMBRELLAS, STICKS
& HANDKERCHIEFS

GROUND FLOOR

SEE OUR NEW RANGE
READY FOR ALL SEASONS

SUPERIOR MATERIAL, STYLE, FIT
FINISH AND WORKMANSHIP.

SELFRIDGE'S

SELFRIDGE & Cº LTD OXFORD STREET, LONDON, W.1

'Something for everyone.
The thrifty housewife's dream. Double
our advertising space. Let the whole
of London know there's something
for everyone at our mid-season sale.'

HARRY, ANNOUNCING A GROUND-BREAKING
SALE AT THE STORE, *MR SELFRIDGE*

SHOP FLOOR THEATRE

Although he left school at fourteen to make his way in the world, the young Harry was a ferocious reader, devouring book after book in his spare time. 'When you're an only child you have to make your own pastimes, and friends,' observes Lindy Woodhead. 'Books and imagination became his closest friends.'

One of his favourites was *Struggles and Triumphs*, the autobiography of circus impresario Phileas T. Barnum. The future Harry Selfridge had much in common with this legendary showman, whose rags-to-riches story proved an inspiration, as Lindy Woodhead writes in *Shopping, Seduction and Mr Selfridge*:

'In many respects the two were very similar. Barnum had a rare gift for publicity. His spectacular museum in New York drew the public in their thousands and he became rich by entertaining them. Like Barnum, Selfridge had the ability to suspend disbelief. His tricks – entertaining people in a great store that was, in a way, just like a circus tent – created such confidence among his friends, family and financial backers that for years they refused to accept that his extravagant, destructive side was gradually eroding his ability to run his business empire.'

In the early days of the store, however, that showmanship proved a boon to sales, with Harry constantly coming up with ideas to attract people to the shop. In-store art exhibitions, cookery demonstrations in the kitchenware department and book signings were all innovations that brought would-be customers pouring

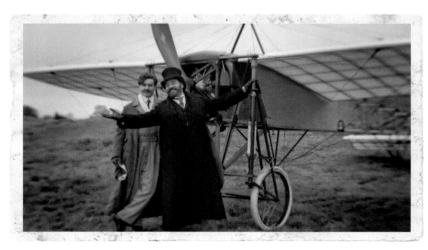

Harry (Jeremy Piven) greeted pilot Louis Blériot (played here by Orlando Seale) as he completed his historical flight and persuaded him to display the plane in the store.

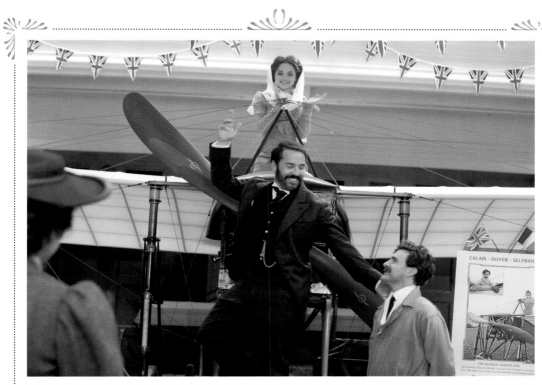

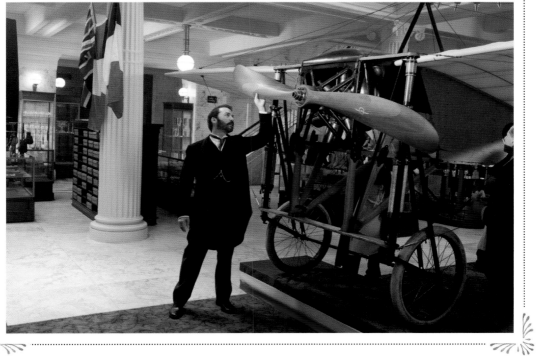

through the doors. His displays seized on the latest trends – for example, when the Ballet Russe came to London, he devoted every window to the show – and he went out of his way to entice famous performers, such as dancers Anna Pavlova and Isadora Duncan, through the famous wooden doors.

In 1914, the store hosted 'A Scientific and Electrical Exhibition', where fascinated futurists could view a vacuum ice machine, an automated telephone exchange and an X-ray machine; they could send messages to Paris through wireless telegraph machines, and wonder at Archibald Low's 'Televista', the precursor for the television. In 1925, Selfridges would also be one of the first places to host a demonstration of the more advanced version, invented by John Logie Baird, as Harry declared: 'This is not a toy – it is a link between all the peoples of the world.'

But it was in July 1909, four months after the store opened, that Harry met a high-flier of a different kind, and scored perhaps his biggest publicity coup. It was the age of aviation and the *Daily Mail* had put up a £1,000 prize for any pilot who could fly across the English Channel by the end of the year. On 25 July 1909, a Frenchman called Louis Blériot took off from Calais and, thirty-six minutes later, successfully landed in Dover. There, he was greeted by a French reporter, a *Daily Mail* journalist and photographer, and Harry Selfridge.

The adventurer was soon persuaded to display his Blériot monoplane in the store for four days, and the fragile craft was put on a train to London, where it made its way from Charing Cross station to Oxford Street on a horse and cart. Harry quickly issued adverts declaring, 'The Public are cordially invited to see this wonderful epoch-making machine', and 150,000 men, women and children took up the invitation.

Filming the scene in series one, set designer Rob Harris went for maximum authenticity – sourcing an original monoplane.

'We were lucky enough to find the one man in the world who has a Blériot aeroplane that's still flying,' he says. 'I trawled the internet and tracked him down in Sweden and, fortunately for us, he was very interesting and wanted to fly it for us, and he brought it over. It's a real, renovated Blériot plane, which was found in a shed.

'Building a large, one-off prop – like the Blériot plane exhibit – is very expensive, especially for a detailed build like this. So to have a real Blériot, from 1910, was brilliant.'

'Every woman should have a Pavlova moment.'
ROSE SELFRIDGE, MR SELFRIDGE

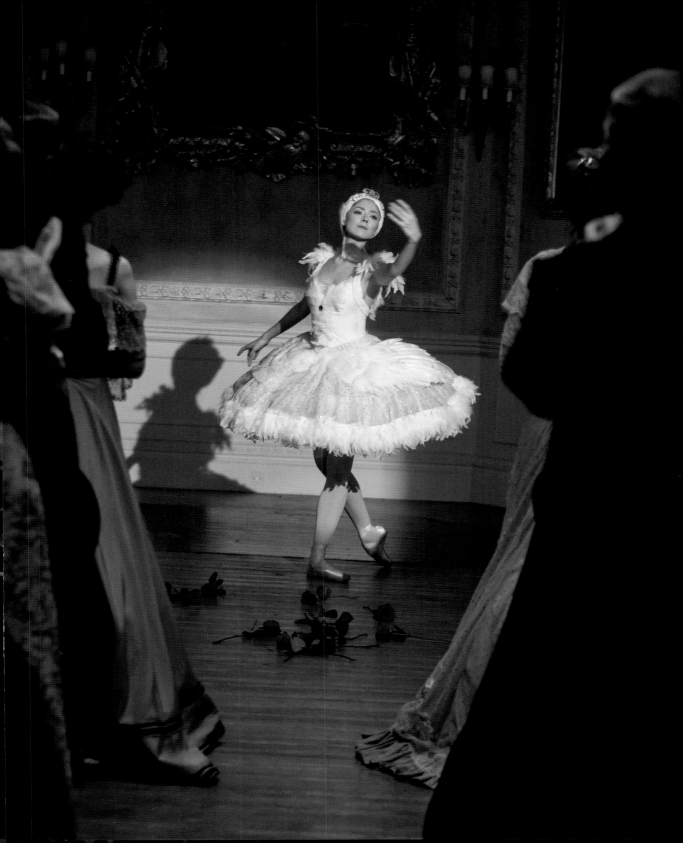

Harry was pictured in front of the store in a 1908 drawing from Vanity Fair, *which the designers added their own twist to for the purpose of the show.*

DARLING OF THE PRESS

Given his innate intuition for publicity, it's no surprise that Harry courted the press from day one. Initially, however, the newspapers watched the flash American with a wary eye.

'The press took a long time to get used to him and his ways,' says Lindy Woodhead. 'The building, for a start, was huge and a lot of people found it very ostentatious and, because he purchased all the small shops to the left and right of his site, they accused him of putting them out of business. They'd have got knocked down eventually but that sort of modernity, that property development, was frowned upon.'

Newspaper magnate Lord Northcliffe was among the first to sample the Selfridges experience, visiting incognito in the first week. He was impressed enough to send a letter to Harry, praising the young salesman who had served him, and the mutual respect the two men had for each other no doubt contributed to the deal Harry struck over the Blériot plane. Indeed, Harry set about building friendships with reporters, editors and gossip writers, sending hampers at Christmas and birthday gifts, and he hired an ex-journalist, James Conaly, to handle his press office. His weekly lunches with close friend and fellow American Ralph Blumenfeld, who happened to be the editor of the *Daily Express*, did no harm either, and in a stroke of genius, he set up a reporters' club room at the store, giving favoured hacks their own personal keys. Inside, they were given access to telephones and typewriters and were guaranteed a free drink and a well-spun story to delight their editors.

Despite the huge amount of advertising revenue he bestowed on the papers, he was always careful to keep them sweet. He once warned his advertising manager, 'Never fight with them, never fall out with them if you can possibly avoid it. They will always have the last word.'

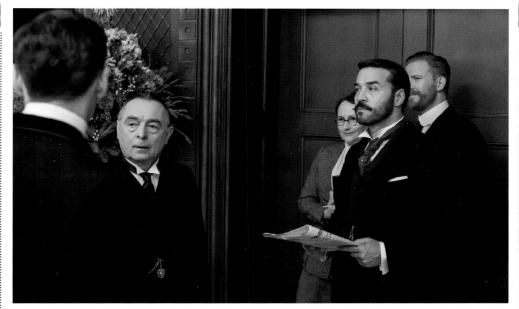

Daily Express

LONDON, MONDAY, JUNE 29, 1914.

ONE HALFPENNY.

Summary of News.

THE QUEEN WINS IRELAND'S LOVE

FATAL FOREST FIRES.

SELFRIDGE'S STORE CELEBRATES 5 YEARS

POLITICS

ANOTHER DIVISION TO AID BUNDLE.

ATTACK NEAR BLOEMFONTEIN

KAISERS' MEETING.

PLAGUE IN NIGERIA.

THE MENACE OF THE MAD MULLAH.

REINFORCING.

BRITISH CASUALTIES.

FRANK EDWARDS

PLAYED BY SAMUEL WEST

As a seasoned newspaper man, Frank Edwards represents the relationship between Harry and the press. Courted at the start by the media-savvy mogul, the pair become close friends – but there are a few rocky patches along the way. In series one, Frank sides with Ellen Love and uses Harry's secrets to attack him in a play, and in series two, the pair fall out when Frank writes an article implicating Harry in the supply of shoddy boots to soldiers on the front.

'Frank turns a situation to his own advantage,' says Samuel West. 'But he's not actually nasty. With the play, he didn't do it out of spite; it's a survival mechanism, and he had to decide which side to be on.

'The war affects him because he turns out to have a very strong sense of truth and of wanting to fight for the truth. I believe that if you had taken a picture of the front line of the First World War from above, and published it on the front page of *The Times*, it would have shortened the war by years, and that's what he wanted to do. Frank wants to put the truth in the paper because he wants to save lives, but the newspaper won't let him so his need to tell the truth is frustrated. He's tricked by Lord Loxley into wrongly shopping Harry. Then he has one chance to save Harry's reputation and his own, and he grabs it. So he redeems himself at the last minute.'

The character of Frank Edwards was inspired by a real person, Edwardian writer Frank Harris.

'Frank Harris was best known for being a sort of pornographer,' admits Samuel. 'He wrote a four-volume autobiography called *My Life and Loves*,

Frank, played by Samuel West, 'turns a situation to his own advantage' but always comes through for Harry in the end.

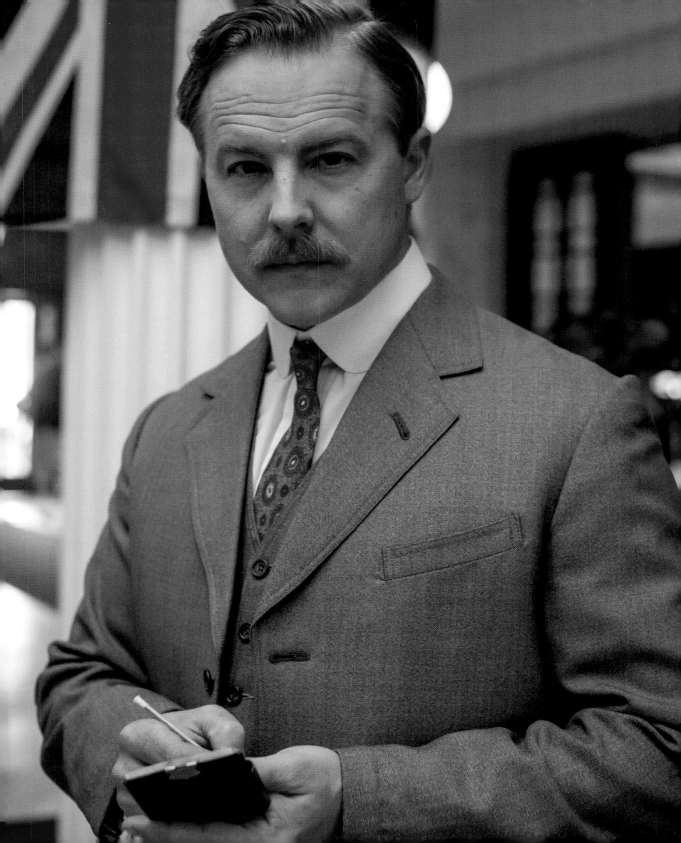

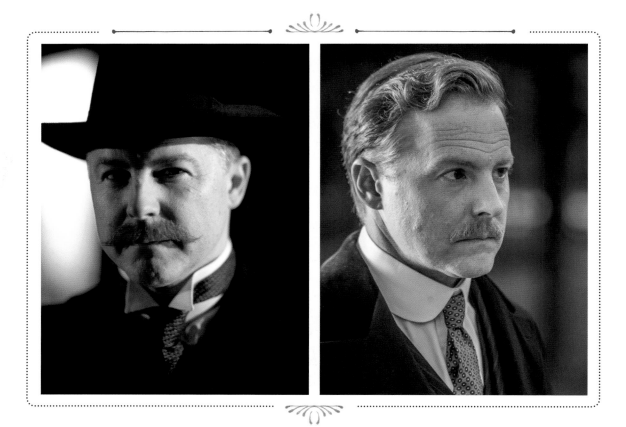

which is famous for being banned. It's extremely graphic. It's the *Fifty Shades of Grey* of its day.

'He was born in Ireland, of Welsh parents, and ran away to America at thirteen, where he became a number of things, including a cowboy. He came back, having reinvented himself, and became a journalist, ran the *Evening News* and became friends with a lot of very influential people.'

As the story moved on, the character broke away from its original inspiration, but one legacy from the real Frank was an impressive moustache, which Samuel sported for the whole of series one.

'Harris looked in the mirror when he was thirteen and said, "I'm ugly. I've got to cover up as much of this as I possibly can", so he grew an enormous moustache. The second thing he did was decide to sleep with as many women as he possibly could as a personal revenge on the world. So the moustache was based on him.'

In series two, however, Samuel decided a change was due, for practical reasons.

'Eagle-eyed viewers will notice that in the second series I have a slightly smaller moustache,' he explains. 'That's partly because of a change in fashion between 1909 and 1914, but also because in series one it was false. When you eat with a moustache stuck to your face with spirit gum, however brilliantly your make-up artist puts it on, it eventually falls off, so we had to stick it on two or three times a day. Plus I hated taking it off so much that I decided to grow one for the second series. That's why the moustache was smaller – and slightly lighter.'

Samuel – who admits he usually plays 'more stuck-up, upper-class English people' – had to perfect a new accent for the role. But a script change meant his hard work left some viewers confused at first.

'There was a line about how Frank had known Harry from Chicago,' he says. 'I thought, "That's useful. I'm playing an Irishman with a slight American Midwestern accent so I'm going get this right." I worked with my dialect coach quite precisely on that – and then they cut the line. So on the first day Twitter was full of people saying, "What the hell is Samuel West doing?" You can't win them all!'

Frank's American adventures also influenced the character's look, with costume designer James Keast choosing a more up-to-date style of suit.

'We chose a light grey suit for Frank, slightly less conservative than the dark grey or black that most men in London were wearing,' says Samuel. 'We thought it would show an American influence, that he would have brought a slightly flashier dress back from Chicago. Then, in the middle of the last series, James said, "We have to have a new suit made for you, because they want you to look sexier. They want a sharper suit." We had this gorgeous, dark-blue, three-piece suit made by a London tailor called Chris Kerr. It's the first time I've been measured for a suit for twenty years.

'In 1914, there were lighter materials, less heavy wools, so I got a very nice hat and a beautiful coat. Journalists tend to dress to be let into places, because if you are scruffy somebody might stop you, especially in shops, so Frank dresses as snappily as he can.'

As well as the snappy suits, the actor loved the products on display in the store – and has even searched out some original Selfridges stock himself.

'Do you believe that someone should always try and tell the truth, when something really matters?'
FRANK EDWARDS,
MR SELFRIDGE

' *For Frank to*
come in with
his slightly
set male ways
and be gently
re-educated
by someone
who obviously
cares about
him – he
should be
so lucky. '

'There is wonderful detail and everything is touchable and saleable, so you feel you can pick up anything and it would be fine. That's a real bonus for an actor.

'I'm a stamp collector and I once had a role as George VI so started getting into George VI stamps'. Then on eBay recently I saw an extraordinary thing, which was an original Selfridges box of first day covers from the wedding of the Queen Mother and George VI, serviced from the store's stamp-collecting department.

'Selfridges had a department for absolutely everything and in the 1930s, when everybody collected stamps, there was a philatelic department. Hundreds of first day covers were stamped in every British colony around the world, and sent back to Selfridges, and I got a set for £150. It's in a little Selfridges box which I recognise, of course, because our set is covered in them.'

When he's not pursuing exclusives for his newspaper, Frank is busy wooing cosmetics queen Kitty – played by Amy Beth Hayes. The romance between the two, which picked up pace in series two, was not in the original storyline, as Samuel explains.

'The affair with Kitty happened because of one scene, where she sold me some ivory-topped pencils and the writers said, "You two obviously work well together, so we should do more of that." I love working with Amy.

'One of the things that makes *Mr Selfridge* different is that, unusually for a big television programme, almost all the big creative departments are controlled by women, the majority of the cast are women, the lead writer is a woman and the producers are women. There's a very different energy in the room, and a different sensibility about the way people behave to each other.

'For Frank to come in with his slightly set male ways and be gently re-educated by someone who obviously cares about him – he should be so lucky!'

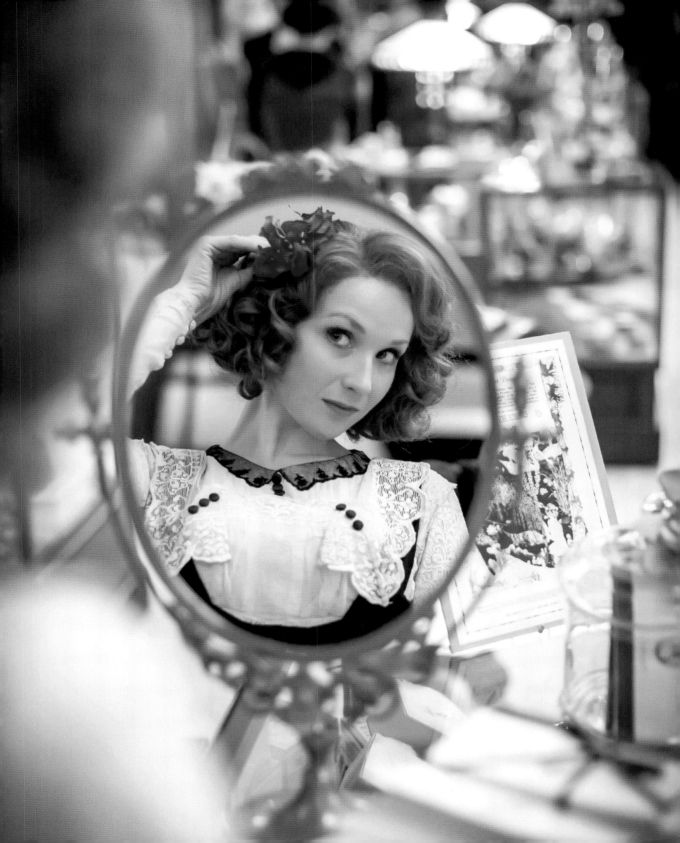

WINDOW DRESSING

Throughout the history of the store, Selfridges' windows have been the talk of the town. The original façade boasted twenty-one display windows, twelve of which consisted of the largest sheets of plate glass in the world. Unlike other department stores, which displayed their wares in the window without much thought to arrangement, theme or aesthetic impact, Harry was determined to make each of his windows a spectacular work of art.

In 1909, Harry hired American Edward Goldsman to design the displays, giving him a large studio and putting staff at his disposal to help him create his masterpieces.

Later, when the front was lit until midnight, Harry advertised his windows as being part of the city's entertainment, and encouraged potential customers to indulge in the new art of window shopping.

On the London set of *Mr Selfridge*, only one of the large windows has been recreated, while another four are rebuilt each series on the external set in Chatham, the biggest of which is an impressive four metres long and two metres high. Moving the whole cast and crew down to the Kent coast is expensive and the schedule is tight, with only a few days in each of the four 'blocks' spent there. With limited filming time on the external shoots, the set dressers have to work fast. Each of the four filming blocks has three storylines – meaning the crew has to set up three new window displays – and they have just one day to get it all on camera.

'We had a little army of prop makers and prop buyers who provided all the things we needed for windows,' explains art director Nic Pallace. 'The windows were all themed and the set dressing is quite theatrical, so every time we went to Chatham we would do all the windows, then redo them for the next episode, and that was quite a bit of a turnaround.

'It's a long day. And when the crew has finished filming, the whole thing has to be taken out again. We couldn't leave anything there.'

The windows, lovingly conceived in the series by Henri Leclair and Agnes Towler, actually recreate many of the iconic displays recorded in the Selfridges archives.

'The archives had a lot of information on window displays, and there is a book called *Selfridges,* which has black and white pictures of them,' reveals set designer Sonja Klaus. 'There are also some coloured-in prints that were taken on Empire Day, at the in-store

Harry (Jeremy Piven) admires one of the stunning widows in his ground-breaking store.

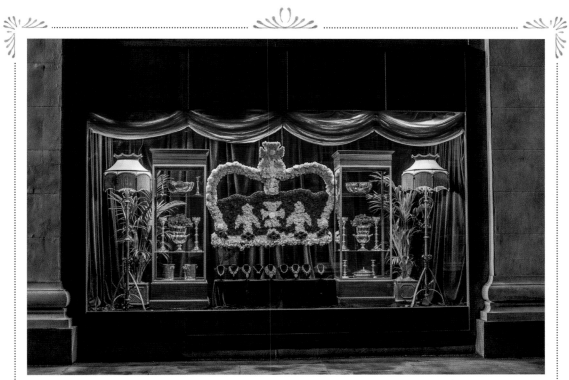

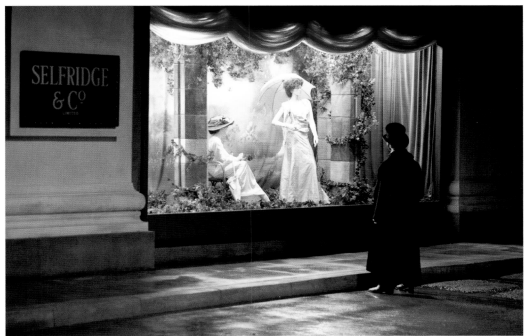

event that Mr Selfridge himself organised, so we took a lot of inspiration from that.'

With the country on the brink of war, Harry pulled out all the stops for the 1914 Empire Day. In the show, Agnes and Henri triumph with a dazzling display of windows, including a Canadian Mountie with a horse, an oriental scene and a sunburst design, next to a huge map of the Empire, with a banner reading, 'The sun never sets on the British Empire.'

Displays in series one included a huge floral crown for a store visit from King Edward VII, a perfume window inspired by Agnes's memories of picking flowers with her mum and row upon row of men's shoes, created by Henri after a trip to Spitalfields Market.

Series two also saw a massive floral figure of '5' in yellow and white, to celebrate the store's fifth birthday, as well as an impressive collection of vintage vacuum cleaners.

'We found a guy who had a collection of 1914 Hoovers and obviously they looked a bit tired, being 100 years old,' recalls Nic. 'But from a distance, on camera, you don't really notice, and they looked great.'

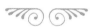

'Very patriotic, Harry. You captured the mood of the nation. You always do.'

LADY MAE, AT THE EMPIRE DAY CELEBRATIONS, *MR SELFRIDGE*

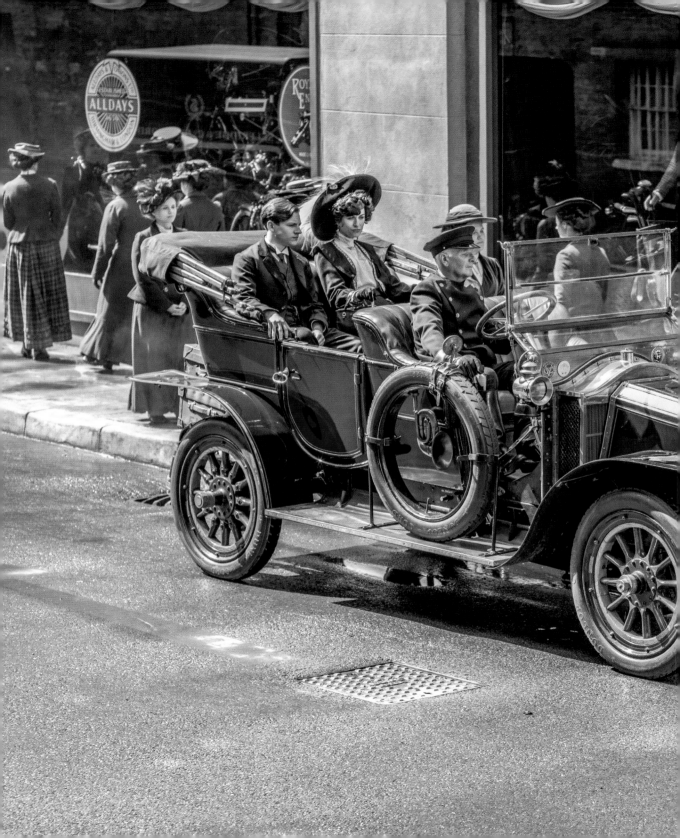

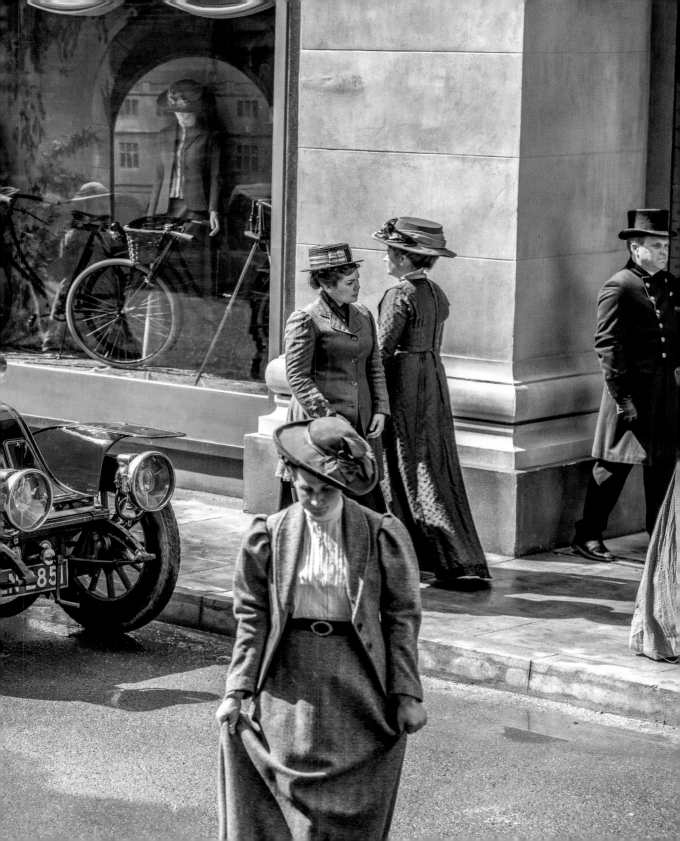

AGNES TOWLER

PLAYED BY AISLING LOFTUS

The character of Agnes Towler reflects Harry's early ambitions, and her determination to make her dreams come true, despite her humble beginnings, is applauded by her forward-thinking boss. Harry felt obliged to take her on when she turned up at his house, seeing as he had been the cause of her losing a sales position in another store, but actress Aisling Loftus feels that he saw something special in her even then.

'Maybe he admires her brazenness,' she says. 'The fact that she went to his house is very shocking. It was born of desperation but she let him know it was because of his misdemeanour that she lost her job. That also takes an awful lot of guts and single-mindedness.

'But she's clearly a grafter and she's got some guts and some steel so, from working his own way up, he probably sees an element of himself in her.'

Unlike Harry, it is her gender, not her background, that threatens to end her glittering career. Having agreed to marry Victor, she has no choice but to hand in her notice, as was the social convention.

'It seems so unfair that you couldn't have it all then,' says Aisling. 'You simply couldn't have a career and have a relationship and a family. There were so many women who were denied the chance to live up to their full potential. There's nothing wrong with someone who chooses to be a wife and a mum over their career today, that's not a life wasted, but for someone like Agnes it is a shame, because she has such a talent and she's such a bright little light. I wonder how many talented women were squandered because of that patriarchal system.'

'Do you think it's wrong to choose love over a career?'

AGNES TOWLER,
MR SELFRIDGE

Aisling Loftus is working-class girl made good, Agnes Towler.

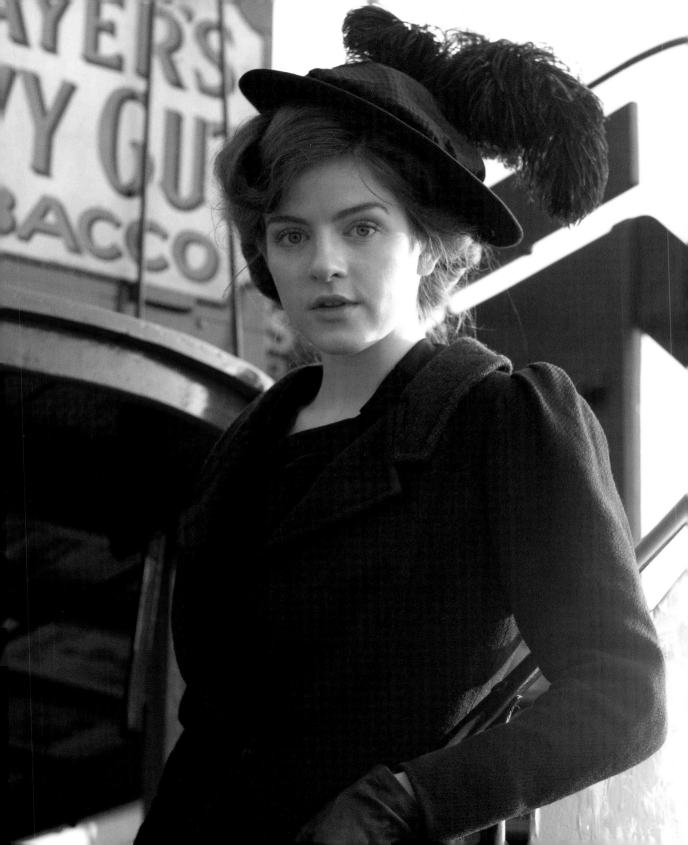

Caught in a love triangle between dependable Victor and glamorous Henri, Agnes struggles with her emotions. But the two men also represent the choice between domesticity and career.

'She's in a real quandary in terms of the comparison between what she thinks is right and what she feels romantically,' says Aisling. 'She's caught in a really difficult position, where she wants comfort and security and dependability, but she knows that all those things may not equate to happiness. With Victor she could have a contented life but with all the opportunity she's been given by Mr Selfridge, going to Paris and seeing more of the world, she's let herself believe in more than "good enough". That's a real conflict for her.'

In order to play the working-class London lass, the Nottingham-born actress had to lose her Northern accent and go back in time.

'The London accent that I know now is either very Kensington or a little bit like patois,' she explains. 'I knew Agnes had to have a good authentic working-class London accent that was of its time, not just a broad brush stroke, so I tried to get as much footage as possible from as far back as I could. I went to the archives of the British Film Institute and, although there was nothing from 1910, I managed to get the 1930s and 1940s.

'There's not a lot because it tended to be posh people, not the working class, who were chronicled at that time.'

As one of the younger members of the cast, Aisling says it was a thrill to be working with Jeremy Piven and Frances O'Connor. And she has great admiration for Amanda Abbington, who plays co-worker and landlady Miss Mardle.

'I absolutely adore Amanda,' she admits. 'It's almost embarrassing because she's kind of aspirational for me. We're great friends but sometimes I think if I could be anything like her as I get older and have kids, I'd be over the moon. She's so stunning, so clever and everything I like about actresses.

'I also spend a lot of time working with Grégory Fitoussi and Trystan Gravelle, and they are both absolutely lovely, proper gentlemen, so we have a great laugh. It's been a joy.'

Although Agnes has an obvious eye for fashion, the predominant colour for Aisling's shop floor wardrobe was black. In series two, however, she got to branch out a little and there was one item in particular that caught the actress's eye.

'There's a really beautiful sandy-coloured woollen coat that I have, and I loved that,' she says. 'It's beautifully tailored and weighs a ton. It was probably like a Burberry mac today in terms of how much I would covet it.'

Despite all the stunning dresses on set, Aisling particularly liked the dapper suits worn by the men.

'I love any of the beautifully tailored stuff, which is all wonderful,' she says. 'I think the guys' clothes look particularly odd because the waists of the trousers are so high that they actually cover their stomachs, and I think that's the main difference between then and today for them. I'm more drawn to the suits. I'd love for my boyfriend to wear a suit like those ones – they look incredible.'

In terms of her own fashion, she says playing Agnes has given her 'more appreciation for flair' than a love of posh frocks. 'I love getting dressed up,' she admits. 'But I'd still be happier when I'm comfortable and invisible if I'm honest.'

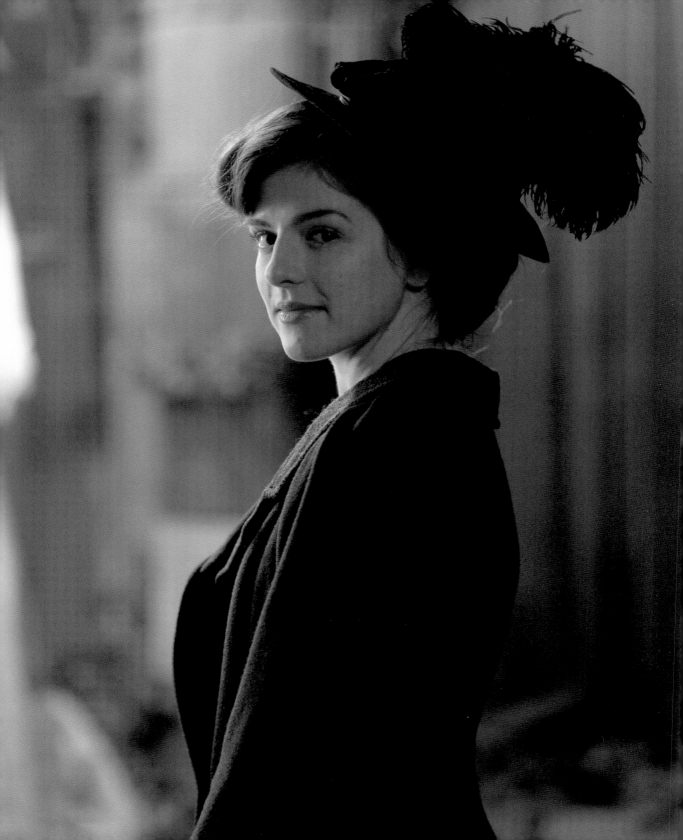

AGNES TOWLER'S WORLD

As the window dresser, Aisling's character has access across all departments, using elements from fashion, accessories, china, luggage and even the tea emporium in her displays. After two series, Aisling admits it is easy to forget how remarkable her daily surroundings are.

'The set is wonderful,' she says. 'You adapt quite quickly and you get so used to all these beautiful things that you forget some of the items cost over a thousand pounds each. The products on set, especially in the stores, are the real deal, so we're surrounded by 1914 luxuries and the set is as close to the real Selfridges as you can get.'

As the only wage earner in a poverty-stricken family, Agnes began the series in a dingy slum, with basic furniture and very little light. The tiny room she shared with little brother George and, on occasion, with her drunken father was visited on a regular basis so, rather than filming on location, set designer Rob Harris built it on the north London set.

'Agnes was obviously the counterpoint to the Selfridges, the cockney girl making good,' Rob comments. 'But she was dealing with an alcoholic dad and sharing with her younger brother, so we obviously made that very small, very drab.

'Most of the houses in London at the time didn't have running water, so they'd be carrying water up three flights of stairs, and carrying coal up to heat the room.'

The tiny studio she shared with Henri, at the store, didn't provide much respite from the dreariness but, as Agnes' light began to shine in series two, she moved to the beautiful home of Miss Mardle and her work space got a bright new make-over too.

'In the first series, the design studio was four walls with no windows,' recalls Nic Pallace. 'We were very limited for space in the warehouse, so it was very difficult to get that sense of reality and natural light. To conquer that sense of gloom, we put in a lot more windows and added artificial outside spaces and we put in a little skylight. In series two, the window is always open and there are light wells which give the impression of daylight. We even added a little soundtrack of pigeons cooing!'

HENRI LECLAIR

PLAYED BY GRÉGORY FITOUSSI

Even as a child, Grégory Fitoussi was unwittingly preparing for the role of artistic director Henri Leclair – by helping out in the family business.

'My father's job was doing exactly the job that Henri was doing,' he reveals. 'He designed the windows of my mother's shop, so they were working together. I saw him doing that when I was a child, and I used to help him sometimes. So Henri's job wasn't far from my world, from my experience.'

Like the charismatic Henri, the French actor has a little artistic flair and appreciates the finer things in life. 'My job is artistic so I am a little bit artistic,' he says. 'I am learning to play music and I'm a fan of paintings. But I'm not a big fashion follower, so that's something very different with Henri Leclair, because he knows what he's talking about.'

Being the only Frenchman in the English-speaking cast was another aspect that helped Grégory get into the character. 'What I liked about Henri is that I can allow myself to behave differently to the other characters because of where he comes from,' he explains. 'It was very difficult for Henri at the beginning because of the language, but the way he reacts to situations can be different because he doesn't have the same rules.

'I could relate to the character because the way I felt on set was exactly like he would feel; being a stranger, trying to do his job as well as he could and loving what he was doing. He's a proud and honest man, loyal to friends and lovers but he is also a lonely man. He's travelling all the time. He doesn't really have any home. And that's how I see myself – I'm travelling a lot and I like that life, going from place to place.'

MISS RAVILLIOUS
'Do you propose putting ladies' underwear in the window, Mr Leclair?'

HENRI LECLAIR
'Nothing would delight me more. What a vision I could create. Sadly, convention decrees otherwise.'

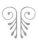

In order to make Henri's experience as a foreigner in Edwardian London as authentic as possible, the Parisian star did little research for his role. 'I have been in period dramas in the past and I've done a lot of movies close to that period,' he recalls. 'But on this one I didn't worry because for Henri, it was the first time he had come to London. He had worked in Chicago before, with Harry, and before that he was in Paris, so he's just arriving in the city. I liked the idea of discovering the city of London and the mood of London through his eyes.'

Grégory says he was thrilled to land a role in an English costume drama because, he believes, 'The English have the reputation of being the best when it comes to period drama.

'It was also great to be part of it because of the costumes, the props and the set – it's a whole world created. I like the period and I love to lose myself in a new world, to try and draw out the way people behaved in that period. For example, in relationships with girls it was very different then. You can allow yourself to be romantic because they did not have so many loves in this period. When they fell in love it was something very strong and very beautiful.'

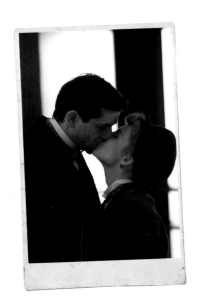

In London, of course, the charismatic fashionista falls for his closest colleague, Agnes Towler, and finds himself in a love triangle with dependable Palm Court manager Victor Colleano. The second series saw Henri return from five years away, working with former lover Valerie, and finally admit to himself that it was Agnes he loved. Grégory says working with co-star Aisling Loftus makes the romantic scenes flow naturally.

'In five years, they haven't seen each other, but everything is still there between them,' he says. 'There is a chemistry between Henri Leclair and Agnes Towler, and I feel the same with Aisling. It's really easy to work with her. I think she is a wonderful actress and she's so believable when you play a scene with her, there's nothing fake about it.

'It's real good luck for an actor to work with an actress like her, I really mean that. So there's something really strong between these two characters, and I guess it's getting stronger.' Even so, Grégory is not ready to see the pair live happily ever after in series three. 'It would be nice if they got together but then it would become less interesting,' he laughs. 'If they just love each other and they have no problem any more, everyone would be bored.'

'There is a chemistry between
Henri Leclair and Agnes
Towler, and I feel the same
with Aisling. It's really
easy to work with her.'
GRÉGORY FITOUSSI,
Henri Leclair

PART 2

SELFRIDGE
& Cº Lᴛᴰ

A TOUR OF THE STORE

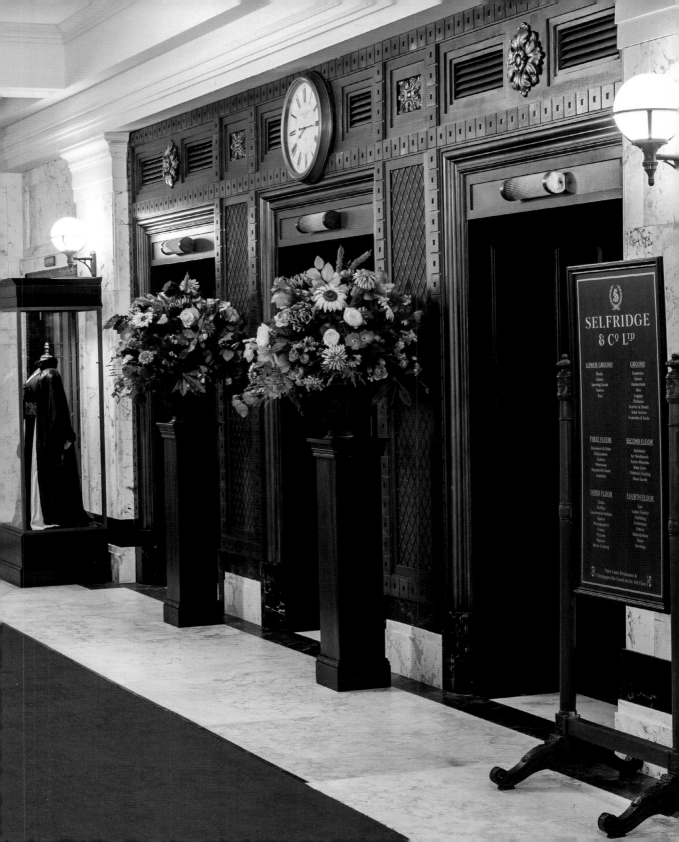

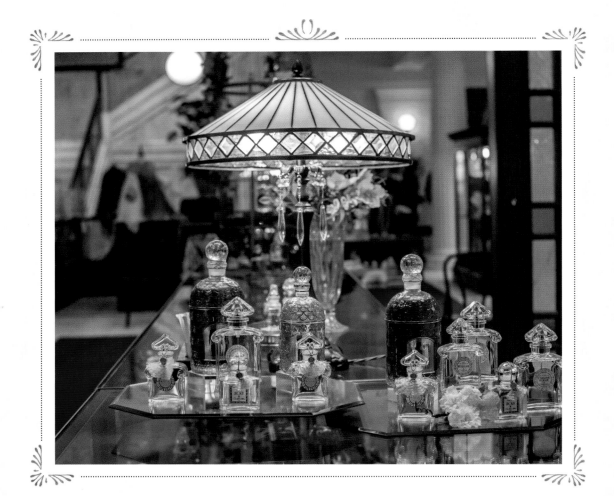

THE COSMETICS COUNTER

THE COSMETICS COUNTER

Today's shoppers are used to seeing displays of perfumes and cosmetics at the front of the store but in 1909, when Selfridge & Co opened their doors, such beauty aids were hidden away amongst the pharmaceuticals – the idea of putting them in a prime position was considered shocking by the ladies of the Establishment.

Things were beginning to change, however, and not least because of Harry's vision.

'There wasn't much make-up around and, particularly in 1909, it was more for ladies in the theatre,' says stylist Konnie Daniel. 'It just wasn't available. But through the series we see that make-up was just coming out and beginning to be made available to the public.'

Even so, the suggestion in series one that make-up should be displayed causes outrage amongst some of Harry's own members of staff, not least Miss Mardle and Mr Crabb.

Although he eventually concedes on the issue of cosmetics, Harry moves perfumes and face creams forward and, by series two, make-up is also seen on the glass counters at the front of the store.

For the set designers, that meant a lot of vintage bottles, jars and packaging had to be sourced.

'We found some great photographs showing the volume of product that was on display in the perfumery department,' says Sonja Klaus. 'There were layers and layers of product, and it was so full you almost couldn't see the cabinet. That is, of course, an unrealistic target for us, because I would have needed more products than we could get hold of to get that depth. But we had a really good shot

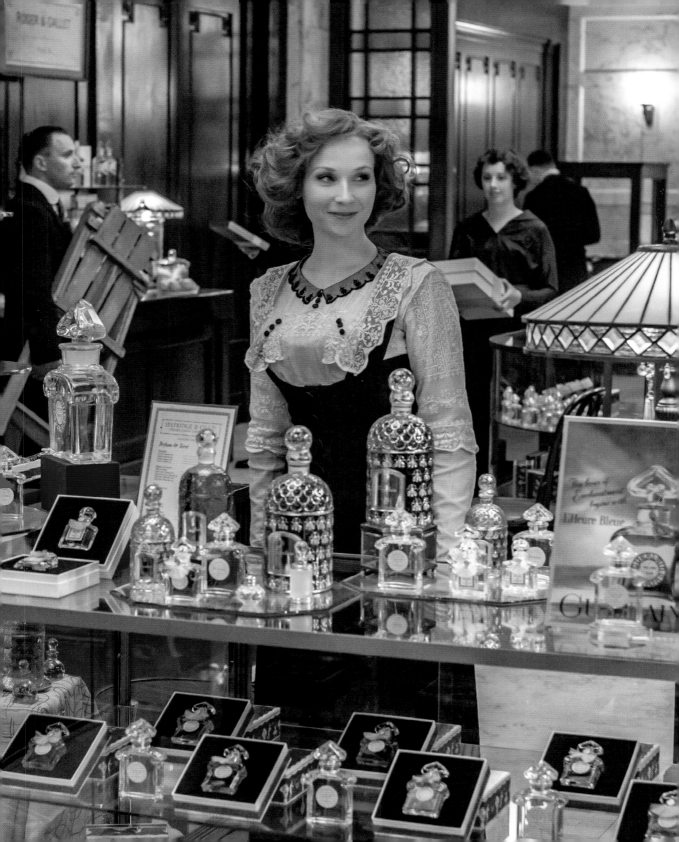

MR SELFRIDGE

'I want to move perfume out
of the pharmacy and give it
its own department.'

MISS MARDLE

'In plain sight? But perfume
is a lady's secret, Mr Selfridge.'

MR SELFRIDGE

'What about a little make-up?
Rouge, lip salve, that sort of
thing. Women are wearing it
now, out and about.'

MR CRABB

'Not respectable women,
surely. My wife wouldn't touch
it and I'm sure yours wouldn't
either, Mr Selfridge.'

at it and we made it look very full, using tricks of the trade, like putting boxes behind the bottles and making sure we had draperies and floral arrangements.'

Production buyer Belinda Cusmano was tasked with tracking down hundreds of perfume bottles and make-up containers with the vintage 1914 look. As they had to look shop-fresh, buying actual period products was out of the question, even in the unlikely event that they were available in the large quantities needed. So Belinda set about finding modern-day bottles that looked as they would have a century ago.

'I did a lot of research with current cosmetic brands that still produce the same bottle as they did in 1914,' she reveals. 'As you can imagine, not many of them did, which is why I turned to Floris, Penhaligon's, Yardley and Guerlain. If those brands hadn't helped us out with the perfume department, it wouldn't have looked half as good as it did.

'Guerlain's scent, L'Heure Bleue, came out in 1912 and they still produce the exact same bottle, which is amazing enough, but it also comes in the exact same box. They let us have over 100 bottles.'

As the empty bottles would have to be returned after use, the production team had to make sure they weren't damaged, and that meant being careful what they filled them with. Instead of gallons of expensive scent, the elegant glassware was filled with alcohol.

'We had to make sure the liquid didn't stain the glass,' reveals Belinda. 'There was talk of using tea, but tea will stain, and we tried olive oil, but it was a bit too green. We found the most successful liquid was alcohol with a little bit of food colouring, because alcohol doesn't stain and when you add colour, it doesn't create sediment at the bottom. It holds the colour really well.'

The make-up proved even more difficult to source, as packaging has changed drastically in 100 years.

'The cosmetic counter, which Kitty runs, was the hardest section to do,' says Belinda. 'Between 1909 and 1914, cosmetics started to get more popular. Mascara, which came as a black block and brush, was only just starting to get a market and rouge was more widely sold. But it didn't really become a mainstream, acceptable fashion item until 1917, so we've stretched it a little bit.

'The boxes were made out of paper or leather and there's no way I could get fifty of each of every colour, and that looked new. Luckily,

Bourjois and Rimmel gave us permission to use their graphics and then a wonderful woman called Catherine Chin, who has made custom bespoke pots for Sonja for previous projects, reproduced historically accurate mascara and rouge boxes from 1912 designs. They were so good that Rimmel borrowed them afterwards for their 180th birthday party celebrations.'

Past the perfumery on the ground floor lies the toiletry department, where talcum powders, soaps and fragrant bath salts tempt the shoppers to treat themselves. For those, Belinda went to Harry's native land to find a company that still presents its luxury goods in classic cut glass.

'Lady Primrose products come in beautiful crystal glasswear, from powder puff dispensers to beautiful jars filled with bath salts, so they pretty much filled the toiletry area.'

Once a customer's luxury goods were selected, the Selfridges staff would wrap each item in beautiful tissue paper and ribbons. But even though Harry brought ladies' beauty secrets out into the

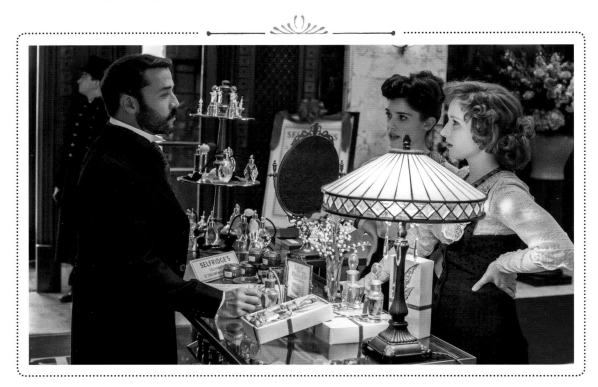

Bourjois was one of the brands that advertised their beauty products in the store.

open by putting them on display, most of his customers wouldn't have been seen carrying them out of the store.

'Although you could now go into the shop and take your perfume and cosmetics away with you, most people still wouldn't walk out with a carrier bag in those days,' says Sonja. 'They would choose their perfume, then it would be put on their account and delivered to their house by the time they got home, at least for the level of clientele that would have frequented Selfridges. You wouldn't see a barrow boy going into Selfridges every day because he wouldn't have been able to afford it, but he might save up his money for a while and then go in to buy a tiny bottle of perfume for his sweetheart, which he would have had beautifully wrapped. He would be the rare customer who carried his purchase out of the shop himself.'

LIPSTICK AND LACQUER

While gloss and glamour are at the core of both the store and the series, subtlety is the watchword when it comes to make-up. In pre-war Britain, the majority of women steered clear of cosmetics, seeing them as the flighty folly of showgirls, actresses and ladies of loose morals. Those that wore a little were at pains to make it as undetectable as possible. But putting the cast in front of the camera without a scrap of slap is not an option in the age of high-definition television.

'Because most women didn't wear make-up, many of the cast had to have a subtle, cosmetic-free look and the style depended on their position,' explains Konnie Daniel. 'The shop-floor girls had to look presentable and clean, but still amazing and well turned-out. The upper-class ladies, who had servants to help make them look their best, with hair pieces or wigs, may have had a smidgen of powder or rouge, which had been around since the eighteenth century, so they looked much more glamorous than the shop assistants.'

Such restraint does not apply to the more shameless characters – such as Ellen Love. In one intimate scene in series one, Harry reclines on the bed and watches his lover, a beautiful Gaiety Girl, apply her racy, red lip tint at the mirror.

'Ellen came from a theatrical background, a totally different world, and she is a very modern girl, she's the future, so she had to look glamorous while still contrasting with the upper-class ladies,' says Konnie. 'She developed through the series. As she became "The Spirit of Selfridges", she became even

Boldini's portrait of Marchesa Luisa Casati (left) shows the style that inspired the look of some characters, including Ellen Love (Zoë Tapper, right).

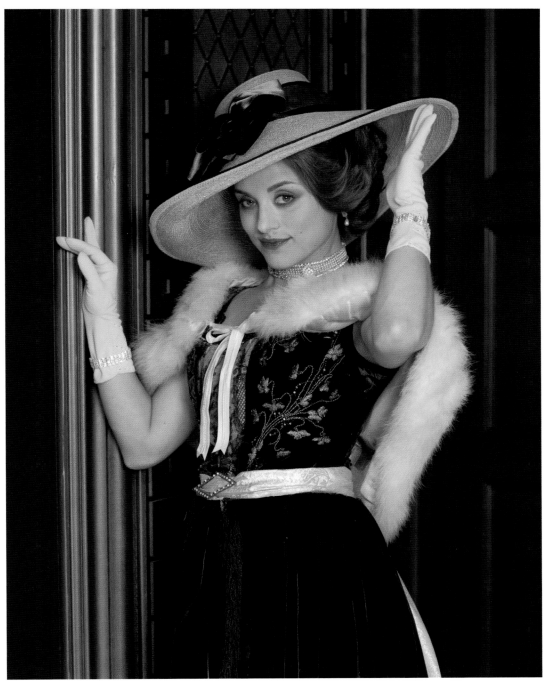

more glorious and then she went through another transformation as she stepped away from it all. By the end of the series, she is more like a silent movie star, a serious actress, like Mary Pickford. She was a fun character to work with because she had three stages of different styles, and also Zoë Tapper is a very beautiful actress.'

In order to research the Edwardian look, Konnie looked closely at paintings from the era as well as watching films such as *Room with a View* and *House of Mirth*, and worked closely with costume designer James Keast and original director Jon Jones to come up with a look for the ladies.

'Jon Jones particularly likes the Italian artist Giovanni Boldini,' she reveals. 'His paintings have striking contrasts and his subjects look almost like they have make-up on. We liked the strong look of the women and the glossiness of the art, and that was the look that James and I went for.

'We weren't making a costume drama that was gritty and Dickensian; it is all about shopping, London and glamour. Back then London and Oxford Street were ground-breaking in fashion and, even now, when you walk around the West End it is always so inspirational.'

AGNES GOES PARISIAN

The second series saw the sweet and innocent Miss Towler returning from her sojourn in Paris a new woman, with a newly influenced sense of style.

'We changed her look totally,' reveals Konnie. 'In the first season she was an insecure young girl who has had it quite tough, looking after her brother and with an abusive father. She looks totally different in series two, much more grown up and yet softer.

'Aisling Loftus is very beautiful and there's not much you can mess up there, so she needs very little help from us.'

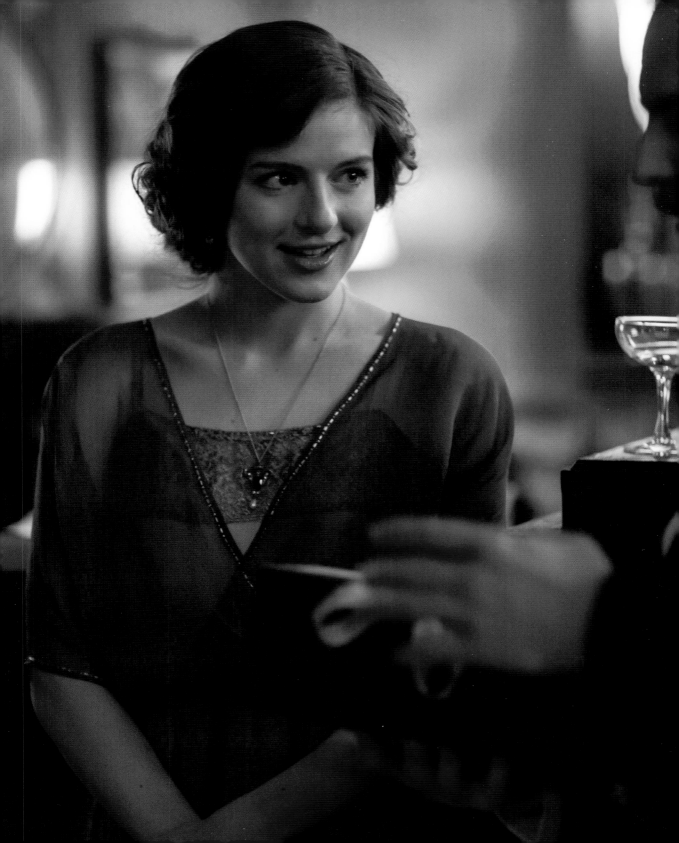

HAIRPINS AND HATS

With a huge cast, and an even bigger set, the stylists have to make sure the right people stand out in a crowd. Hair and make-up play an important part in achieving that, as Konnie explains.

'In the first episode, when we saw the opening of the shop, there were over 100 people standing there, so our main characters have to stand out like flowers in a field of grass. When you have a large cast it's harder for the audience to recognise all the characters, so you need to have a strong look for each one, and the shape and colour of their hair is part of that. So we have the red-haired cheeky girl, the blonde who is a bit nicer, and the dark-haired Miss Mardle, who is quite strict but at the same time quite racy. You want them all to look quite different so that viewers can take one look and say, "Ah, that's Kitty", "That's Agnes".

'The Edwardian era is a difficult period in terms of making people more distinct, and the second season has been a much easier period,' she reveals. 'But I love the Edwardian period and it was always a dream of mine to work on a production set in that time. There are so few opportunities because it only covers ten years, but the biggest transformations happened in those ten years – industrialisation, cars, aeroplanes – so it's really specific in terms of look.

'Not everybody looks pretty in that huge hair and those big hats, but it's very striking; for a stylist, it is a big challenge and a really fun thing to do.'

Although series two is set just five years after the opening, in 1914, Konnie says the style had moved on considerably.

'As always when there is an economic crisis, as there was around that time, people tried to escape and the style went more into the softer Grecian look – loose, with more hair down,' she reveals. 'The silent movie stars such as Lillian Gish, Mabel Norman and Mary Pickford were coming up, and Charlie Chaplin movies were in the cinemas too, so it was a much sexier period and women went for soft curls.'

Konnie had to use a special trick so that Agnes, Rose et al. could release their tumbling locks in one movement – but that's one trade secret she's keeping under her hat.

'There were a lot of letting-hair-down moments in the series, where there is one pin among the millions that you pull out and it all falls down, seductively tumbling over the shoulders. It's a challenge but it's a little bit of magic.'

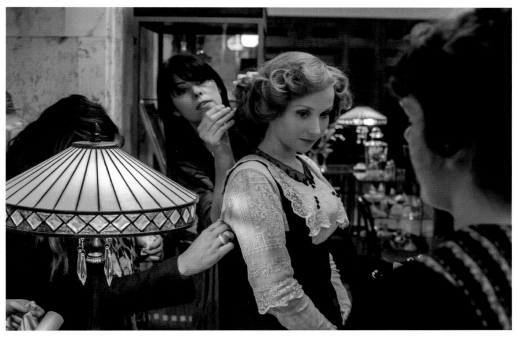

LADY MAE'S LOOK

Katherine Kelly, who had often sported a modern blonde look in other roles, adopted a much darker hair colour to play the wealthy lady of leisure, Lady Mae.

'We wouldn't have wanted her blonde because there wasn't much blonde dye around in that period,' explains Konnie. 'There was always henna about, but the only blondes around would have been natural blondes and that's a difficult look to achieve. Dark hair was the right option for that character, because she is trying very hard to be classy. When someone tries hard to distance themselves from their true background, they often overcompensate, and that's what we tried to do with Katherine Kelly's character. Lady Mae makes such a big effort because she desperately wants to be up there with the in-crowd, and that shows in her style.

'Luckily, Katherine had already dyed her hair for a play she was in when she started doing the show, so it worked in our favour.

'Katherine has a really interesting face and she knows exactly what works for her. It's brilliant to work with her because she has a versatile look and you can transform her quite easily, which is great fun.'

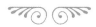

GETTING THE LOOK

Before she gets to work on the cast, Konnie gets together with James Keast and the production design team to exchange ideas. In a planning meeting, each department puts forward their vision of the characters, and together they come up with the final look.

'It's important to know the world we are putting these people in, so we need to know what the sets will look like, and the background of each character – where they are from, where they live, how they live and what that person is like. It's all the little things, like how they hold themselves, how they walk. It all has to come together at the end of the day and that's what the audience sees.

'It's not just turning up and putting a bit of lipstick on!'

Even after the styles are decided, it is essential that the costume department and hair and make-up department work closely with

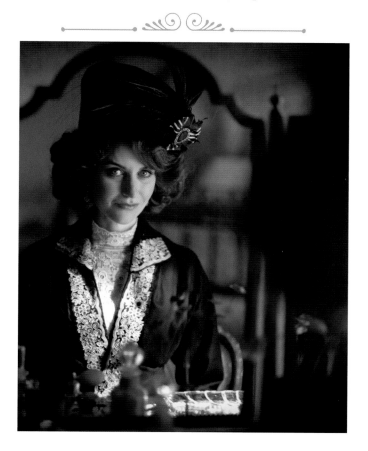

each other to avoid last-minutes hitches – particularly on a production that involves so many hats.

We talk through it a lot,' says Konnie. 'I may not always see the finished costume but I have an idea where it's going, and no one is just doing their own thing. It's a collaboration because the hat that the costume department chooses has to go on to the hairdo, it has to work with what they are wearing and what they're doing.'

For most of the female cast, getting into character means an early call time. Before they go on set, the actresses spend an average of an hour in hair and make-up (with an additional twenty minutes if they are to wear a hat), then up to an hour in the costume department, meaning Konnie usually starts work at around 5.45am. She works with a core team of five, plus a trainee, but on the shop floor shoots and party scenes, which require many more actors, an additional ten stylists are drafted in.

'My team deals with the main characters and the other team deals with all the extras, such as the customers, the extra shop staff, guests at Lady Mae's house, people on the street or in the theatre,' reveals Konnie. 'People milling around the store have to look equally amazing because the camera can come in close.'

Once all the actors are on set, the team is on hand at all times to help with any stray strands of hair and last-minute make-up retouches. Filming in autumn and winter in the UK can bring its own set of challenges.

'On set there is heavy involvement from us, because anything can happen,' says Konnie. 'The warehouse is quite cold, so the cast often put on warm coats between scenes, which can mess up their hair or knock the hats out of place. It's easier on the shop floor because there are no hats, but you have to constantly check the cast and make sure they look their best. As soon as we are done with the initial hair and make-up, we head out to the set with our box of tricks.'

Over the course of the series, Konnie has formed a bond with all the regular cast.

'In a long-running show, you become a bit of a mother and the person the actors come to in an emergency. I always have a stock of toothbrushes, deodorant and hair products that they can use in a drawer in my room, so they can come to Mummy for whatever they need.'

KONNIE DANIEL
Stylist

'*It's a collaboration because the hat that the costume department chooses has to go on to the hairdo, it has to work with what they are wearing and what they're doing.*'

GILDING THE ROSE

As the confident American hostess and composed
wife and mother, Rose Selfridge's look had
to be as natural as possible.

'Rose is a really amazing character. She's
American, she's a rich woman and she goes through
a transformation in the series,' says Konnie. 'She moves
to London with her family to follow her husband's
passion and tries to find her own way but she's
a strong woman so she's a great character to style.

'Frances O'Connor is gorgeous, really easy to work
with, and she has beautiful hair which makes it easy
to style. Style-wise, Rose is more natural because,
unlike Mae, she's at ease with her position. With Rose
the hair goes up and she looks beautiful, but without
making any effort, so with Frances we had to pull
back a bit, on make-up, on hair and on everything.'

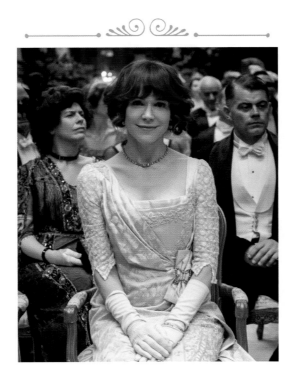

MAKING UP THE MEN

Although the male leads miss out on the elaborate hairdos and wide-brimmed hats, they spend almost as much time in hair and make-up as their female counterparts, thanks to a royal role model.

'I have to do as much for them as the women,' laughs Konnie. 'The Edwardian age was quite beardy because Edward VII, the King, had a huge beard. It was considered classy, so a man with money would have a beautiful beard and there was lots of beard paraphernalia around. For instance, they would put a piece of fabric over it when they slept, to stop it going wonky, and there were creams to keep it conditioned so people would invest quite a bit in their beards. We have to trim them and keep them looking immaculate at all times.'

Tom Goodman-Hill – who plays chief of staff, Mr Grove – welcomed his new look.

'I have been getting more hirsute as I've got older, so I was tending to go towards a beard anyway,' he says. 'When we knew Jeremy was going to have a beard and twirly moustache, we decided that his chief of staff would try and follow that and it worked out well because our colouring is completely different.

'I quite like a beard off screen as well. My favourite Christmas present this year was beard moisturiser!'

As well as tending their facial fuzz, Konnie makes sure that their haircuts are kept trimmed and neat, as well-to-do Edwardian men took great pride in their grooming.

'They had barbered, tailored haircuts, especially at the back, because they wore very stiff collars,' says Konnie. 'That requires good hairdressing skills. I worked in a barber shop for twelve years, so I am very particular about barbering. We also have to dye hair to get rid of some grey for some of them, so there are quite a lot of details to see to.'

The boys even get their turn in the make-up chair. 'They don't always have perfect skin tone and they might have rings under their eyes, so a little work is required. The show is about beauty and gloss, people looking as good as they can, and that sometimes requires some work on our part.'

TOM GOODMAN-HILL
Mr Grove

'*My favourite Christmas present this year was beard moisturiser!*'

HARRY GETS HAIRY

For Harry Selfridge a groomed appearance was essential, and his barber would give him a regular shave before his morning rounds. When it came to the series, it was decided to add a beard to the real Harry's ever-present moustache.

'The decision for Jeremy to have a beard really came from him,' reveals Konnie. 'I wouldn't have forced it onto him. The real Mr Selfridge always had a huge moustache but we wanted to make it more accessible to now and beards are very "in" right now, as they were then. Jeremy also wanted to break away from his previous character, in the series *Entourage*, and a beard was the best way to transform him into Mr Selfridge.'

Harry and Mr Grove display their well-kempt facial hair.

THE FASHION DEPARTMENT

THE FASHION DEPARTMENT

Shopping for elegant outfits at the beginning of the twentieth century was very different from today's experience. Hardly any garments, other than capes and cloaks, were available off the peg, and every dress was made to the specification of the customer. Most of the clothes were hand-stitched, rather than machined, and Selfridges employed their own seamstresses to make up the garments in the store's workrooms, boasting that the dresses and suits were 'made on our own premises'. Those with sewing skills or their own dressmakers could buy ready-cut pieces, such as unhemmed skirts and dress lengths, to be finished off at home.

With no rails of dresses to rifle through and try on, the latest styles were displayed on mannequins, to be reproduced to order. When it came to decorating the fictional fashion department – the domain of Miss Ravillious in series one and Mr Thackeray in series two – each dummy was dressed with the utmost care.

'We did quite a lot of research into the way they would be pinned so the costume dressers pinned them exactly right,' explains production buyer Belinda Cusmano. 'A lot of thought went into the way the fashion looked and the script mentioned designers of the time, such as Poiret and Lucille, so we took inspiration from that. When we'd pinned the gowns on, we embellished them with jewellery which was fun, fun, fun.'

The mannequins were bought at the start of filming, as they would be in constant use throughout the series. During each ten-week shoot, they get four or five make-overs, reflecting seasonal looks and changes in storyline. 'We would change the clothing

'We did quite a lot of research into the way the mannequins would be pinned so the costume dressers pinned them exactly right.'

BELINDA CUSMANO,
PRODUCTION BUYER

depending on what Mr Thackeray wanted to display, or what Agnes was working on,' says set designer Sonja Klaus. 'We employed four lovely ladies who worked in the theatre and they went off to props companies and rented clothes.'

Alongside the elegant gowns, racks of beautiful shoes in colourful silk or soft leather are dotted throughout the floor, while the counters offer a glimpse of the beautiful embellishments that ladies of the day could choose to add their own personal touch to each dress.

'We bought a lot of the shoes in Germany, then had them hand-dyed and embellished with cheap brooches or buckles here,' reveals Belinda. 'We used racks of fabric rolls in Agnes's studio, but in the store we used sample boards wrapped with beads and lace, to show the haberdashery element.'

Although the props department choose the outfits for the mannequins on display on the shop floor, costume designer James Keast often reaps the benefits of their work. 'The props people hire a lot of the costumes on the stands from the same costumier I use so, if we are there at the same time, we'll consult about what I'm putting people in and what we want the shoppers to buy. So in episode three a dress might be on display in the fashion department and in episode five I can have one of the characters or one of the extras wearing it, so it looks like they've bought it from Selfridges.'

The finest lace and antique brooches were among the details that made the set so authentic.

SELFRIDGE STYLE

From the day it first opened its doors in 1909, Selfridges has been synonymous with style, so when it came to recreating the era every character, from Mr Selfridge to the hundreds of extras, had to look the part. With up to eighty actors in the busiest scenes, 250 costumes may be required for just one episode, and over the course of a whole series, 1,500 different looks are created.

In order to get the best value from each outfit, costume designer James Keast has become a master at recycling and remodelling. 'The costumes that the extras wear will have to be used twenty times, maybe more, during the course of filming, so you can't afford for them to be so distracting that you recognise them every time you see them,' he explains. 'We don't want the audience saying, "Look, there's that hat again." So for a lot of the costumes we used darker reds, darker greens and darker blues so we can reuse them as much as possible.'

But even the most eagle-eyed viewer would miss the return of an outfit after James has worked his sartorial magic on it. 'Just because it's the same garment, it needn't necessarily look the same,' he continues. 'For example, you can have a coat that is worn on its own at its first appearance. The second time you see it, it's got a little fur trimming and collar to make it look like a different coat; and the third time, it has a great big stole over the top of it. Then you can add a tiny little hat so the silhouette is one shape, and the next week a great big wide hat that changes the silhouette again. In that way the same garment looks different every time you see it.

'You could have a black lace evening dress with a coloured shift underneath that shows through.

BELINDA
CUSMANO
Production Buyer

'*We bought a lot of the shoes in Germany, then had them dyed and embellished here.*'

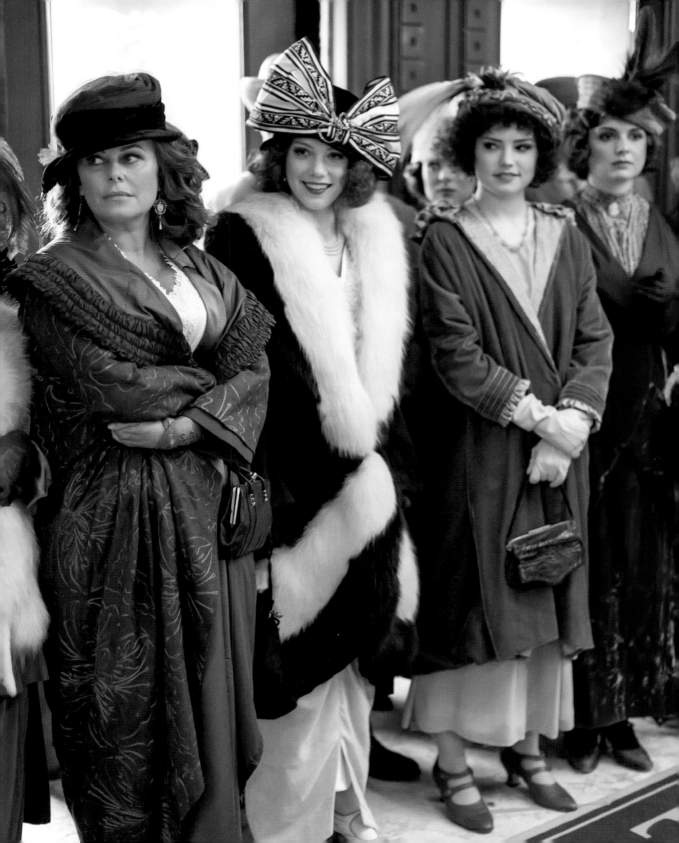

Ribbons and lace in the haberdashery and, right, The Blue Hat by John Duncan Fergusson.

You change the lining and it's a completely different frock altogether. You look at each garment and think, "What can I do to that to make it look different?"'

One aspect of the Edwardian period that helps to keep the number of costumes down is the fact that a limited wardrobe would have been owned by the majority in any case. Fabric to make clothing was hugely expensive compared to the average wage of between 5 and 13 shillings a week (£25–£65 in today's money), so shop staff would only have had one or two work outfits, which would be washed at the weekend on their day off, plus their 'Sunday best'.

The store setting also meant that many of the leading characters would spend all their screen time in the universal black uniform worn by shop-workers of the time. 'When I first landed the role, I imagined these wonderful period costume and thought, "I wonder what I'll be wearing?"' laughs Aisling Loftus, who plays Agnes. 'Then I discovered everything was a variation on a black uniform, with very subtle differences. It was only in the second series that Agnes was given her own flair and her own personal touches to her work clothes, and then sometimes had some more colourful looks for parties, so it was really fun to wear those new costumes. Plus, I got to wear more hats and coats.'

Before Selfridges revolutionised the way women shopped, dresses and suits were made to measure by a dressmaker, and would take weeks and several fittings to complete, which proved hugely expensive. As a result, even high-society women – like the painstakingly fashionable Lady Mae – would have envied the extensive wardrobes of today.

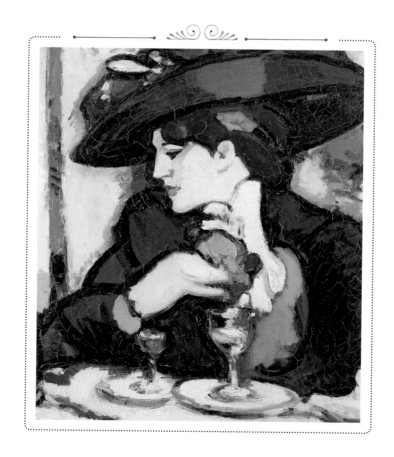

JAMES KEAST
Wardrobe Director

'We decided that because we had a "black out" for the majority of the shop workers, we should try to push colour for the other principals – like Lady Mae and Ellen Love – and the extras.'

'Even very wealthy people wouldn't have forty new outfits – that's a very modern thing,' explains James. 'In this period, even middle- and upper-middle-class women might have three or four new outfits to last a year. There were no dry cleaners, but the well-to-do would have a lady's maid to keep their dresses pristine.

'However, in terms of a modern audience watching a modern television drama, even if it is period, viewers are expecting the high-society characters to be wearing lots of fabulous frocks. In order to demonstrate the wealth of someone like Lady Mae, we have to give her twenty-five evening dresses – like the early twentieth-century version of Victoria Beckham.'

Because so many lead characters were dressed in black uniform, James says, he added more vibrant splashes wherever he could – taking his inspiration from the painters of the era.

J A M E S K E A S T
Wardrobe Director

'I took inspiration from artists like the Scottish Colourists Fergusson and Cadell.'

'I knew quite a bit about the period already, through working on other projects, but I researched the characters and took some inspiration from artists like the Scottish Colourists Fergusson and Cadell. They painted upper-class ladies, but it's not so much the portrait that inspires me, but the bold colour they use and the light and dark.

'After that, I sat with the director and discussed the real Selfridges of the period, and the paintings. We decided that because we had a "black out" for the majority of the shop workers, we should try to push colour for the other principals – like Lady Mae and Ellen Love – and the extras.'

Having decided on the colours for the character, James then sets about creating or finding the right garments for each scene, although not everything is made from scratch.

'For one-off outfits for the extras, I go to a costume hire company but, because we're filming for six or seven months, I make most of the costumes for the principals, such as the basic black skirts and blouses for the shop workers.'

As on any production, the costume department is constrained by the budget and thrift is James's byword.

'I buy in bits and pieces,' he explains. 'I'll go on the internet, trawl charity shops and car boot sales. I'm always in charity shops, and people look at me a bit strangely as I rummage through the women's clothes. Sometimes I can find a hideous frock but it will have a piece of trim on it which I can take off and use, or a piece of fabric that can be made into something else. I'm always picking up bits of bed linen, lengths of fabric. Charity shops are also a great place to get coats, which nobody wants because they have often gone out of fashion, but the basic fabric can be fantastic.'

Despite his tireless hunt for second-hand fabrics, James rarely buys genunine vintage items, other than jewellery and the occasional accessory.

'You can't use vintage items on film because if something is actually 100 years old, it probably looks 100 years old.'

Having worked on many a period piece, James often looks to find the costumes he has designed before. But he doesn't always get what he wants, as he discovered when he went searching for an outfit for an episode featuring Mack and Mabel – legendary film producer Mack Sennett and actress Mabel Normand.

'Mabel was only in a few scenes, but when she arrives I wanted

everyone in the shop to look around and say, "Wow. An American film actress",' he recalls. 'The coat that I thought would be perfect for that character was one that I'd made when I worked on the TV series *The House of Eliott,* which is black velvet with a gold print on it and a great big fur collar. But the costume designer on *Downton Abbey* had since hired it for Shirley MacLaine, and it was in an exhibition somewhere.

'Instead, I found another one which was blue-black velvet with a white fur trim. I had a hat made to match the coat and then I had a dress made to match the hat, and that really gave the outfit the "wow" factor.'

GETTING THE LOOK

James is among the first of the production team to see the scripts but, even then, he may have only three weeks to come up with all the outfits for the next 'block' of filming. The first thing he does, with the help of his assistant, Sarah Moore, is break the scripts down into characters and work out how many costumes each one needs for each block.

'For example in the breakdown of a story, Lady Mae is seen in evening dress, morning dress and a day suit,' he explains. 'As she is the wealthiest woman in London, I can't have her seen in the same evening dress every time; if she has a couple of scenes in evening dress, I'll make her two, plus two day suits for going out and about.'

James does the same with every character, right down to the extras. Then he thinks about the fabric needed for each outfit – that decision depends on the class of the wearer, with wealthy characters being swathed in fine lace, silk and satin, while the poorer classes have to settle for wools, cottons and linens.

'After that, I work out how much I can spend on each outfit and how often it will be used. I then decide whether I need to make it or hire it from a costume house. If something is to be worn in one scene, or two scenes, it's not worthwhile spending thousands of pounds on fabric, so I often base the design on fabric I already have myself and make it as cheaply as possible, or I'll look in vintage shops and online. If it is cheaper to buy an original garment rather than hire or make one, I will.'

James and Sarah then set about making, hiring and buying the necessary outfits, as well as outsourcing some of the dressmaking

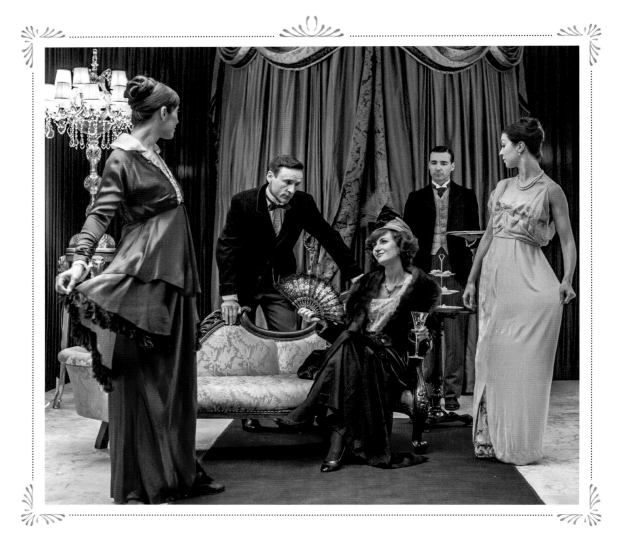

MR THACKERAY
'I showed her the most wonderful
creations. They just didn't
suit her mood.'

MR SELFRIDGE
'It is your job to suit her mood.
The customer is always right.'

to other trusted companies. As the first filming day approaches, fittings with the principal cast are booked in – although James admits that, because of their busy schedules, he doesn't always get as much time as he'd like.

'Usually we get one fitting, two if we're lucky, but three is preferable,' he says. 'At the first fitting we are still making the dress; at the second we might have made a hat to go with it but, ideally, if we have a third fitting, we can get all the finished components together and make sure everything works.

'It's at that stage that you tend to spot that really it needs a pearl necklace, or a diamond necklace. If it's on the day of filming, we can only hope the accessories we have on set work and fit, but they don't always.'

On series two, James reveals, there was an unforeseen hitch when it came to dressing Katherine Kelly, as Lady Mae.

'Katherine was busy so she wasn't always available to fit and then she fell pregnant,' he recalls. 'That meant we had to redesign and recut the costumes to hide the bump, which is fine when an actress is three months pregnant, but when they're six months pregnant it's pretty difficult.

'We had already fitted her costumes and made them, because we didn't have a lot of access to her, and then she turned up on day one of the new block, after a break, and she was starting to show, which meant that nothing fitted her at all. I let out as much as possible but I also had to remake a lot of them from scratch and, in the meantime, we had to improvise by doing some scenes with a coat on and using a few other tricks of the trade.'

During the shooting of the show, James has a talented team of costumiers to make sure everything runs smoothly, led by supervisor Jane Batt. The day before each shoot, James, Sarah and Jane sit down and go through the scenes being filmed the following day to make sure all the necessary outfits, shoes, accessories and jewellery are on set and ready to wear. It's Jane's job, on the day of the filming, to make sure everything is laundered, cleaned and pressed, and to deal with any repairs or alterations that crop up on set.

While Jane makes everything tick in the costume department, another two dressers are on set throughout to make sure every hatpin, brooch and collar is in place and everybody looks as they should for each scene. For the more crowded scenes, such as

'*The first time you see Miss Mardle – played by Amanda Abbington – she is in a black frock but she has a collar covered by embroidery in many different threads, which is a way of introducing a bit of colour. In the second series, I did a similar thing. I made predominantly black dresses but I used a piece of braid that I bought in a charity shop to decorate a collar, or go down the front, just to add a touch of colour to the costume.*

'*In the second series, Agnes wears a predominantly black dress but I've given her a separate blouse underneath and one of those was black based and covered in beautiful embroidery. In fact, it was made from an old piano shawl that was falling to bits.*'

a high-profile event in the store or a night at Delphine's, more dressers are drafted in to help with the many extras on set.

'My team are very clever so, as I go through the clothing, I will say to them, "Go and make a belt out of that," or "Make a blouse out of that."

'If they're not busy on the set, they're always adding bits and pieces to the wardrobe, which is a cost-effective way of doing it because the staff are already being paid and we're using fabrics that cost maybe £3 in a charity shop.

'Detail is so important because it's television, and it's high definition, so you need to look at as much detail as possible.'

DRESSING MR SELFRIDGE

For Jeremy Piven's showman shopkeeper, costume designer James Keast took the Mr Selfridge described in Lindy Woodhead's book and added a flamboyant twist of his own. Harry Gordon Selfridge was always a formal dresser, wearing a suit and morning coats during the day, and tails in the evening, and James had all the basics made by a north London costumer, based on the fabrics that would have been used in the era.

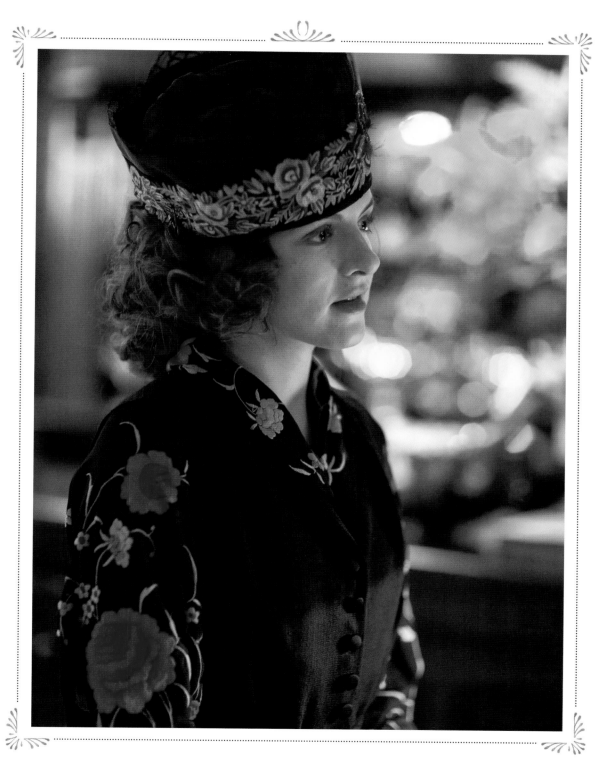

His impressive wardrobe includes striped trousers, double-breasted waistcoats, wing-collar shirts and stylish overcoats – all based on the Edwardian dress. But James took advantage of every opportunity he could to add colour to the look.

'For the men I do try to use fabrics, shapes and colour as much as I would with women but you are slightly restricted because you're still cutting that fabric into a jacket or a pair of trousers or a waistcoat. Waistcoats and ties are the main areas where you can push the boundaries a little.'

As a result, Harry has a fine collection of patterned waistcoats, cut from beautiful silks. For the neckwear, James looked no further than his own collection of vintage ties.

'I have about 5,000 men's ties, including hundreds from the 1950s and 1960s, and those are the ones I used,' he reveals. 'The sixties look was very Edwardian in tone, with The Beatles and other pop stars and the Carnaby Street trendsetters wearing period ties, colours and fabrics, so I've used them.

'Probably ninety per cent of the ties on the male cast are original sixties ties. A character who is traditional can be a bit darker and a bit more staid, and when we want to add a little bit of flamboyance to a character, they get a splash of colour. The nature of television means that, because of the small screen, a lot of the shots are head and shoulders, and so the tie becomes very important.'

When it came to the look of the character, actor Jeremy Piven decided that the magnificent moustache that Harry sported in real life would be replaced by a beard.

'Harry had a moustache and mutton chops and a look that I couldn't pull off nearly as well as he did,' he explains. 'I wouldn't have looked good like that at all. I wanted to have facial hair as an homage to him but a moustache would have been too distracting, and it was just one of those instinctual things that happened.'

While The Chief's three-piece suits and pristine shirts were down to designer James Keast, the dapper actor insists he relishes his period wardrobe.

'I love the braces and the costume and it's all just amazing to wear,' he says. 'I'm a fan of that particular look, the cut and the waistcoat, and the whole thing. You're strapped in there and you can't help but feel of the time. James does a brilliant job and he knows how to stretch a buck. He's great at what he does.'

JAMES KEAST
Wardrobe Director

'*I have about 5,000 men's ties, including hundreds from the 1950s and 1960s, and those are the ones I used.*'

CORSETS AND COUTURE

The female silhouette of the Edwardian era was created by a straight-fronted corset, known as the 'S-bend corset', which forced the torso forward and caused the behind to stick out. Before the shop girls of Selfridges could be dressed in their black daywear, they had to be firmly laced into their period undergarments. For Aisling Loftus, however, the corset was more of a blessing than a curse.

'The corset is a bit of a shock, initially, but then your body starts to move in a different way,' she says. 'As much as it's uncomfortable if you eat too much dessert at lunchtime, I like it because I'm held in a different position and it really helps with the propriety. There's no slobbing about as you're constantly standing to attention, so I think it's a really useful little tool to set you back into that mind, that time and that place.'

By 1914, when the second series is set, the female silhouette was beginning to change and the most fashionable of ladies were ditching the restrictive undergarments – thanks to revolutionary French designer Paul Poiret.

'Poiret changed the shape of underwear, to mirror a woman's natural curves, which meant the way women moved, the way they dressed, was revolutionised,' explains James. 'He cut fabric differently, and draped it differently, and he kick-started a change in women's fashion, which the First World War went on to change even further, beyond recognition. Because most of the men were off fighting and women had to do men's work, they had to wear clothes that reflected what they were doing. You couldn't suddenly go into the fields and harvest corn in a corset, so the corsets were out and the underwear changed, as well as the outer wear.

'That's reflected in the storyline, when some of the women have to take over the men's jobs, but it's also reflected in the way we dress the rest of the cast, with shorter hemlines and different fabrics.'

While the younger shop girls may have been happy to throw off the shackles of the stay, not all the characters abandoned their corsets for series two.

'Some of shop girls didn't need corsets, and they didn't actually make any difference, but for some of the more mature fashion staff, like Miss Mardle, that's a step too far,' says James. 'She kept her corset because that's the proper thing to do, a bit like in the sixties when young girls were all wearing mini-skirts while, for the older

generation, that was too racy. You get stuck in your own period and the way you wear clothes is influenced by the way you were brought up. So the young girls are ditching the corsets and the older ones are hanging on to them.'

The feeling of emancipation is enhanced in series three, when the war is over and the Roaring Twenties are just around the corner. The changes mean a whole new style for the younger cast members, especially the women.

'There wasn't much access to fabrics during the war because they came from China and India but suddenly, once the war was over, there was an access to all these materials that coincided with a new freedom in what women were wearing.

'They felt they'd been working in the fields for four years and could do a man's job, so there was a feeling of emancipation, and even the way women walked changed because of the looseness of clothing. Underwear moved away from the tight boned style and became more a way of giving women a fashionable shape, which continued into the twenties when you had the bustier to flatten the bust, flapper style.

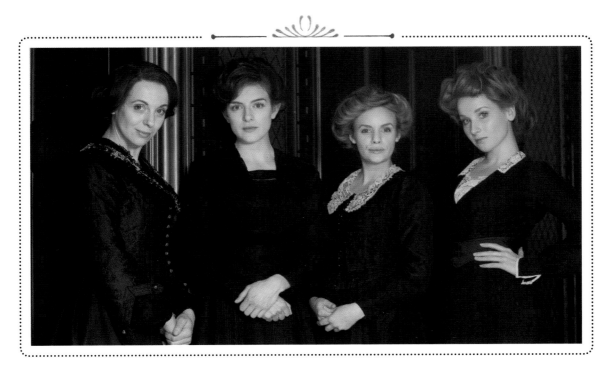

LADY MAE'S WARDROBE

As a self-appointed leader of fashion, Lady Mae had to have the most luxurious and sumptuous fashion range of all the cast. The endless rounds of shopping, lunch appointments and social gatherings meant an array of day suits, cocktail dresses and evening wear, not to mention a vast collection of hats.

'The audience expects Lady Loxley to have an extensive and fashionable wardrobe, so we had to make her look as different as possible,' says designer James Keast. 'For that I went to France. I got a lot of reference from the French fashion magazines of the period, which gave her a slight edge and made her look like she was one step ahead of everybody else.'

'In the first series, my favourite costume was the pale blue day suit, which took me by surprise when I went for the first fitting,' says Katherine Kelly. 'Because she was not a very nice woman, especially in the first series, I imagined her in deep rich colours, like navy blues, purples and reds, which we did use some of. But James bought this powder blue suit out and I said, "I'm not quite sure. That's not what I imagined. That's quite soft." So he explained that, when I'm in the store, in Selfridges, and all the staff are in black, this is what makes Lady Mae stand out.

'Also, in those days, there were no washing machines or dry cleaners, so it was servants who cleaned your clothes and everybody wore dark colours because London was so dirty. If you wore a light colour, that demonstrated how wealthy you were, because you obviously had the staff to clean it.'

'With lead characters like Lady Mae, we went for bold colours as much as possible, and I made her evening dresses bright and vibrant,' says James Keast. 'But at the same time you don't want to the audience to say, "There's that pink suit again." It would be great if we had an endless budget and could make as many costumes as we liked, but we can't, so it's about balancing the number of costumes we can afford while allowing the characters to be shown off.'

'Because Lady Mae is the richest out of everybody, and because her hobby was shopping and fashion, and she was a lady of leisure otherwise, she did get the best outfits,' says Katherine.

'In series two, before Mae's downfall sends her back into her pre-marriage clothes, I had a beautiful purple evening dress with beads all over the top half. It was really stunning because the beads

LORD LOXLEY
'You appear rather well known here.'

LADY MAE
'I lead fashion. What do you expect?'

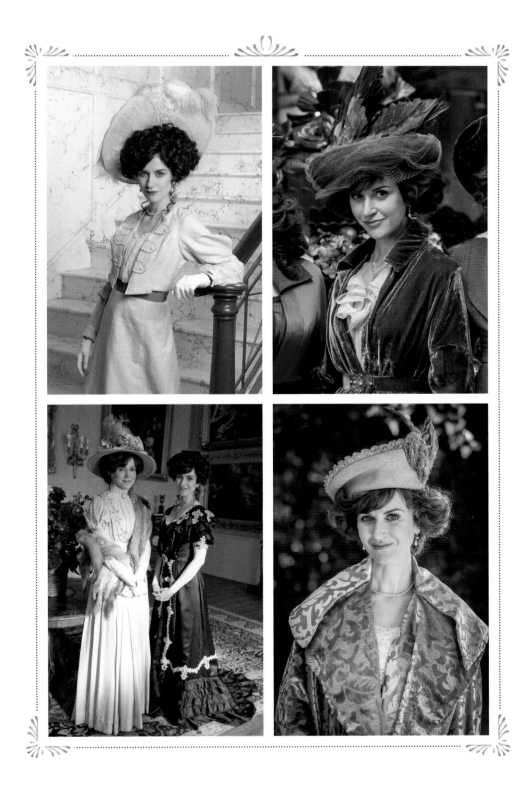

are original, and the costume department built the rest of the dress around the beaded bits to preserve that material. Everything is made to measure, so they always look fantastic.'

Lady Mae's outfits weren't the only thing to be updated in series two. Five years after she first walked through the door of Selfridges store, the aristocratic trendsetter got the chance to let her hair down. But Katherine would rather she hadn't.

'I definitely preferred my hair in series one. Series two is not really my thing,' says the actress. 'The hats are a lot smaller and the hair is a lot looser and freer, but I preferred it when we had really big hats and the hair was very styled, rather than that loose look.'

Between the two series, Katherine had a makeover of her own, losing her longer locks for a shorter style, like a 'boy cut'.

'That's the downside of playing the richest character – you have the longest make-up call, especially when your hair is as short as mine,' she reveals. 'They didn't want to use a wig so, in series two, it was all hair pieces, which had to be built on top and woven in. I had a two-hour call before I was on set, so I was picked up as early as 4.30 in the morning and I was always the first in.'

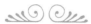

*'We disgraced divorcees
have one advantage –
absolutely nothing to lose.'*

LADY MAE TO DELPHINE,
MR SELFRIDGE

LADY MAE LOXLEY

Playing the part of Mr Selfridge's witty, resourceful benefactor Lady Mae Loxley was a whole new experience for Katherine Kelly.

'I didn't know much about Harry Selfridge at all,' she admits. 'I'd been to Selfridges a lot because I was living in central London, but I didn't know the story behind the store. When the part in *Mr Selfridge* came up, I read Lindy's book – I'm a sucker for a true story so I thought, "This is going to be great."'

Like Harry, Lady Mae has clawed her way up from the bottom to become one of the wealthy elite of London. Starting out as a Gaiety Girl – a dancer at the slightly risqué musical theatre that Harry himself loved to frequent – she gained riches and respectability with her marriage to Lord Loxley. Their similarly humble beginnings, and her constant search for the new and the exciting, means she is one of the first to accept Harry into the fold and introduce him to her influential friends.

'In another time, she and Harry would probably have been business partners, but she couldn't do that because she was a woman,' explains Katherine. 'So she does the best she can.

'But I love the Edwardian period. It's such a time of change, especially for women. Women suddenly seem to come to the forefront, and play a more active role in society, rather than behind closed doors, so I've always liked that period.'

Although the paths of Mr Selfridge and Rose are dictated by the facts, the writers could be much freer with the fictional characters, like Lady Mae, and Katherine has enjoyed the twists of fate endured by her alter ego.

KATHERINE KELLY
Lady Mae Loxley

' *I love the Edwardian period. It's such a time of change, especially for women. Women suddenly seem to come to the forefront, and play a more active role in society, rather than behind closed doors, so I've always liked that period.* '

SELFRIDGE & C° LTD
OXFORD STREET, LONDON, W.1.

My Dear Lady Mae,
you are greatly missed at the store. Please Join us for a social gathering at Delphines. I'll Send a car

H. Gordon Selfridge

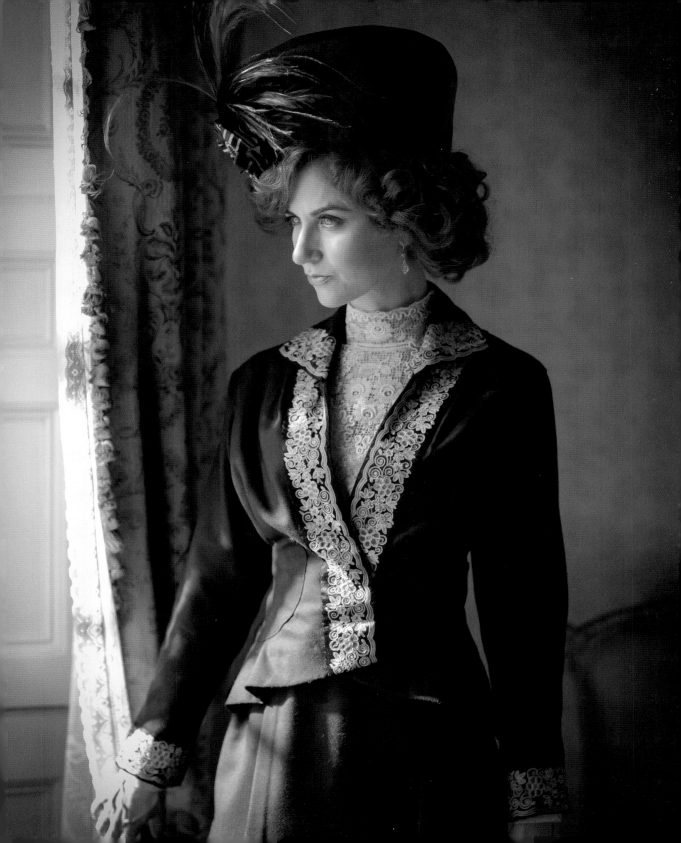

'Lady Mae isn't a real person, but she's a few women from that era, mashed together,' explains the actress. 'That definitely makes it exciting. If you are a real character, you know what's going to happen to you, but with me, when they came up with the plot for series two, it was a complete surprise.'

In the first years of Harry's venture, Lady Mae does her bit to keep the tills of Selfridges ringing – spending her husband's fortunes on extravagant fashion items and supping at her favourite table in the Palm Court.

But things take a nasty turn in the second series, when her elusive husband is announced with the portentous words from Mae's lady's maid, Pimble: 'If you please, Lady Loxley. Lord Loxley is downstairs. He's brought luggage.'

'It did get a lot darker in series two, but I like that,' says Katherine. 'I think Mae was the character we knew the least about at the end of series one, because you never saw her behind closed doors. You only saw her when she wanted to be seen, when she was throwing a party or when she was at Selfridges, treating the shop floor like her catwalk.

'Suddenly, in the second series, you got to see what was really going on. You got to see Lady Mae when she wouldn't want you to see her, which made a big difference.'

As well as cancelling her beloved store account, Loxley – played by Aidan McArdle – puts paid to her other pastime of entertaining young lovers.

'I only get one dalliance, which is rubbish,' laughs the star. 'The fellas are a bit thin on the ground for Lady Mae in series two. She's

'If you please, Lady Loxley. Lord Loxley is downstairs. He's brought luggage.'

PIMBLE, MAID TO LADY MAE, *MR SELFRIDGE*

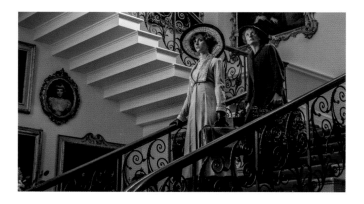

got bigger problems with the financial burden they're about to be hit by, so she can't fit them in.

'The one lover Mae got was played by Jack Fox, which was great because I went to RADA with his brother, Laurence. I used to go round to their house when I was about eighteen, and Jack would have been about fourteen, so it was fun to have him playing my toyboy for a couple of episodes.'

After Lord Loxley's verbal and physical abuse become too much for her, Lady Mae leaves her husband – a brave move in an era when women who chose to divorce had no rights. But that puts a serious curb on her spending.

'Lady Mae had been a trend-setter during her marriage, but when she leaves Lord Loxley and says she'll only take what she came with, she's back to the very basic clothes that she would have had before her marriage. She was a Gaiety Girl, so they were passable, but they're not the decadent clothes we saw in the first series and the beginning of the second. In fact, I look a bit rubbish for the last part of series two, but that's fitting: Loxley wants to see her back in the gutter, so he won't give her any money.'

Katherine's beautiful Edwardian dresses had one minor drawback – the restrictive underwear below.

'Those corsets are pretty hellish when you're not used to wearing one,' she reveals. 'You can't sit, you can't eat, and you don't know what to do with yourself.

'We had them specially made, and James Keast did what he could to make them as comfortable as possible, because sometimes you have to wear them for fourteen hours, but I definitely didn't have the stamina for them.

'Frances O'Connor was brilliant with her corset but I never seemed to build up a tolerance for it. It was actually worse if I'd worn it the day before.'

Katherine breathed a sigh of relief when she was released from the corset strings in series two. When she found out she was pregnant during filming, the waist-synching undies had to go.

'The costume department had to start doing the opposite and put panels in the back of my dresses because I looked pregnant right from the start,' laughs Katherine. 'We covered it up quite well, I hope, but my ribcage began to expand and my chest got going straight away. So I was kind of bursting out of my costumes, even at twelve weeks!'

TONY
LADY MAE'S
YOUNG LOVER
*'Aren't I even
allowed to think
for myself?'*

LADY MAE
*'No, that's not
the point of you
at all. In fact,
I'm beginning to
wonder what
the point is.'*

THE ACCESSORIES DEPARTMENT

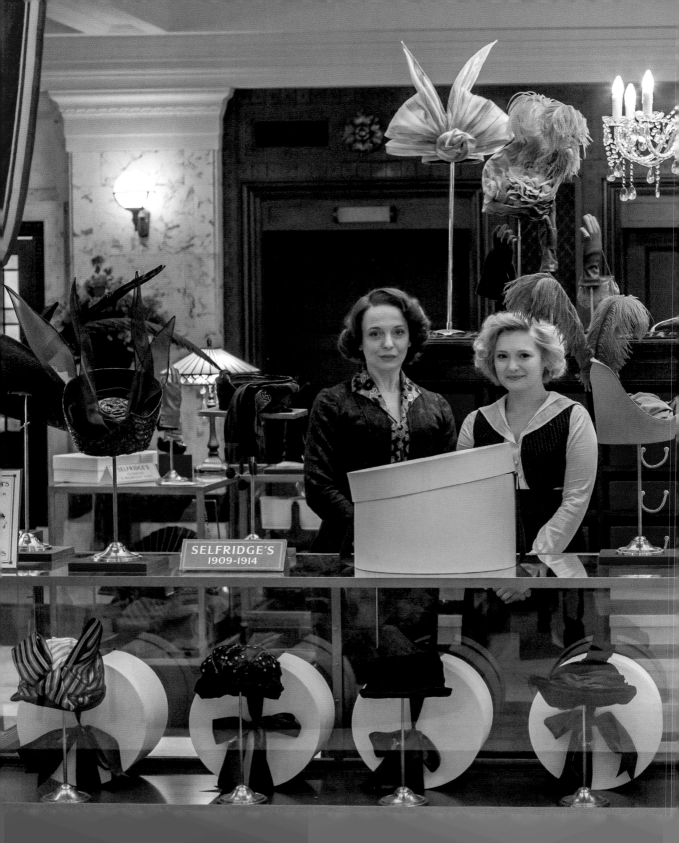

SELFRIDGE'S
1909–1914

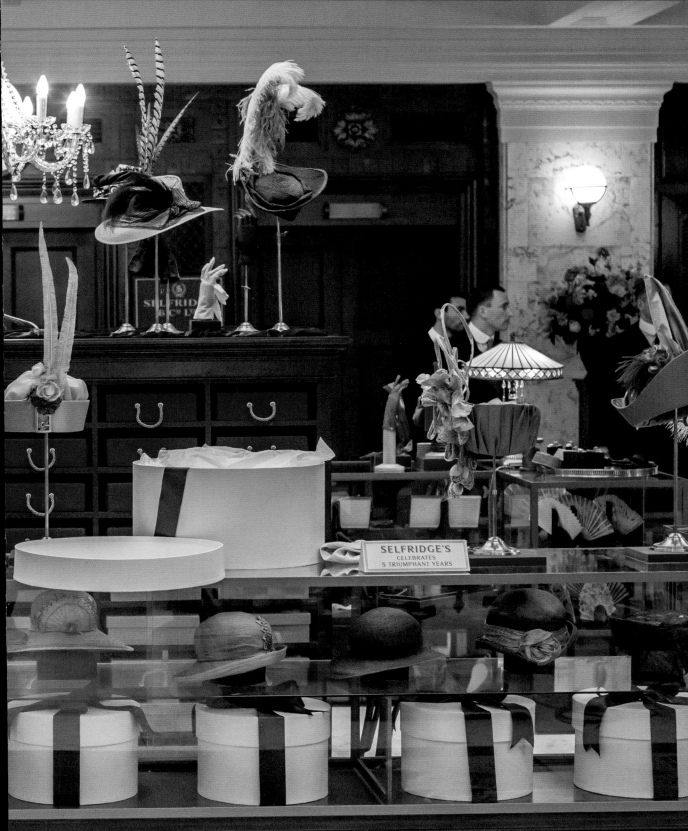

SELFRIDGE'S
CELEBRATES
5 TRIUMPHANT YEARS

THE ACCESSORIES DEPARTMENT

Of all the departments in the Selfridges of yesteryear, accessories had the most diverse range of products in the store – from hats and handbags to handkerchiefs and hair ribbons. The counters were a riot of colour, with silk scarves and soft kid gloves, umbrellas and fans and many more goods visible in the glass cases.

For the props team, the many beautiful items on display meant sourcing a wide range of very different stock. For the second series, glove company Dents provided 160 pairs of gloves which, mixed with the stock that had been bought for series one, brought the total number to 350. For the hat displays, ten were made to order and another fifty or so hired from a prop shop, and 150 umbrellas were placed in stands around the department.

'The umbrellas were purchased or hired and I bought all the bags,' reveals production buyer Belinda Cusmano. 'I did quite a lot of research and then I had them made in India, so that they looked authentic to the 1914 period.

'We did buy a lot of beautiful elbow-length kid gloves from the period that still looked like they were in great condition, but you can't buy ten of each. They featured in the displays where we would only have to use one pair, or a combination of different designs.'

When it came to the 500 linen handkerchiefs on display, set designer Sonja Klaus put in an extra effort to get the packaging exactly right.

'When you buy a handkerchief set, it will often come in a square box and when you open that box it's all displayed beautifully, folded and pressed,

A wide and varied range of stock was sourced for display in the glass cases on set.

with a little ribbon or bow and it all looks lovely,' she explains. 'They fold it in such a way that it shows off what the lace or pattern is, then they are secured with tiny little pins.

'We couldn't afford to go to the Irish linen companies and buy their expensive hankies, because they cost up to £50 for a set, so we bought hankies in bulk or bought them on eBay, and sent them away to be washed and starched, which cost us 10p per hankie. When they came back I separated them all myself, then ironed them and then I made up about twenty boxes, pressing them all into patterns and tying them with tiny little bows.

'It took hours, but it was worth it because that's how they would have been packaged back in the day. There's no point in doing something unless you are going to do it properly.'

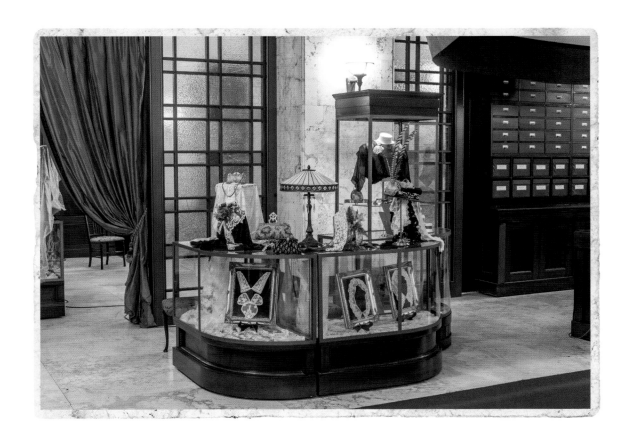

MISS MARDLE

PLAYED BY AMANDA ABBINGTON

Surrounded by gleaming glass cases, neatly displayed gloves and a dazzling array of silk scarves, Miss Mardle reigns supreme. As the queen of accessories, she boasts an unerring eye when it comes to what the customer is looking for.

Amanda Abbington, who plays the formidable head of department, feels privileged to be among the frills and fripperies and admits it brings out her inner milliner.

'I just love trying on the hats,' she says. 'I have a thing about hats anyway. I love looking at the craftsmanship and I'm fascinated by the way you can add a feather, and add bits and pieces to it, and it completely changes it. I'm definitely a hats and shoes girl.

'I also love the scarves and I can't resist touching the fans. The beaded handbags they had at that time were fabulous too. Everything is so feminine and pretty.'

Amanda is fascinated by the history of the women of the Edwardian and pre-war era, as well as the fashion. 'I've always been interested in that period because of the suffragettes,' she says. 'It was a time of huge social change and also a very feminine time, a beautiful period in terms of the way women looked and how they dressed, especially upper-class women. The Edwardian era is quite modish, very peacocky and I love it.'

There was disappointment, however, that Miss Mardle turned out to be the least 'peacocky' of all the characters in *Mr Selfridge*.

'In the first series, I saw the beautiful Zoë Tapper and Katherine Kelly coming on to the set in these

AMANDA
ABBINGTON
Miss Mardle

'*I'm definitely a hats and shoes girl.*'

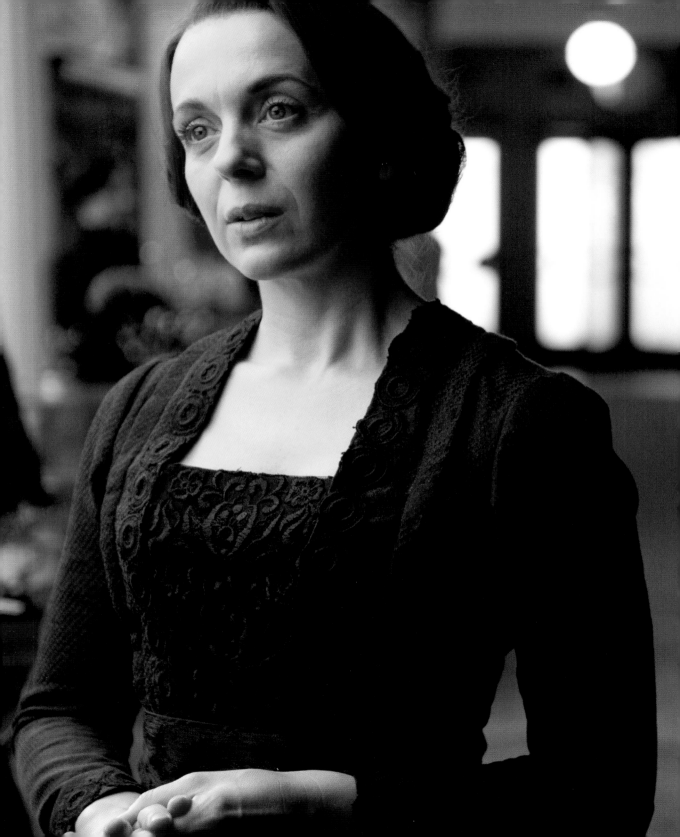

'A place for everything and everything in its place, Miss Towler, and memorise as you go. To work in accessories is to work in the most exacting department in the whole store. Ignorant people think we deal in little trifling things, but the accomplished accessories assistant has, at her fingertips, over 6,000 separate items of merchandise and I shall expect you to know them all and to be able to locate each one at a moment's notice. Is that understood?'

MISS MARDLE,
MR SELFRIDGE

fantastic gowns, with feathers and hats, and there I was in my black utility wear for the shop floor.

'It was fun for about five minutes, but I was in the same costume day in day out, with very little change, so I kept thinking, "Everyone is having loads of changes and I'm not." I had a little bit of costume envy.'

Strangely, the actress was initially excited about wearing a corset for the drama. 'I hadn't done a period drama where I needed to wear a corset, so the idea of that was so exciting. Within an hour of wearing it I was thinking, "Well, this is uncomfortable! I'm not enjoying this any more. I can't sit down, I can't slouch, I can't lie down."

'It was very restrictive, but for the character it was great, because you immediately get a sense of being held, and being slightly repressed and not so free with everything, with your demeanour, your manner and how you speak. It has a bearing on every aspect of how you hold yourself.

'It does change your shape as well. You get out of it and for several hours afterwards you have an amazing hourglass figure, then you slowly mulch back into your 2014 shape!'

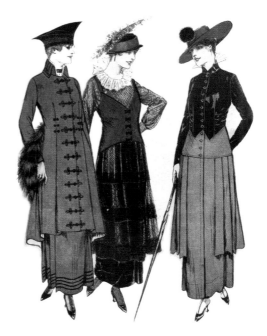

As well as the wool dress and corset, the short-haired actress has to contend with a heavy wig throughout the hot summer shoot.

'The Mardle wig is now a staple in the hair and make-up department,' she laughs. 'It goes away in its box every winter and comes out again every summer. In the first week or two of the series, because we're moving five years on each time, the hairstyle changes. So for a little while, they're fiddling and honing it, but once they've got it down, I can be in hair and make-up for just an hour – which is not bad.'

As Andrew Davies previously mentioned, the character of Miss Mardle was originally created as a much older, larger lady who ruled the department with a rod of iron and whose life away from the store was left untouched. But after he wrote in the affair with Mr Grove, and knocked a few years off her age, Amanda was cast.

'She was very different, originally, to how they saw her finally,' she says. 'But when I read the script, Miss Mardle stood out for me. I loved that character. Still waters run deep, and she's quite a passionate woman underneath that very austere veneer.'

At the end of series one, however, Mr Grove broke her heart when, soon after the death of his wife, he announced his engagement to staff member Doris.

'Mr Grove did the worst thing he could possibly do, which is go off with a younger woman who is also one of her shop girls,' says Amanda. 'It's a double blow. She was already feeling vulnerable about how old she is and how she's missed her calling for children, and he tells her, "I realised I was going to end up dying alone." But that's exactly what's going to happen to her.'

After the death of her brother, however, she is left with a large house and an independent income in series two – as well as a young admirer in Belgian refugee Florian.

'You see her beginning to blossom, and she starts to turn heads throughout the series,' explains Amanda. 'She starts to add touches. She adds little earrings, she makes more of an effort with herself because she realises she's getting a bit of attention, and of course Mr Grove hates that and gets very jealous.'

It also meant that Amanda finally got out of the black dress, as more scenes were set in the character's home and private life. 'She had a fantastic dress when she went to the music hall night. It was most beautiful beaded dress, with a lovely green underlay, so that was very exciting.'

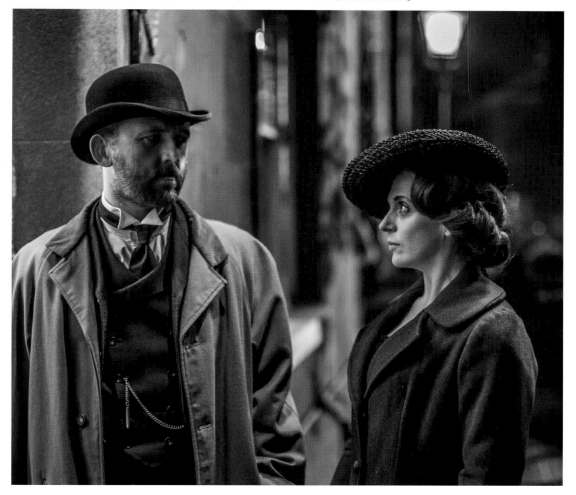

'Mr Grove did the worst thing
he could possibly do, which is go
off with a younger woman who
is also one of her shop girls.'

AMANDA ABBINGTON,
Miss Mardle

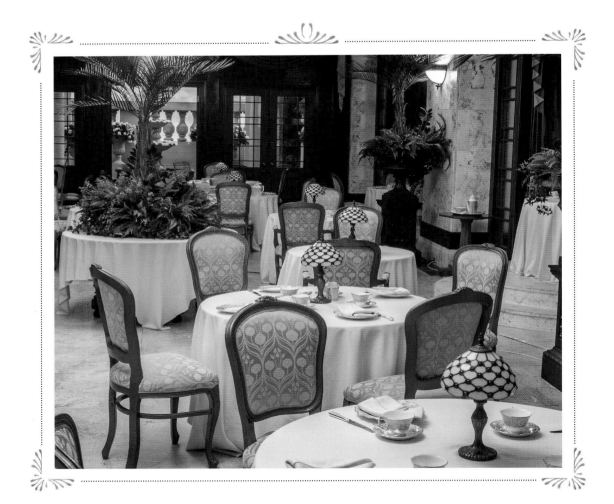

THE PALM COURT

THE PALM COURT

One of the biggest innovations that Harry Selfridge brought to shopping was the in-store restaurant. Today, cafés, coffee shops and eateries grace the floors of every department store and large supermarket in the UK but in 1909, the Palm Court was the first of its kind.

There, the ladies who lunched could enjoy a three-course meal while the house band played the latest dance numbers, or a bored husband could treat himself to afternoon tea while his wife perused the wares. There was even a smoking room – for the male customers only, of course – so that they could enjoy a post-prandial cigar in peace.

As a much-frequented area of the store – and the venue for much of the entertainment laid on by Harry – the Palm Court was built as a permanent set at the north London studio. The marble room with dark wood doors was beautifully furnished with small round tables covered in starched white cloths, surrounded by blue velvet chairs. At one end, framed with mosaic stained glass, stood a stage. It was in this room that a controversial séance upset Mr Grove, that Lady Mae fired up the suffragette cause and that Agnes first danced with Victor.

In series two, the restaurant was moved to the roof and gained a set of French doors at the back, behind the stage. The blue carpet switched to red and the blue chairs were replaced with cream and gold.

'I put a garden outside the Palm Court and some glass doors that hadn't been there before,' explains set designer Sonja Klaus. 'I opened it up, added some booths and changed the colour scheme.'

The double doors at the back meant that the lighting crew could simulate daylight pouring

through the glass, to make a brighter set. 'The back of the set opens on to a match of the Selfridges rooftop,' says art director Nic Pallace. 'We copied the balustrade, so if you are on Oxford Street now and you look up, you'll see the same balustrade on the store. That made the Palm Court look fantastically light, because daylight was flooding in from the back of the set.'

Another addition was the cascading stone fountain, seen through the doors behind the stage. On closer inspection, however, the 'water' turns out to be cleverly crafted twists of cling film. 'When real water runs over the top of the cling film and then into the mats of the fountain, it dampens the sound. The noise of a fountain drives the sound department potty, so we had to devise a method whereby the fountain is only switched on when it can't be heard. For continuity, the cling film is positioned where the water actually falls, so you never lose the look of running water. It's an old props trick.'

Inside, the vintage look is completed by beautiful dinner services from Royal Crown Derby, Waterford Crystal glasses and cutlery from Arthur Price – as used on the *Titanic* in 1912.

PALM COURT
RESTAURANT

SECRETS OF THE PALM COURT

Ruinart, a champagne house established in an old abbey in 1729, provided various intriguingly shaped bottles for the set, and guests are regularly seen sipping the expensive bubbly. But according to Trystan Gravelle, who plays suave Palm Court manager Victor Colleano, the reality on set is a little less refined.

'There's a lot of ginger ale drunk, as it looks like champagne, so there's a lot of belching,' he laughs. 'If we're pouring wine, it's actually grape juice and that's the worst for me, because it's lovely – it's too good. When you drink that and you have to do a few takes, you're back and forth to the toilet for the rest of the day. It triggers something off. You lose me every quarter of an hour!'

For Trystan, the tastiest scenes are the ones where afternoon tea is served, and there's no trickery there.

'The buns and sandwiches are real, so we get a treat when there's afternoon tea in the scene,' he admits. 'The chocolates are incredible, beautiful Belgian chocolates. The tea and coffee are kept hot in flasks and they have kettles there to make it fresh, so it's very rare that you take a mouthful of cold tea and have to spit it out again.'

THE PALM COURT MENU

Although considered an elegant place to take luncheon, the store's restaurant was in fact not too prohibitively priced. A middle-income professional, for example, might choose a set menu of three courses for five shillings – approximately £20 in today's money – while the more extravagant tastes could be catered for by the à la carte fare.

The art department carefully recreated the stylish menus for the set, choosing popular dishes of the day such a Printanière (a thin soup made from seasonal vegetables) and Russian salad, as well as a huge range of cakes and sandwiches for afternoon tea.

For afternoon tea at the Palm Court, customers could choose a tasty bun for as little as 1d – about 33p today – or ice-cream for 3d (99p).

On the following pages is the set menu for lunch, as served by Victor and his team in the show, and a selection of the cakes and hot drinks offered on the Palm Court tea menu.

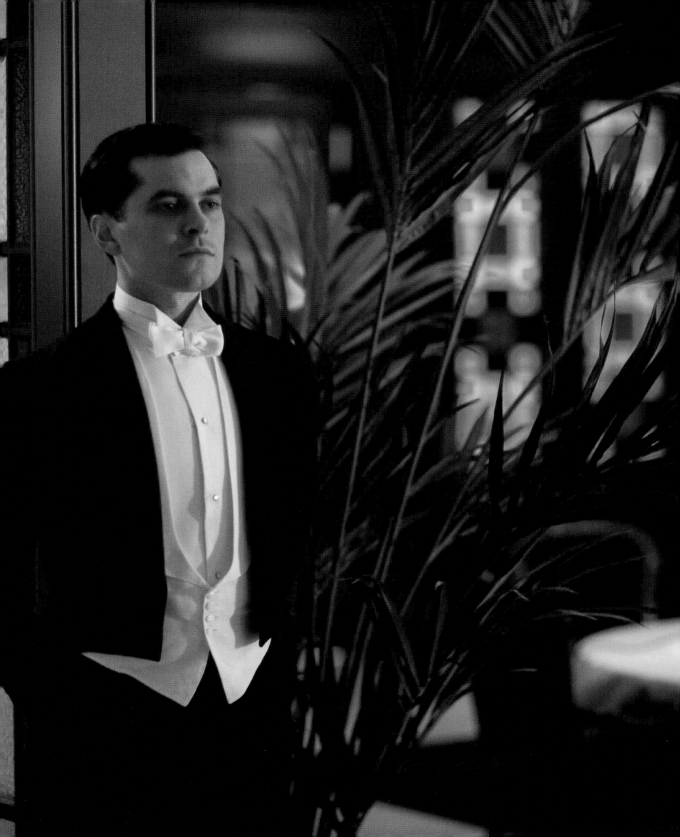

PALM COURT
RESTAURANT

STARTER
Celery consommé – Printanière

MAIN COURSE
Roast rib of prime beef,
roast potatoes, green beans
and carrots
or
Fried haddock with tartare
sauce, beans and chips

DESSERT
Baked custard pudding,
French cream sauce
or
Chocolate ice cream
or
Fruit and cheese

COFFEE

PALM COURT
RESTAURANT
A la Carte

STARTERS
Celery consommé – Printanière
Olives, cold slaw, stuffed peppers, radishes

FISH AND POULTRY
Fried perch – Tartes sauce
Potatoes – julienne
Boiled capon – oyster sauce

MAIN COURSE
Roast rib of prime beef
Roast pork – apple sauce

Roast lamb – mint sauce
Game pie – hunter's style
Tenderloin of beef – Muscovienne
Lobster of fruit – au confiture

VEGETABLES
Russian salad – mayonnaise
Boiled mashed potatoes, baked sweet potatoes, stewed corn
Spaghetti au gratin, lima beans, asparagus tips

DESSERT
Baked custard pudding – French cream sauce
Green apple pie, lemon pie
Duchess cake, ginger cakes, lady fingers
Compote of peaches, whipped cream

FRUIT AND CHEESES
Apples, grapes, bananas, mixed nuts
Layer raisins, Cheddar, Roquefort and dairy cheese
Water crackers
Chocolate ice cream

RUSSIAN SALAD

A popular dish on Edwardian menus,
Russian salad was invented by Belgian chef
Lucien Olivier at one of Moscow's finest
restaurants, the Hermitage, in the 1860s.
Originally, the salad contained veal tongue, caviar,
lettuce, crayfish tails, capers, smoked duck and
grouse, although the exact ingredients of the
dressing was a closely guarded secret. At the turn
of the twentieth century, Olivier's sous-chef, Ivan
Ivanoff, snuck into the private kitchen where
Olivier prepared it, worked out the recipe and took
it to a rival restaurant, calling it Capital Salad,
as well as selling it to several publishers around
the world. Those who tasted both, however,
claimed Ivanoff's salad was inferior, suggesting
he had not surmised the ingredients correctly.

Inevitably, as the salad became globally popular,
ingredients were often substituted for cheaper
or more seasonally available alternatives,
and the mystery dressing was usually replaced
with fresh mayonnaise.

SELFRIDGE
& Cº LᵀᴰD

AFTERNOON TEA

TEA SPECIALITIES

Rock buns, madeleine cakes, Congreen tarts, jam tarts,
shortbreads, sponge sandwiches, raspberry buns,
Edinburgh scones, ginger cakes and strawberry biscuits
Each 1d

BUNS

Scone (half) .. … … … … … … … … … … … … … … … …1d
Standard rolls .. … … … … … … … … … … … … … …1d
Bun toasted with butter .. … … … … … … … … … …2d
Edinburgh scones … … … … … … … … … … … … …2d
Sultana tea cake… … … … … … … … … … … … … … …1d

ICES

Strawberry or vanilla .. … … … … … … … … … … … …3d & 6d
Iced meringue… … … … … … … … … … … … … … … …3d

BEVERAGES

Tea (the most perfect the world produces) freshly … … … … …3d
Made for each person per cup . … … … … … … … … … … … …2d
Per pot per person
China … … … … … … … … … … … … … … … … … …2d
Coffee … … … … … … … … … … … … … … … … … …2d
Coffee (iced).. … … … … … … … … … … … … … … …3d
Palm Court chocolate (speciality)… … … … … … … … …3d
Cocoa … … … … … … … … … … … … … … … … … …3d
Milk… … … … … … … … … … … … … … … … … … …3d
Hot milk per glass … … … … … … … … … … … … …2d
Bovril with biscuits . … … … … … … … … … … … … …3d
Bovril (iced) with soda. … … … … … … … … … … … …3d
Egg and milk … … … … … … … … … … … … … … …3d
Soda and milk .. … … … … … … … … … … … … … …2d

PALM COURT RESTAURANT

A NICE CUPPA

The Palm Court isn't the only place selling tea by the end of series two. When young Gordon moves up to the shop floor from the loading bay, Harry creates a tea emporium for his son to run. To stock the shelves, production buyer Belinda Cusmano turned to Mariage Frères, a French boutique tea company whose only UK outlet, coincidentally, is in the basement of Selfridges.

'They have absolutely gorgeous teas,' says Belinda. 'They gave us all the tea canisters used on the shelves and let us use all their graphics. We also took inspiration from their current tea shop displays, which have a very period feel about them anyway, so that was quite an important part of the new set.'

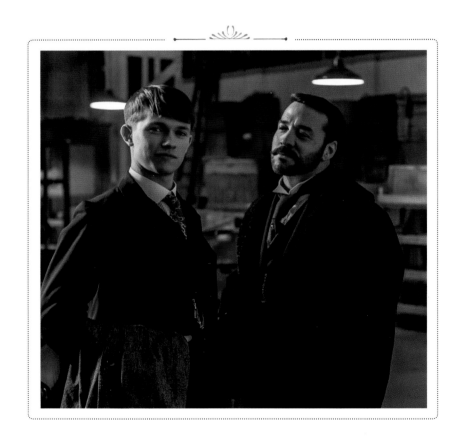

CHOCOLATE TREAT

'One of the really important scenes in episode two
of series one is a charity fundraiser which involves
a lot of chocolate,' recalls Belinda Cusmano. 'The
script mentions Neuhaus, a famous Belgian chocolatier
established in 1857, and the son of founder Jean
Neuhaus comes to Selfridges to do a demonstration.
He makes chocolate roses, and offers one to Rose.

'We had 2,500 chocolates arrive from Belgium
and I literally hand-selected fifty different designs
that I thought looked like chocolate that would have
been produced then. I researched the original Ballotin
box, and we had ribbons designed, which said
"Belgian Relief Fund", to put round the boxes
to make it authentic.'

For actress Aisling Loftus, the arrival of the luxury
chocs – which retail at £40 for a 500g box – left a bitter
taste. 'That was one day when Agnes wasn't in a scene,'
she laughs. 'I'm gutted because I'm pretty sure that most
of the chocolates, if not all of them, disappeared home
with people by the end of the day.'

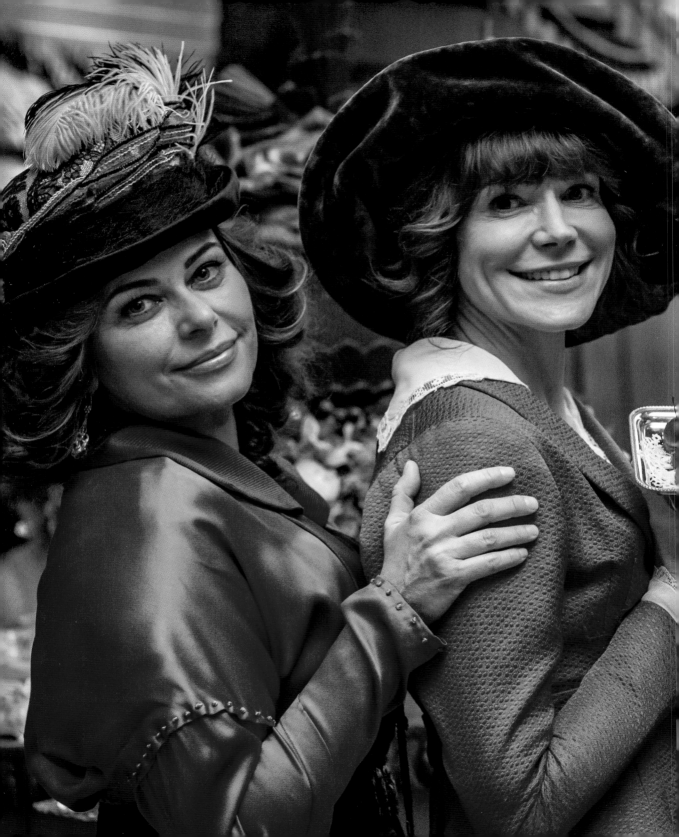

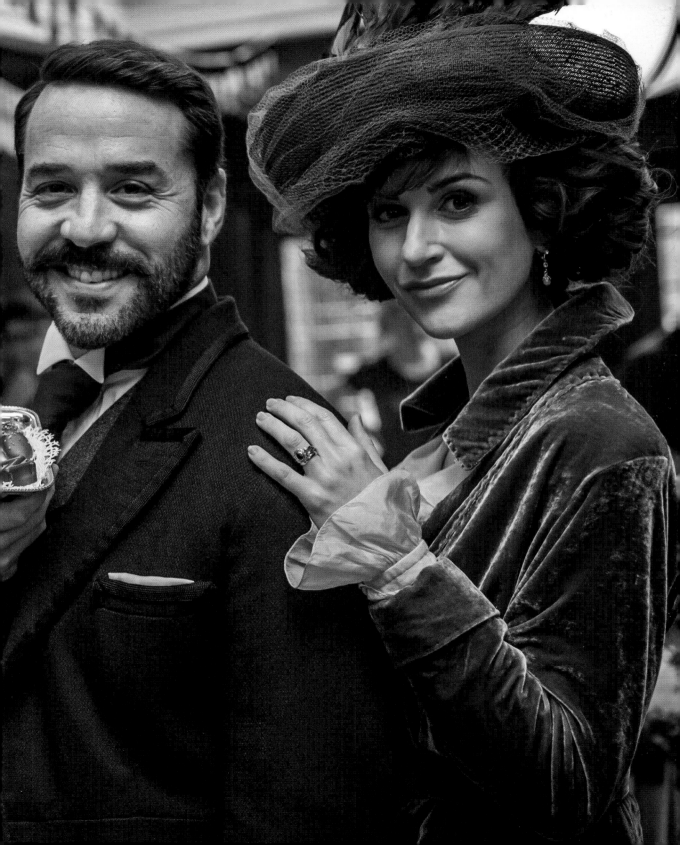

VICTOR COLLEANO

PLAYED BY TRYSTAN GRAVELLE

As Palm Court manager, Victor Colleano is the
perfect host, sailing through the restaurant with
a charming smile and keeping his customers –
especially the female ones – happy at all times. But,
behind the scenes, things don't always go so smoothly.

'My crowning moment of glory, in series one,
was when I had to pour tea into a glass and look
Lady Mae in the eye at the same time,' Trystan
Gravelle recalls. 'As I poured, I had to bring the
pot up really high. So I looked into her eyes, raised
the pot really high, with the tea pouring out of the
spout into the glass, and I was thinking, "That's
right. I'm a smooth operator." It went everywhere!

'We had to swap tables and get a clean tablecloth,
because there was tea all over the place and
I'd stained it for good. Katherine Kelly managed
to escape the deluge and she did well, holding
her grin and her composure throughout.'

All the actors playing serving staff, both in the
restaurant and in the grand houses of the series,
were given lessons in silver service. 'They showed
us how to serve people and there was a lot of
etiquette to learn,' says Trystan. 'They seem like
small things, but if that is your job and you pride
yourself on doing it right, one little error is huge.

'Having had the butlering classes, charging the
white wine glass with red wine or serving at the wrong
side felt like the biggest mistake in the world. Nobody
is likely to notice, but to you it's like life and death.

'I've messed up a couple of times when I'm holding
a tray, especially in the first couple of episodes, when
there was a bit of excitement and nervousness.'

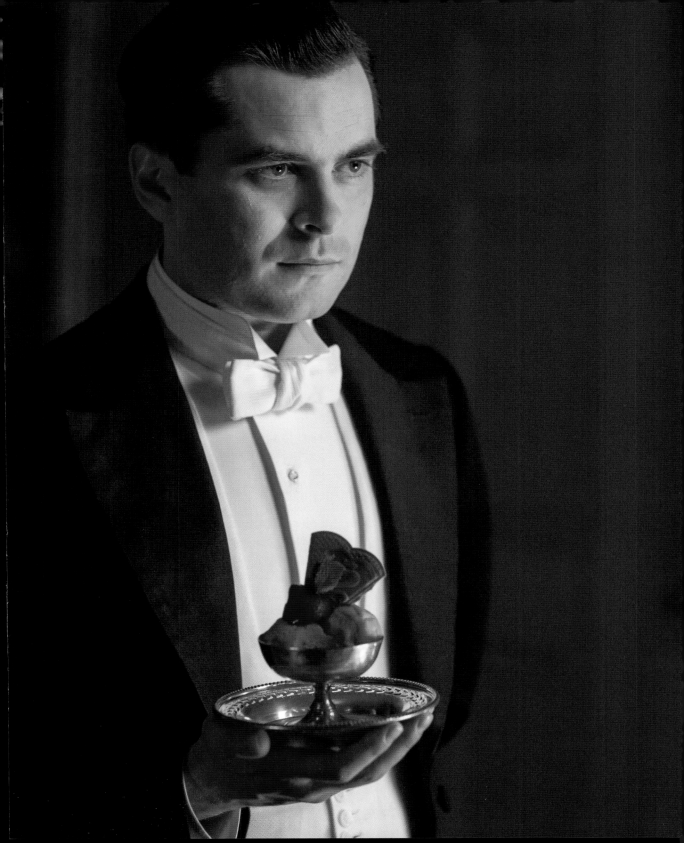

In real life, the Llanelli-born actor has a strong Welsh burr, but putting on a London accent to play the ambitious working-class lad from Italy via the East End came easily enough – thanks to his family background.

'My stepdad is from Lewisham and by the time I started filming I'd lived in London for twelve years, so I had a little bit of a head start. Victor has aspirations to better himself, so I had to tone it down because he doesn't want anybody to know he's a bit of a wide boy. My step-grandfather was a bit of a "Gordon Bennett" cockney, so I thought about how he used to speak when he wanted to impress people and was trying to sound posher, and that was Victor's accent.'

In series one, Victor was taken on as a waiter in the restaurant, proving a big hit with the wealthy female customers – especially Lady Mae.

'He got led astray by the older women who were coming into the restaurant, and he played the game,' says Trystan. 'He didn't really want to, but he did, and maybe that was a chink in the armour. Ultimately, he's from the wrong side of the tracks, but he is a good man.'

His desire to make something out of his life and his subsequent entanglement with the likes of Lady Loxley is understandable, believes Trystan, given his character's modest background. 'He's come from a tough upbringing, as I'm sure was the case back then for anybody who came from a different country to better themselves,' he explains. 'It's always tough getting started and you have to deal with prejudice. I can understand why he'd want to better himself and put on show, and he can be a bit cocky, and all of that is born out of fear. But he does have his principles, and his morals, and he will stand up for what is right.'

In series two, he rose through the ranks as both manager of the Palm Court and the owner of his own restaurant – left to him by his Uncle Gio. He also popped the question to the love of his life, Agnes.

'We saw a lot more of his family life, with his cousins, family, friends and his Uncle Gio. It's nice to see these people in their spare time because you see a lot of them done up like poodles in the shop window, and you can make up your mind about them a little bit more if you see them at home, and understand what they had to contend with in that era.'

TRYSTAN
GRAVELLE
Victor Colleano

*' Ultimately,
Victor is from
the wrong side
of the tracks, but
he is a good man. '*

Although desperate to settle down with Agnes, Victor battled conflicting emotions about staying behind to run Gio's business while the rest of the male staff fought in the Great War.

'He was about to join up, he was about to sign on the dotted line, when somebody came to tell him his uncle was on his deathbed,' says Trystan. 'He gets a bit of flak for that but he also questions his own masculinity, and paranoia descends on him because he worries people think he's a coward. There was a lot of pressure back then for men to keep a brave face on everything and not lose it, however bad it gets, so although all this is bubbling up inside, he always tries to keep a calm, cool exterior and plays the ice man.'

Trystan landed the role of the suave Italian after meeting with producer Chrissy Skins and director Jon Jones on the first series. But he admits that he wasn't in the best frame of mind for the audition, thanks to a sartorial disaster. 'I didn't get much sleep the night before because the clothes that I wanted to wear had shrunk in the wash!' he laughs. 'My flatmate put my trousers in the tumble-dryer and ruined them, and I had nothing to wear, so I didn't have a relaxed night before the big day.'

The tight trousers might have been preparation for the next six months, as Trystan found Victor's wardrobe to be less than comfortable. 'The outfits are all fantastic,' he reveals. 'But for me, day in, day out, wearing them is a nightmare on the neck because the collars are stiffly starched. They either choke you or rub you until you have a bit of a hangman mark round the neck.

'I think I was a bit of a pain for the first month, because I kept coming in saying, "I can't breathe in this. How can I say my lines if I can't breathe?" I was being a bit of a diva, but you quickly get used to that sort of thing.

'The problem is that the more they send them away to be washed and starched again, the tighter they get. The trick is to lie about your size!'

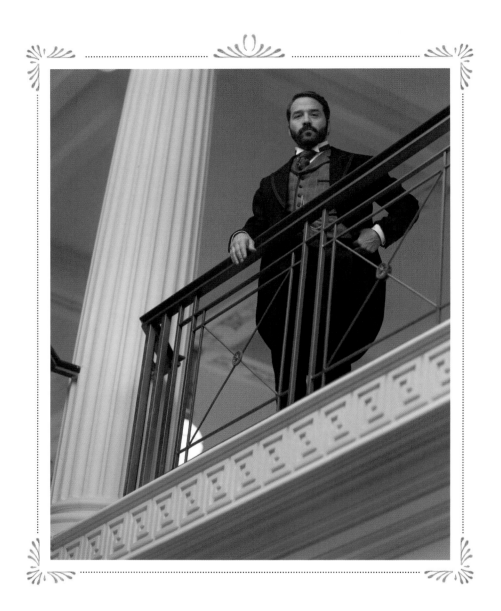

SELFRIDGES REBORN

On an industrial estate in north-west London, nestled between DIY superstores, garages and car washes, stands a disused carpet warehouse. The unassuming exterior and run-down surroundings are a far cry from the gleaming white stone and marble of Selfridge & Co. Step inside, however, and you are instantly transported 100 years back to the early days of the famous flagship store.

Marble floors stretch as far as the eye can see, punctuated by great stone pillars, stained glass panels and deep red carpets, signalling the walkways for well-to-do customers. A sweeping marble staircase leads up to the stone balustrade of the mezzanine floor, below which the huge wooden lift doors dominate the wall.

Glass cabinets crammed with period products, from perfumes to pottery, fill the floor and, behind the counters, beautiful dark wood cabinets with hundreds of drawers promise more exquisite goods to be perused by eager shoppers. Mannequins dressed in luxurious finery and displays of beautiful silk shoes are dotted throughout the fashion department and stunning china and silverware are found in taller display cabinets in another part of the store.

The overwhelming feeling is one of space – a vast shopping empire where an Edwardian lady of leisure could happily spend a few hours, and a great deal of her husband's money, while moving from one department to another. Tom Goodman-Hill, who plays Mr Grove, remembers his first time on set with a sense of awe.

'I was utterly staggered,' he admits. 'Amanda Abbington and I were the last to be cast so we were

Modern-day cables weave in and out of the antique frocks on a day of shooting in north-west London.

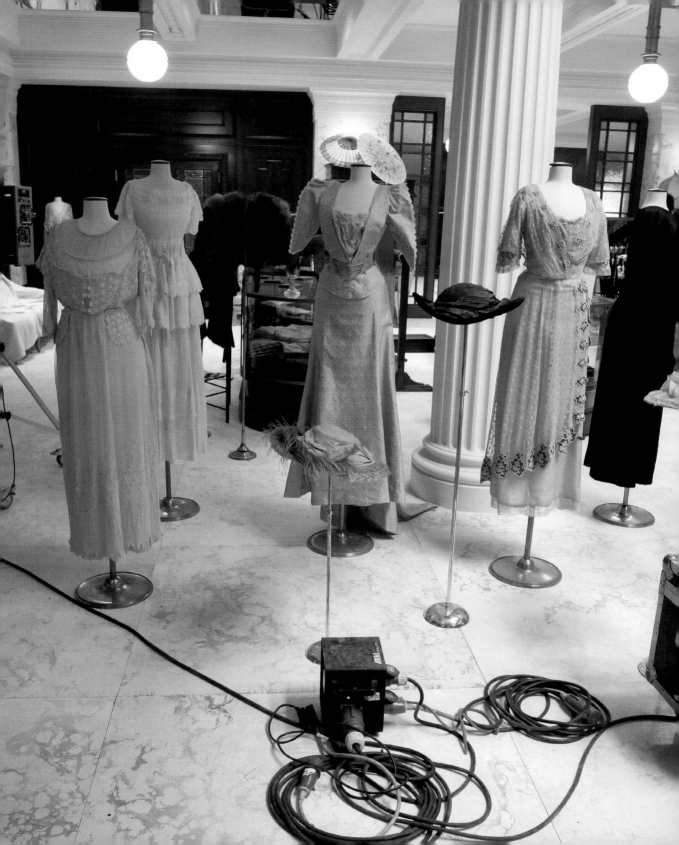

the last to be walked around before filming began. It was only three-quarters built but, even so, the jaws dropped. I certainly wasn't expecting what we saw. I thought we would find corners of rooms and parts of the store, so that you would move around to make it look real, like most TV sets, but there was this huge store inside the warehouse and I have never seen a set so staggeringly built or so huge. You can walk for a full minute and never break the spell.'

Samuel West, who plays journalist Frank Edwards, was equally impressed.

'I was delighted with it,' he says. 'When you tell people it's shot in an abandoned warehouse in north-west London, you're partly sending up the glamour of television filming but, actually, the great thing about that wonderful space is that it's so large. Everybody is used to small areas of a set being believable, but you're also used to that idea that if you walk round the corner you're going to see the paint and the plaster and the lino and cables. The great thing about this set is that it doesn't end for ages. You just walk and walk, and you're still in the shop. For the first shot of the second series, which pans along the whole width of the ground floor, director Anthony

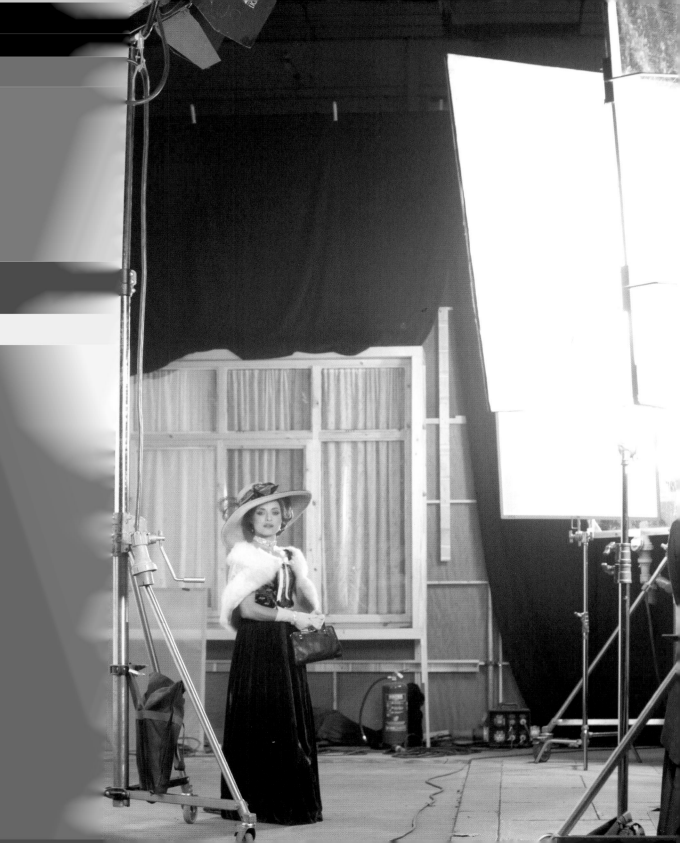

Byrne could just send the camera great distances and never run out of set. Kitty and I can have a long conversation walking past five counters, and we still haven't run out of set. And it's been beautifully designed so I think they've done a remarkable job – twice.'

The huge lifts are exact replicas of the ones Harry had custom-made in 1909 and were built from scratch on set.

BUILDING BIG

While Harry Selfridge spent three years perfecting his West End behemoth, production designer Rob Harris had just twelve weeks to recreate the store. The first port of call was Selfridges itself, where he studied pictures in the archives and looked at the building's original features, hidden behind the modern-day shop fittings. Then he set about building the interiors in the warehouse.

'You can't build the whole store, which is spread over six floors, so you have to distil it down to the story you want,' he reveals. 'We built the ground floor, a bit of the fourth floor, the second floor and they were then redressed and changed to become different departments, adapting the space we had in the warehouse.

'We were starting from nothing and building a place that people still go to and will recognise. At the same time we had to create our own world around the script. The hardest part is getting an overall view of it and making it as big as possible in a smaller space, because it was a huge store.'

To get the authentic feel, Rob's team of carpenters, metal workers and expert set builders built all the architectural features themselves. 'The size of the team varies but we start off with a huge number of people because it's always down to the wire,' he explains. 'We had a maximum of about ninety people working while we did the initial rush, and then it comes down to the more skilled elements.'

The huge lifts – exact replicas of the ones Harry had custom-made in 1909 – were built from scratch, the staircase constructed and the metal handrails crafted on site, while the ionic columns were built from MDF. For the hundreds of metres of marble flooring, Rob employed a technique familiar to most high-school art students. 'We first find out what sort of marble it is, what date it would have been produced, and then we make a huge bath with a combination of warm water and oil paints, which float on the top, and we add the MDF. When you whisk it out it looks like marble. We used a huge amount of marbled MDF – on all the floors and all the walls.'

SHOP PROPS

While the set was being built, a props team was busy scouring the country for period fixtures and fittings. As it is a long-running series, filmed over six months, many of the props would be more expensive to hire than buy so the team set about searching online and at auctions and sales for mannequins, shoe racks and turn-of-the-century light fittings. One of the most important additions to the shop floor were the counters, but the quantity needed for such an expansive space meant that originals were hard to come by.

'You can't source them because we needed such a huge run of identical counters,' says Rob. 'You have to strike lucky with shops closing and selling them off, and we managed to buy ten of the larger display counters. All the smaller counters, which formed the basis of the shop floor, we made by hand.

'They were metal frames with toughened glass. We had a construction team on the set all the time, which did all the woodwork, and we outsourced the metalwork.'

For series two, the store was given a revamp by a new team of designers, as art director Nic Pallace explains.

'We inherited a bit of a blank canvas really,' he says. 'The set had been stripped back to the basic raw spec after series one, so when we walked in in January last year it was a cold warehouse with a bit of blank scenery, and that was it. It's great from a design point of view because it allows you to put your own mark on it.'

The structure of the store set stayed largely the same but, as the story had moved on by five years, set designer Sonja Klaus introduced some updates.

'In 1914, they liked to think they were quite progressive,' she says. 'Aeroplanes had begun to be thought about in a big way, and motorcars were becoming common, so the world was changing. I think it's very important when you are doing a show like this – particularly about someone like Mr Selfridge, who loved to keep up with the changes going on in the world – that you're reflecting that in the programme.'

For Sonja, it was important that the huge expanse of the ground floor was captured on camera. Like Rob, she visited the Oxford Street store to get a sense of the real thing.

'I walked around to try and get the feeling of the scale,' she recalls. 'That shop is massive, and the perfumery is huge. We only had half

NIC PALLACE
Art Director

'*When we walked on to the set last January, it was a cold warehouse with a bit of blank scenery.*'

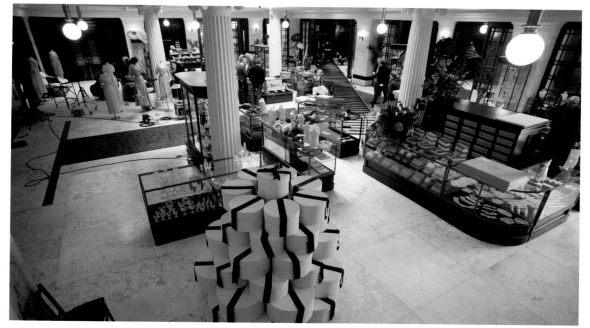

the size of that, but the ceiling height and the proportions were there. I asked that nothing else be put on the ground floor, because when you walked in the door all you would have seen was the perfumery department.

'At first, people were saying, "But where is the accessories department?" The truth is accessories would have been on the other side of the store, miles from the start of perfumes, because the store is so huge.'

In the main store, Sonja updated the display cabinets with a bit of crafty recycling. 'The glass cabinets had been made along with some other fixtures and fittings, so we chopped them into bits to reshape them or added to them. For example, for the display for Mariage Frères, the tea company, I made new pediments on the top. I also took some old shelving units and cut them up, repainted them and made them into something else.'

Sonja also added light to the set with a few minor changes.

'Lighting is very key to a set,' she says. 'So we put some beautiful Tiffany-style lamps on the counters, with little crystal drops on them, and added quite a lot of globe lighting on the ceiling.'

Production buyer Belinda Cusmano sourced many of the products put on sale on the shop floor, and says the established store had more of a heartbeat than the newly opened 1909 version.

'Because the series jumps to 1914 for series two, the Selfridge store is flourishing, but it has the shadow of the First World War hanging over it.

'The store now has a lot more hustle and bustle, it's a lot busier, there's a stronger customer presence so all the set dressings need to reflect that.'

The answer was to source more of everything so that the counters looked busier and the displays more sumptuous. As well as hundreds of perfume bottles, cosmetic cases, gloves and handkerchiefs, Belinda borrowed thousands of pounds' worth of china, silverware and luggage.

'On the mezzanine level we have a china department and Royal Crown Derby fine china is displayed throughout, along with some Waterford Crystal. The china is ridiculously expensive. To give you an idea, one of the dinner plates costs £250.

'Luckily there weren't any breakages that I'm aware of, which is pretty remarkable considering they let us have them all for six months.'

In the luggage department, row upon row of Globetrotter leather suitcases were lined up. 'They've been making exquisite handmade suitcases since 1897, and they made the same designs in 1912 as they do now. They also have a really cool poster with an elephant standing on a suitcase, which they let us use.'

Katherine Kelly, the actress behind the store's most valued customer Lady Mae Loxley, was blown away by the results.

'The stunning set is what makes the show,' she says. 'It's so opulent, no expense spared, and that was definitely Harry's sort of mantra, so it's the one show they couldn't really scrimp on. The shop floor is a joyful place to be. It's always wonderful to be surrounded by nice things when you're filming.'

Amanda Abbington, *Mr Selfridge*'s Miss Mardle, also has nothing but praise for the set dressers and prop buyers. 'It is fantastic. You're on that set for eight hours and you forget you are in a warehouse in 2014,' she says. 'You feel like you have gone back in time, because the attention to detail is so meticulous. The props department have done an amazing job with all the accessories.'

MR GROVE

PLAYED BY TOM GOODMAN-HILL

Along the corridor from Mr Selfridge's bright palatial office, Mr Grove sits in his small, dark room, surrounded by piles of paper and tottering files, next door to the similar surroundings inhabited by Mr Crabb. But actor Tom Goodman-Hill reveals the two offices are closer than you might imagine.

'Whenever either of us has a scene, the same set is dressed and redressed to make it into his office or mine,' he says. 'In series two, Ron Cook and I shared a lot of scenes together and it became a running joke that, at the start of the scene, one or the other of us would say, "Get out of my office!"'

Tom landed the role of the store's chief of staff with no time to spare, and admits he knew little about London in the early twentieth century. 'I had never been in anything that was turn of the century and I didn't know anything about Mr Selfridge,' he says. 'I found out I had the part just before I went on holiday and would be starting shooting as soon as I got back, so I read Lindy's book on holiday and then used the scripts and storylines to find the character of Mr Grove.

'The story of Mr Selfridge himself was all news to me. I didn't even know he was American and had no idea he was such an immensely colourful character. Part of finding the character of Grove was to decide which aspects of Harry he would approve of and which he wouldn't, but we decided that deep down he hero-worships Harry.

'Luckily Mr Grove is almost entirely fictional, although he is nominally based on Percy Best, the head of staff at the time. But I'm sure his private life wasn't as colourful as Mr Grove's.'

'This ship needs a captain. I am that man.'

MR GROVE, AS HARRY RECOVERS FROM A CAR CRASH, *MR SELFRIDGE*

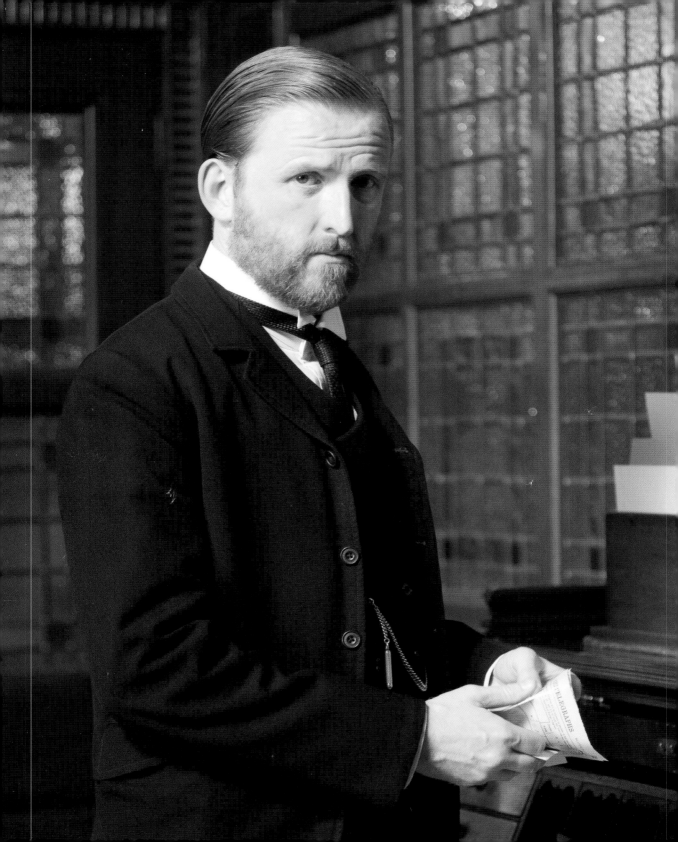

Indeed, the seemingly upright manager spends series one enjoying steamy liaisons with Miss Mardle, as his invalid wife lies at home. When his wife finally passes away, he cruelly casts his lover aside in favour of her younger assistant, Doris, citing the need to have a family – a bitter blow to Josie Mardle.

'Miss Mardle is the love of his life, there's no question of that,' explains Tom. 'I think the reasons he gave her for the engagement to Doris are entirely genuine. His desire to have children of his own drove him to marry another woman because, after Hettie's death, he realised that he and Josie Mardle were too old, and that brought things to a head.

'He was a cad towards Miss Mardle, but he does love her. It's just that his desire to have a son, to have a family, overrides his feelings for her.'

It's a case of being careful what you wish for, as Roger's house is soon overrun with little ones and he struggles to reconcile his decision. Meanwhile, Miss Mardle is moving on, finding romance with a handsome Belgian refugee – and Mr Grove has to deal with his resulting jealousy.

'There's no question he regrets his choices in series two,' reflects Tom. 'He is married to Doris, they have downsized to cope with the financial pressure of a family and because he didn't want Doris to have to live in his marital home, and she keeps popping out children. So he is living in a townhouse and finding family life extremely difficult. He's also struggling to cope with the pressure of work, even though he lives to work. Added to that, he is having to put on a brave face in front of Miss Mardle.

'They have to find a way to co-exist which means that Miss Mardle must find a way to forgive him and he must find a way to let her go. They have to put aside the enmity and hurt of the past and become friends again.'

The advent of war adds to Mr Grove's angst, as he sees younger men enlisting to fight for their country.

'Being a man of a certain age, he is too old to be conscripted and he finds that tough,' says Tom. 'Although he loves his work, he is finding it hard to stay in the shop, and becoming increasingly aware of his own mortality.'

As an actor, Tom admits he enjoys the period costumes and the 'dressing up' aspect of the role.

TOM
GOODMAN-HILL
Mr Grove

'*There's no question Mr Grove regrets his choices in series two.*'

'I love dressing up and the formal clothes suit me, because I'm six foot tall and stand quite straight, so I love a tailored suit and a well-made boot,' he says. 'James Keast and I wanted to reflect his character, and give him a buttoned-up greased-back look, harking back to the military past which we decided he had. But in the second series, his style changed. Being a middle-aged man married to a younger woman, and having something of a mid-life crisis, he got a lot sharper, slimmer, his beard and moustache got a bit shorter and his collars more turned down.

'His new look also reflects his hero-worship of Harry. Roger is becoming a more stylish man because he is working alongside Harry and sees the way he dresses, and Harry is the most stylish man in the room. So in series two, he begins to modernise and get more up-to-the-minute, and I much prefer the clothes he is wearing this time around.'

While Mr Grove struggles with his emotions, Tom has an on-set battle of his own.

'I have tremendous trouble putting on the ties,' he laughs. 'Every time I have to put a tie on, I have to rush to a mirror to put it on because the collar is so starched and closely fitted, it's tricky to get a tie in between.'

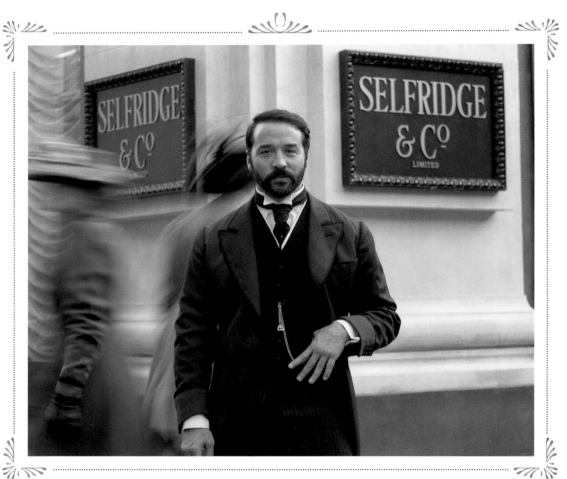

THE OUTSIDE WORLD

THE OUTSIDE WORLD

While the original Selfridges store still dominates the west end of Oxford Street, the building has evolved since its 1909 opening. Between 1924 and 1929, a huge extension, designed by Sir John Burnett, was added to the western end of the store. It has since remained fundamentally unchanged but the additional frontage, plus the modern-day bustle of London's busiest shopping street, meant it was impossible to shoot a period drama there.

'Obviously, if you are making a series about Selfridges, you need the exterior, but you can't film outside Oxford Street Selfridges because it's not the period store and it's twice the size it was in the time we're covering,' says Rob Harris, who designs the sets.

Instead, the exterior shots were moved down to the Historic Dockyards at Chatham, where the wide spaces meant the facade could be built and left up throughout the six-month filming schedule. But the imposing stone structure seen in the series is largely an illusion. The actual set is a replica of the ground floor, which stands about 15 feet high, but the rest of the building's exterior is computer generated.

After the first series, the set was demolished and, in series two, the designers started again from scratch. As Nic Pallace, art director on the second series, explains, filming somewhere nearer to their north London production base proved a non-starter. And one of the major problems was Selfridges' iconic windows, the largest of any store at the time. 'We looked at a lot of other possibilities, because Chatham is quite a long way to travel, but we soon found out why the original set builders went there in the first place,' he reveals. 'It's because of the

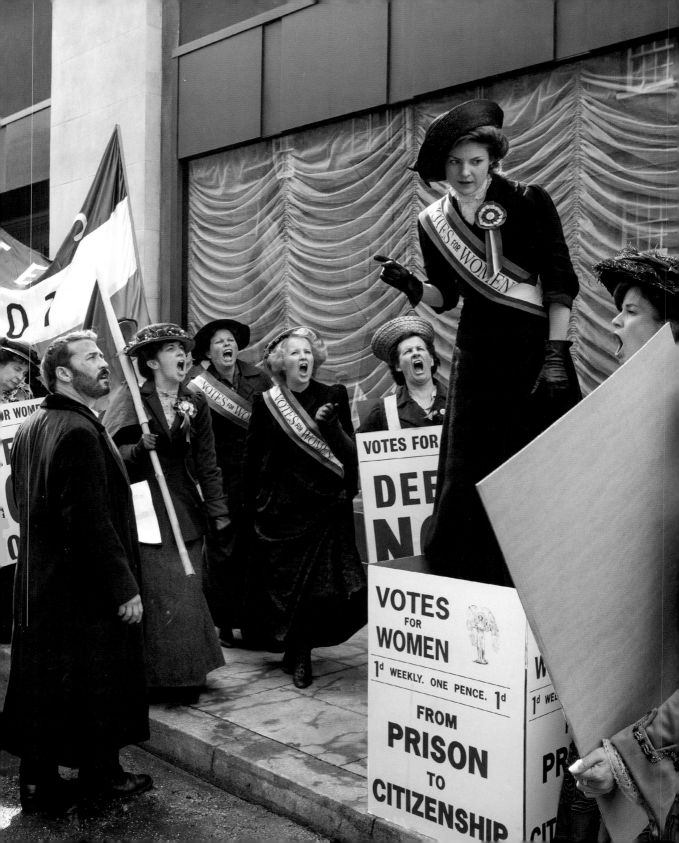

enormous glass windows, which will reflect whatever is on the other side of the road. In Chatham, we had enough space to build the other side of the street as well.

'As it's private land, we have free rein there and we can have a whole day of filming without any intrusion from outside.

'Finally, because it is a wide street, we can put a lot of our own traffic in, so we had a horse-drawn omnibus and some vintage cars to get that hugely busy feel. We can then enhance the images on the computer, so it looks even busier on the screen.'

OUT AND ABOUT

The Chatham set may solve the Oxford Street problem, but the storylines of the main characters, away from the store, meant numerous shoots at various outside locations, in and around London. For example, Whittlesey Street near Waterloo was used as the home that Mr Grove now shares with Doris; a house in Stepney Green became Miss Mardle's spacious new home; and Princelet Street, in the East End, was the site of Uncle Gio's restaurant.

But even the most authentic streets need a makeover before they can pass as pre-war London. Road signs, traffic lights, burglar alarms and even doorbells need to be covered up, along with shop signs and road markings. 'We did a lot more on location in series two. Going into London, in the middle of Mayfair, to recreate 1914 is quite a challenge,' say Nic. 'There's a lot of modern technology and street furniture to hide, modern windows and doors, and you wouldn't believe the amount of work that goes into covering all those things up.'

At Arnold Circus in Shoreditch, which doubled as the outside of the café, the set designers pulled out all the stops to turn back time. 'We had to do the whole row of shops – cover all the signage, redress all the windows, taking out what was in there and putting in period stuff. We also had to cover the actual road to hide the markings, so every time we filmed there we took a huge lorry of gravel to spread on the ground. We have a whole bag full of tricks to cover things up. Period vehicles are useful for parking in front of things, like traffic lights, but we also have quite a lot of boxes that go over the lights, and are made to look like something appropriate.

'We put fabric in the windows of shops to hide the modern stock inside and we have to paint exteriors as well.'

NIC PALLACE
Art Director

'*Going into London, in the middle of Mayfair, to recreate 1914 is quite a challenge.*'

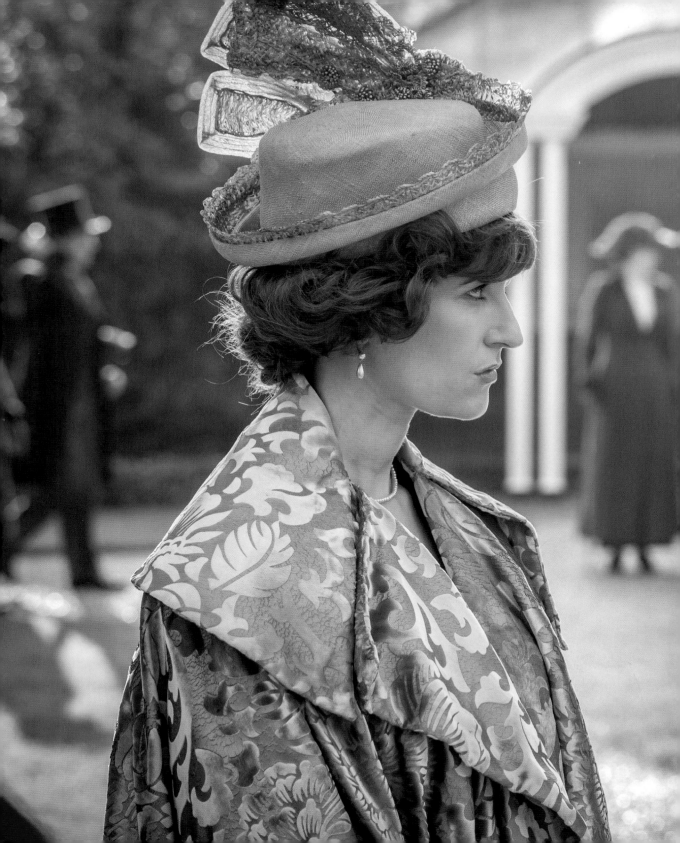

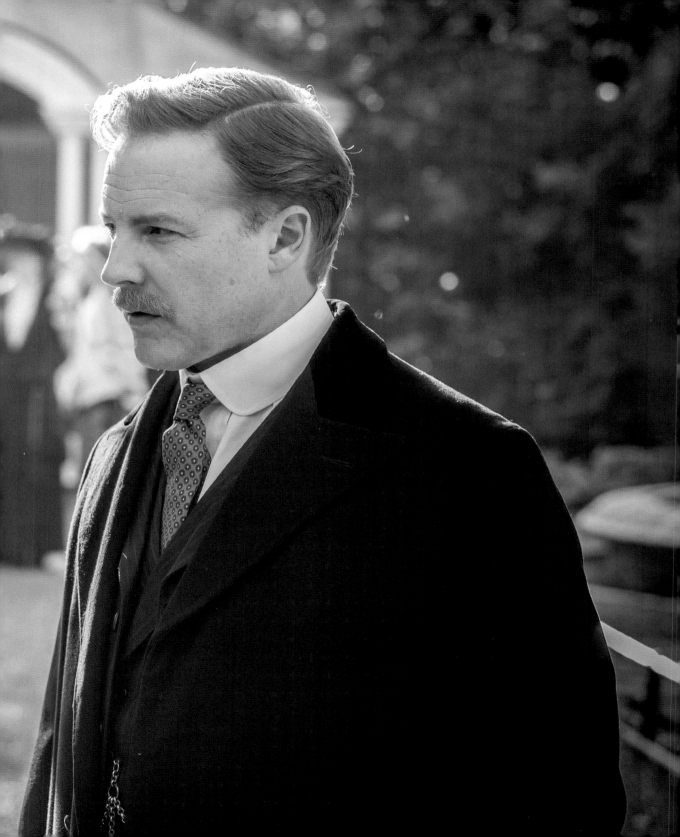

Cast member Samuel West is used to filming period dramas, but he was impressed with the location shoots on *Mr Selfridge*. 'The pleasure of being in a series that is undoubtedly successful is that they have got a bit of money to spend, so that means external period shots are quite well populated,' he reveals. 'We did an extraordinary street scene at a café at the end of the last series, which was stuffed with carriages and horses and people and costermongers. It's set dressing but it's very handsome and it makes quite a statement.'

Although shooting in the heart of London, the film crew didn't close the roads entirely – just asked for a little patience from local drivers. 'We were allowed by police to do "managed" road closures,' says Nic. 'We have a stop/go sign, like you have at road works, and we only stop cars for the duration while we complete a shot, then let them through between takes.'

Before filming in each street, of course, the location manager contacts businesses and residents to make sure they are all on board with the plans, and aware of any likely disruption. The art department can then work their magic. 'We often turn up and look at the streets, then scratch our heads a bit, and say, "How are we going to make this look like 1914?" But we have a vision of what we can do in the back of our minds and we know it's going to look good when we've finished. It's very rewarding to turn that around.'

NIC PALLACE
Art Director

'*We have a vision of what we can do in the back of our minds and we know it's going to look good when we've finished. It's very rewarding to turn that around.*'

Some of the outdoor scenes required less tinkering to turn back time. Samuel West, whose character Frank Edwards treats Kitty to romantic dates in Regent's Park, reveals the setting is almost unchanged in the last century. 'There were a few jolly picnics in the park with Kitty, in true London fashion, under grey skies,' he laughs. 'If you shoot towards the terraces in Regent's Park, or just towards the trees, and make sure you don't get any modern bins, then you get a couple of well-dressed extras with a dog – it's remarkable how quickly you go back 100 years. It's rather beautiful.'

UNCLE GIO'S RESTAURANT

The scenes both in and outside the restaurant, left to Victor on the death of his uncle, were shot in Princelet Street, just off Brick Lane, in the East End. As a protected street, many of the features are perfect for period drama, but there is still a lot of disguising to be done.

'Forty per cent of the street is fine, but then you get brand-new front doors with brand-new door furniture on, which is just not going to work, so we use "plugs". These are very, very thin fake doors and windows, which we wedge in front of the real ones on the day of filming and are easily removed afterwards. We also made fibre-glass lamp posts of that period.

'The interior we cleared and re-dressed with period furniture and props to create the Italian restaurant.'

MISS MARDLE'S HOUSE

In the first series, the head of accessories lived in a modest flat where she shared weekly liaisons with Mr Grove, the love of her life. These scenes were filmed in a house in west London, as Rob Harris explains. 'There weren't enough scenes to justify building a set, and we had to do other scenes on the same day, so we filmed in a large house which we used for several different sets. We just painted and dressed the interior for the duration of the shoot.'

In series two, Miss Mardle became a lady of property, inheriting a large, elegant house which she then invited Agnes to share. A stunning property in Stepney Green doubled as the ladies' new home.

'That was a great location, rich in authentic features, including a cobbled road, and the interior has been beautifully preserved by its owner,' says Nic. 'However, it was still a lot of work, mainly because of the scale of the house and how much furniture we required to fill it.

'We visited four times in the shooting of the series. Each time the owners' furniture and possessions were carefully removed and put in storage, and we would bring in our props and drapes to create Miss Mardle's magnificent home.'

THE PRISON CELLS

In series two, Henri Leclair is arrested on suspicion of being a spy. The prison scenes, when ex-love Agnes visits him, were shot in the cells of Surrey County Hall, built in 1893 below an ornate courtroom which still stands today.

'The prison cells were stripped out and painted,' says Nic. 'And we built many period architectural features to create an authentic Victorian/Edwardian prison.'

LORD AND LADY LOXLEY'S HOME

As the most aristocratic and wealthy of the characters – at least until Loxley's gambling debts caught up with them – the home of Lady Mae and her overbearing husband had to be as sumptuous and grand as possible. Wrotham Park, a beautiful stately home in the Hertfordshire countryside, provided the interiors for the Loxley household, as well as the exterior shots for the staff's firearm lessons.

'We used that quite a lot because we had to take the crew out there for a few days, so we maximised shooting there,' says Nic. 'But as it

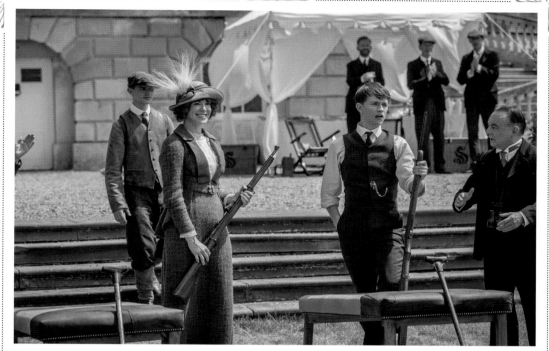

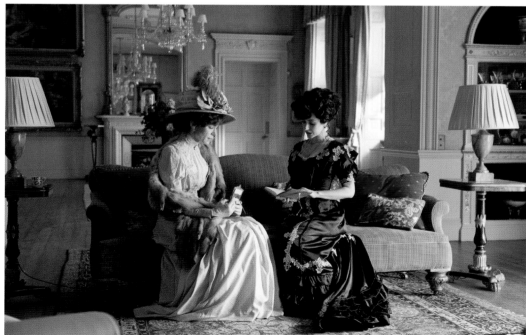

was supposed to be the Loxleys' London house, we couldn't shoot out the windows so net curtains helped there.

'It's one of a few large stately homes within the M25 that are useable for film locations and the large rooms give it a sense of scale.'

Because of the well-preserved nature of Wrotham Park, minimal set dressing is needed to turn the rooms into Lady Mae's abode.

'We took out the obvious things, anything modern or just not the right period, and we took in quite a lot of furniture,' Nic reveals. 'We wouldn't touch anything structurally and, although we often wallpaper or paint, we didn't even do any decorating this time. It was all in the set decoration, the furniture, the tableware and the candelabras.'

For the finishing touches, florist Jayne Copperwaite added numerous floral arrangements and plants to Lady Mae's beautiful home. 'As it was filmed in a house with natural light we could use the real thing, so Lady Mae had real flowers and plants, which were always fresh in her bedroom, library and hallway.'

GETTING AROUND

The Edwardian era was an interesting time in transport, particularly in London. The first private motor cars had appeared on the streets in the 1890s and, by the time Selfridges opened its doors, the West End was an increasingly congested mix of chauffeured automobiles, motorised taxis and horse-drawn omnibuses and carriages.

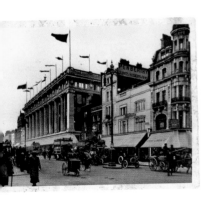

The store itself began with a fleet of fifty horse-drawn vans which was soon swelled by the purchase of sixty-five petrol vans and eleven electric vans. For the production, that meant sourcing quite a few vintage vehicles, which could all be painted with the distinctive Selfridge green.

'A friend of mine, Michael Geary, sources vehicles for me whenever I'm working in Britain,' recalls Rob Harris. 'He found three vans that we could put wooden shells on the back of, and we painted the livery on these boxes that were then built for us on the existing truck chassis.'

The Model T Ford vans, while built in the same years, are not all identical because, as Michael explains, there was no such thing as a production line in 1909. 'They vary slightly because they were built before mass production,' he says. 'They were hand built and the customer would buy a "chassis cab", and then they would have

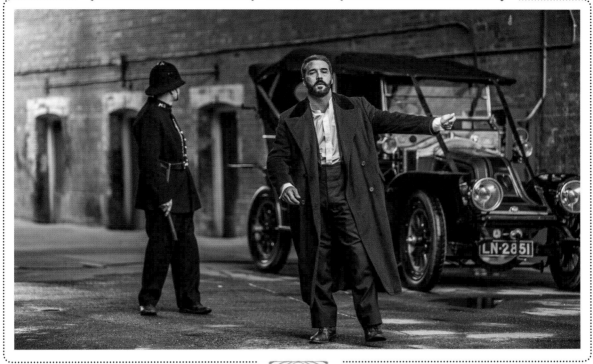

the coach built around that. The people building the vans used the skill set they used to build horse-drawn coaches, which is why they are called coachworks. That's why they were often more elaborate in design than the vehicles built today.'

The vehicles on set are all hired, not bought, because they only make occasional appearances in the show.

'Most of the exteriors are on the Chatham set, where we shoot in one block, so we don't need them for long,' says Rob. 'If you buy them, they are not only expensive, but you have to employ somebody to keep them running. Instead, we hire them from the owners, who often drive them as well. After the first series, Michael then held on to the cladding in case there was a second series.'

For series two, the cladding got a spruce up, with an updated design including gold writing, to reflect the growing success of the store, and was put to use again. But set designer Sonja Klaus added a few more horse-drawn vehicles to the mix.

'I popped in an omnibus that was horse-drawn, and we had horse-drawn carriages, because it's important to show that, while there is this progression to cars and vans, people still had horses, carts and carriages, and actually there were more of those than cars. Harry had vans but many of Selfridges' deliveries were done with horses as well.

'But we kept the vans because we often use those to block up certain areas where we need to hide scary modern things while on location.'

Although petrol rationing came later in the First World War, fuel was expensive, so many people went back to good old horse-power, as Nic Pallace explains. 'A lot of horses came back into action to save money and times were a bit harder so, visually, that gave the street a lot more interest as far as we were concerned.'

Being fabulously wealthy and hugely taken with the latest models Harry, naturally, had the best car on set. In series one, he travelled majestically in a fabulous Daimler Limousine, in red and blue, and also managed to crash a silver Rolls-Royce in a moment of madness.

'The interior of the limo was nothing like you would find today,' reveals Michael. 'Luxury cars then were so opulent that it was more like somebody's living room.'

For series two, Harry updated his vehicle and was chauffeured around in a 1914 Renault.

'With the cars, we did try to stick within the exact time period,' explains Sonja. 'A lot of people would have bought a car in 1910 and would still have that in 1914, but Harry Selfridge wouldn't. Harry would have the latest car, just because he could. And why not? He doesn't have to go around in a car that's ten years old.'

Many of the sixty-plus vehicles hired through Michael come with their own driver, for the simple reason that the owners don't like to be parted with their pride and joy. 'Most of the cars are privately owned and the owners won't let anyone else drive them,' says Sonja. They spend a lot of time loving them; they buff them, they polish them and look after them. So in a lot of the street scenes the people who are dressed up as chauffeurs are actually the cars' owners.'

When it comes to dating the vehicles, the team has to be absolutely certain to get the dates right, in order to keep the armchair experts happy. 'We have to be so careful,' laughs Sonja. 'Because if we get it wrong, somebody watching will say, "They didn't have that car then" or "That model didn't come out until August!"'

MICHAEL GEARY
Responsible for sourcing
vehicles on *Mr Selfridge*

' *Luxury cars back then were so opulent that it was more like someone's living room.* '

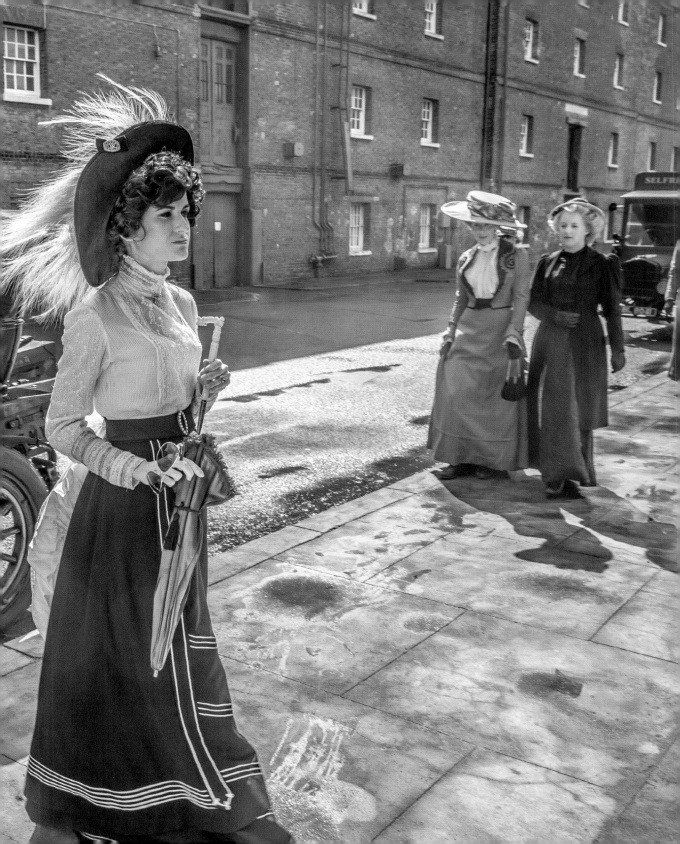

SOHO NIGHTS

By the end of 1914, the Defence of the Realm Act – passed four days after Britain declared war on Germany – had seriously curtailed the drinking habits of Londoners. Pubs were forced to shut in the afternoon and at 9.30 in the evening, and alcoholic drinks were watered down to keep the population sober, alert and productive. As a result of these draconian measures, however, the underground clubs and dance venues of London, where a strong drink could be had 'after hours', thrived.

'London was a vibrant, buzzing city, with lots of army officers going to seedy nightclubs and spending their money,' says Lindy Woodhead. 'Shortages didn't really kick in until 1916, and Londoners were able to dance through the First World War – unlike Paris, where everything closed down.'

Harry, Frank and even Rose get their own taste of underground London in the decadent surroundings of Delphine's, where champagne cocktails and ragtime flow in equal measure.

'Soldiers on leave would go to places like Delphine's, having developed a taste of Continental life in France,' says historical advisor Juliet Gardiner. 'The sleazy underground clubs would have thrived, but in general people's incomes were low, so it wasn't like the Second World War when the Americans came over, splashing money around. The people at Delphine's would have been a well-heeled set, the rich young people of London.'

DESIGNING DELPHINE'S

The nightclub, built on the main stage of the north-west London warehouse, was one of the few sets that

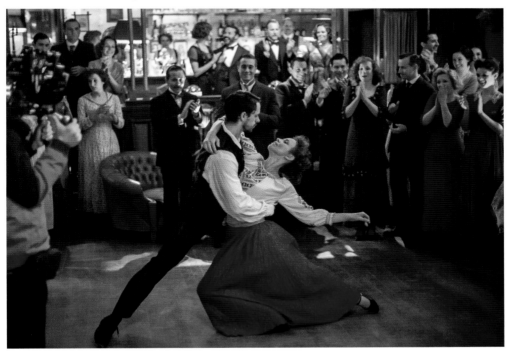

was brand new for series two. Sonja Klaus and director Anthony Byrne visited a couple of nightclubs in modern-day Soho that retain the shabby splendour of yesteryear, and decided the ambience would be 'Boho chic, a little bit sleazy, a bit *Cage aux Folles* or *Cabaret*'.

'If you were in London for real, you would be inheriting a space that was Victorian or even earlier, Georgian, and they were all building on top of each other in those days,' explains Sonja. 'Soho, in particular, was very crammed with narrow passageways and so we wanted to have that feeling. We wanted to give it a layering of opium den and underworld.'

Turning a wide, flat space into an underground nightclub presents quite a challenge but the production team had some old design tricks up their sleeves.

'When you go into Delphine's, you're not sure if you're going up or down and that's an old trick. So you go in and walk up some steps, then up some more, then you walk along a corridor, where more steps appear to go down to the left hand side, then you go down steps and then down some more steps and then you go to the bar area, you go back up steps to go to Delphine's office. It all gives you that feeling that you are going down into the back of a building but you're not really sure.

'The narrow corridors and the seating areas in little niches all helped to add to that feeling of mystery, and gives the setting a bit of depth and extra interest.'

The décor, in all its fading opulence, provides a stark contrast to the clean, white grandeur of the store. The wallpaper in the bar area boasts a host of stunning peacocks, with glistening silver tails, and the pewter wallpaper behind the bar picks out the same sheen. The walls of the corridors are adorned with saucy Rubenesque maidens, beautiful flower arrangements with genuine peacock feathers sit in the alcoves with the banquette seating, and a magnificent stuffed peacock guards the hallway.

'I had a bit of a peacock thing going on because they were mad about peacocks in that era, so Delphine had a stuffed peacock in the hallway, lovingly called Bernard by Emma Dale, who supplied it for us,' laughs Sonja. 'Then I put peacock wallpaper in the main room and I used a lot of silvers, brasses and golds.

'For the wall paintings, I used a very fine deco artist called James

Gemmill. I told him I wanted something a little bit raunchy and he said, "Can I show some breasts and bottoms?" So I said, "I don't see why not. Go ahead."

'There's a lady at the end who has this marvellous headgear on, she looks like she's got all these petals coming out of her head, which was actually copied from a black and white photo that we found from a Parisian cabaret show of the era.

'We also used Jamie Newell, my other favourite painter, and the two of them are amazing.'

After creating the fabulous interior, Sonja had to make sure it looked old and faded which meant sanding some of the newly painted walls down. 'It had to have a worn but elegant look about it and aging is something that is my bugbear. I often watch TV or films and think, "I wish they'd aged that down a little bit more." When people are coming and going in a building, things get touched and things get grubby, even if we don't notice it. Delphine's has heavy traffic so you want to show that, but there's also the fact that she inherited the space and added her own touches, and may have even aged it down herself to give it that used, lived-in look.'

The most sumptuous addition to the club was the lighting – shipped in from a company in Venice, which specialises in Fortuny, a designer of lamps since 1903. Venetia Studium lent the production a stunning array of designs worth £15,000. 'It was exquisite,' says production buyer Belinda Cusmano. 'We used it throughout Delphine's, from a Scheherezade light in the entrance right down to the silk hanging lights and the oriental lights inside. There is a huge amount of detail in them. They're silk, they're hand-painted and they have original Venetian glass beads on them so they are really beautiful.'

The graphics team, led by Dan Burke, designed cocktail menus to slot into the antique silver holders on every table and for the display behind the bar, Belinda sourced some period bottles.

'We actually hired a lot of the bottles that have period graphics on them, because you have to be careful what bottles you feature, and you need to get all the labels cleared. We also found some absinthe dispensers which added to the Bohemian, Parisian feel of the club. We actually found some absinthe glasses with the silver sugar cube rests, so we used the real thing.'

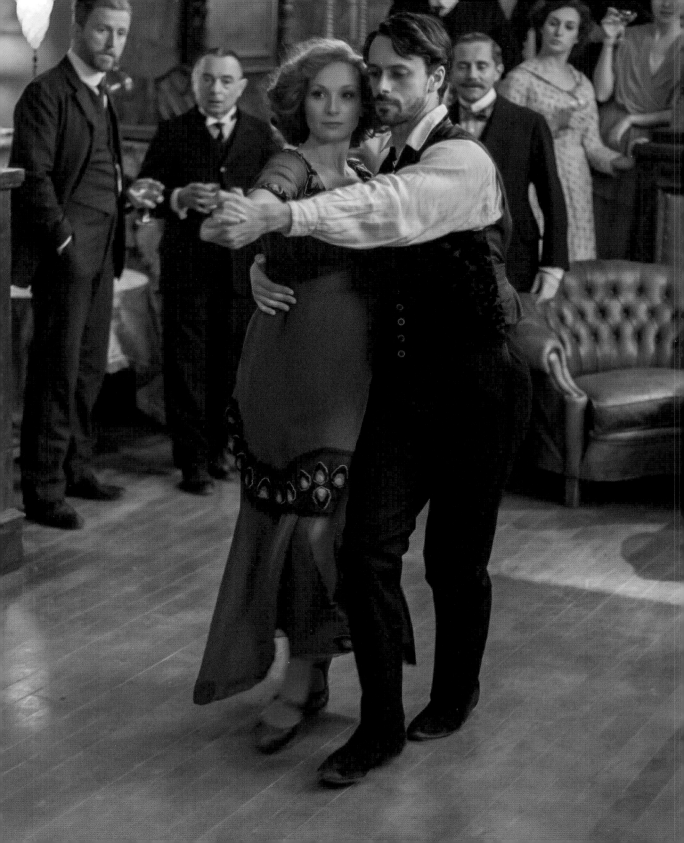

DELPHINE DAY

PLAYED BY POLLY WALKER

The businesswoman behind the London nightspot
is the colourful, brazen Delphine, played by Polly
Walker. Her modern thinking and determination to
succeed mirrors that of Harry, while her artistic side
appeals to Rose, who befriends her on the ship home
from America.

'She's somebody who knows a lot of people in
society, she knows a lot of politicians, which could
benefit Harry,' says Polly. 'But she's a Bohemian and
that's what Rose found so attractive about her. She
knows all the artists and the Bohemian set, and that
to Rose is so exciting.'

In an era when married women didn't work
and divorce was rare, the free-spirited Delphine
scandalises and tantalises in equal measure,
especially when she releases a racy autobiography
detailing her sexual liaisons with men. Polly said
she found the character a breath of fresh air.

'It's nice not to play the boring old little wife role,'
she laughs. 'I'm not talking about Rose but generally,
as a woman, you get to play a lot of conventional
characters, so it's nice to play someone who's a bit
out there.

'I didn't have much to go on in the first script, but
she seemed controversial and she seemed different
to the women of that period. I wasn't quite sure what
her agenda was so I was intrigued. It's nice to play
the naughty one. It's much more fun.'

As a financially independent divorcee and
a businesswoman, Delphine faces a daily battle
against the conventions of the day and the

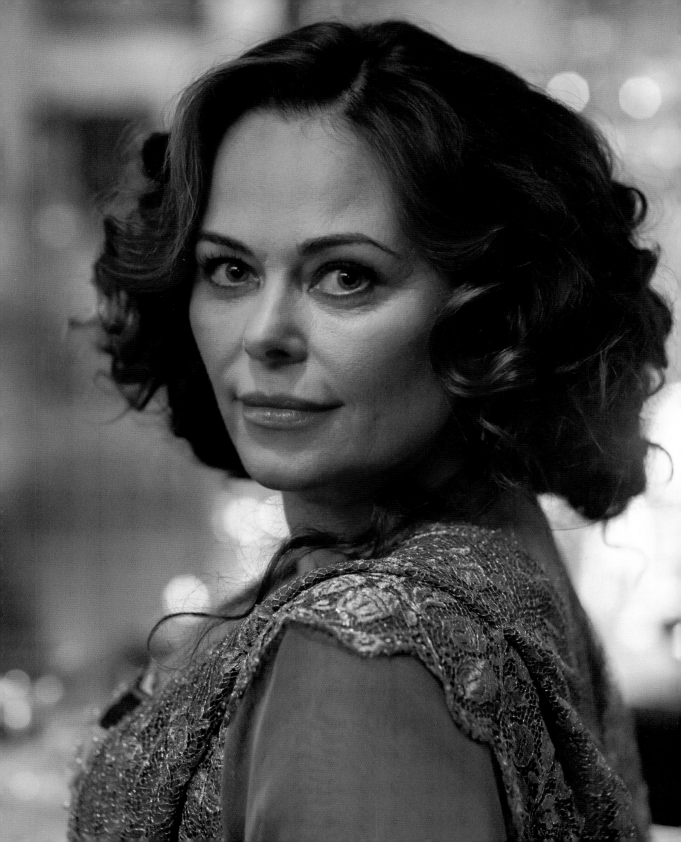

inequalities facing women. 'She's an independent, unconventional woman. She's been divorced three times. She runs a nightclub, which is very unusual in those days because women didn't generally work, and she's obviously travelled, so she's living a very different life to that which most women would live.

'She a grafter, she's an opportunist and she's a survivor. Women couldn't have borrowed from banks in those days, so she really is having to survive on her wits and managing to get money out of people, and running a business.

'Her morals are slightly dubious and she's certainly governed by her need for success and money, which means she makes certain choices.'

One of those choices involves making a play for Harry, despite her friendship with his wife. 'I think her friendship with Rose is genuine, but she's a bit of an opportunist,' reflects Polly. 'She doesn't fall in love with Mr Selfridge at all, but she certainly wants his money.'

Being a new addition to series two, the actress was thrilled with the set and particularly taken with Delphine's domain. 'I don't know any clubs like that, so small and intimate but very atmospheric,' she says. 'But it was the sort of club I'd like to go to.'

She was also thrilled with the costumes, which were slightly more brazen and seductive than many of the female leads. 'Because my character didn't have that much money she had quite a small selection,' she reveals. 'We recycled quite a lot of what I wore, which they would have done back then anyway, but they are amazing costumes.

'With the corset, for the first week you think, "Oh my God, I can't function," and then you get used to them quite quickly. It's always hard first time when you put it on in the morning, because it's cold, then your body warms it up and it becomes much more comfortable. But it's always nice to take off at the end of the day.'

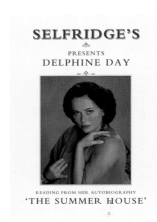

SELFRIDGE'S
PRESENTS
DELPHINE DAY

READING FROM HER AUTOBIOGRAPHY
'THE SUMMER HOUSE'

POLLY WALKER
Delphine Day

'*Delphine's a grafter, she's an opportunist and she's a survivor.*'

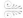

A CHANGING WORLD

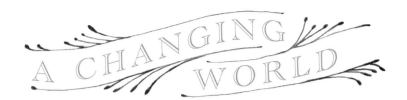

A CHANGING WORLD

By the time the store celebrated its tenth birthday, in March 1919, the UK was on the cusp of a new era. Still reeling from the tragedy of the First World War, which had claimed almost a million British lives and left a million more wounded, the country was undergoing a social change. Women, who had worked in stores, offices and factories throughout the four-year war, refused to go back into domestic service, and the men returning from the front struggled to readjust and deal with the horrors they had witnessed in the trenches.

In London, however, the Roaring Twenties were just around the corner, dancing was all the rage and the younger members of the society set were about to become the outrageous, hedonistic 'Bright Young People' who defined the decade.

'In series two, we were at the beginning of the war, and everyone thought it would be over by Christmas,' says the lead writer, Kate Brooke. 'Jump five years and they've all been through it, and from a writer's point of view that is fascinating because all your characters have changed in some way.

'So series three begins a few months after the war, when everybody is trying to pick themselves up from the biggest, most appalling tragedy. It affected all of our characters in different ways and no one can ever be quite the same again. They are trying to redefine themselves and work out their futures, and within that it is fantastic to have an optimist like Harry, who will say, "We've got to move forward. We've got to put this behind us." You need that, and at the same time it's a hard thing to do.'

Harry proudly walks Rosalie down the aisle in series three.

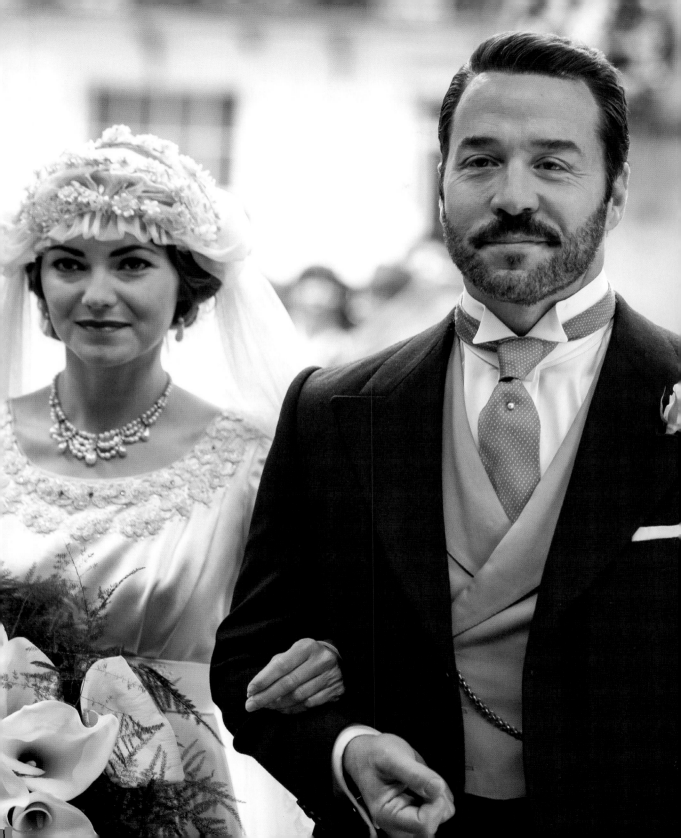

The world of Harry Selfridge had also shifted dramatically. The death of his beloved Rose, during the Spanish flu epidemic of 1918, knocked him for six and would eventually lead him on a path of self-destruction and ruin. His relationship with his children – particularly Gordon and Violette – was fraught with conflict and his eldest daughter, Rosalie, was about to wed an impoverished Russian aristocrat.

'After Rose's death, Harry is doing anything that he can to distract himself, because if he stands still for a moment he'll lose it completely,' says Jeremy Piven. 'So he's just trying to be a moving target and preserve her legacy, but he's more obsessed than ever with work, with expansion and you know where that's going to lead. That's not going to end well – but it sure is fun to play.'

'Losing Rose was a massive loss to Harry, because she was very much his ballast,' explains Kate. 'We are much more focused on his family in series three because he doesn't have the wise and wonderful Rose to help him with his children, and he struggles. So we are really looking into the conflicts that develop within the Selfridge family. It sums up much of the feeling of the time, on the cusp of the twenties, where everything was changing. It was about the older generation being in conflict with the younger generation, and trying to understand them.'

For series three, Kara and Hannah Tointon join the cast as Rosalie and Violette. As the series opens – with Rosalie's wedding to Serge de Bolotoff – the family is in turmoil. Gordon, played by actor Greg Austin, feels he's in the shadow of his father, while Harry disapproves of his son's increasingly close relationship with shop girl Grace. Violette – as strong-willed as her father – has become a rebellious young woman who relishes the wild antics of the young London socialites.

'Violette was a rebel in real life,' says Kate. 'She was a great aviator and a great party animal, and I think she was probably the closest to Harry in personality. She had his drive, but because she was a girl it was never an option for her to take over the store.

'Also, being a girl in 1919, there was a dearth of men to marry because a lot of them had been killed, and that was a big problem. What were bright, interesting women going to do after the war? We play that dilemma out through Violette.'

Outside of the family dramas, Henri returns, scarred from his

JEREMY PIVEN
Harry Selfridge

'*After Rose's death, Harry is doing anything he can to distract himself, because if he stands still he'll lose it completely.*'

war experiences, and Victor is at the forefront of London's burgeoning nightlife, having taken over Delphine's club. Doris returns, in the midst of a family dilemma which Miss Mardle inadvertently becomes involved in, and Lord Loxley is back with a vengeance.

'Loxley has spent some time in prison and then America, and his anger at Harry is compounded by the fact that Harry has helped Lady Mae escape him,' reveals Kate. 'That's an added reason for his overriding desire to bring Harry down.'

Despite the austere war years, the store continues to evolve and move with the times, with brand-new fashions and a few new additions.

'In 1919, fashion was so exciting,' says Kate. 'It's about to totally change to shingled haircuts and corset-less dresses and so much was moving forward. Beauty and perfume has become much bigger than accessories and there's more to tempt men into the store, with a few gentleman's toiletries on sale and a window display for razors and blades.

'The Palm Court is much less stately than it was and rather more wild, and we've got some exciting new parts of the store, like the information bureau, which Harry set up. Anyone could go in and ask for anything, ranging from tickets to the theatre to the answer to an obscure question on any subject, and they would guarantee they would get the answer in two or three days. It's like a 1919 version of Google.'

While the store continues to prosper, however, the 'King of Oxford Street' is beginning to lose his grip on his business affairs and on his private life.

'Harry really went off the rails in the twenties. We're not there quite yet, but we are sowing the seeds of that,' says Kate. 'It's a darker journey for Harry, and he is set on the path towards his self-destruction. But even within that he is a marvellously optimistic character. He always thinks that everything is going to go his way, which is probably part of his problem. He thinks that people will do what he wants and he thinks that the world will not darken.

'Harry's personal life absolutely mirrored the tragedy of the war because he lost Rose. So it's about how to pick yourself up from grief, and that really does resonate throughout the series. Although it's definitely darker, it's a very exciting period to be investigating. And, of course, within the darkness there is still a lot of laughter and many wonderful treasures on display in the store.'

CAST LIST

SERIES 1 AND 2

Harry Selfridge	**Jeremy Piven**
Rose Selfridge	**Frances O'Connor**
Lois Selfridge	**Kika Markham**
Lady Mae Loxley	**Katherine Kelly**
Lord Loxley	**Aidan McArdle**
Agnes Towler	**Aisling Loftus**
Henri Leclair	**Grégory Fitoussi**
Victor Colleano	**Trystan Gravelle**
Roger Grove	**Tom Goodman-Hill**
Josie Mardle	**Amanda Abbington**
Mr Crabb	**Ron Cook**
Frank Edwards	**Samuel West**
Kitty Hawkins	**Amy Beth Hayes**
Doris Miller/Grove	**Lauren Crace**
Mr Thackeray	**Cal MacAninch**
Miss Blenkinsop	**Deborah Cornelius**
Miss Plunkett	**Sadie Shimmin**
Miss Bunting	**Pippa Haywood**
Miss Ravillious	**Anna Madeley**
George Towler	**Calum Callaghan**
Reg Towler	**Nick Moran**
Delphine Day	**Polly Walker**
Ellen Love	**Zoë Tapper**
Rosalie Selfridge	**Poppy Lee Friar**

Gordon Selfridge	**Adam Wilson (series 1)**
	Greg Austin (series 2)
Violette Selfridge	**Freya Wilson (series 1)**
	Millie Brady (series 2)
Beatrice Selfridge	**Raffey Cassidy (series 1)**
	Alana Boden (series 2)
Tony Travers	**Will Payne**
Fraser	**Malcolm Rennie**
Franco Colleano	**Sean Teale**
Florian Dupont	**Oliver Farnworth**
Grace Calthorpe	**Amy Morgan**

NEW FOR SERIES 3

Rosalie Selfridge	**Kara Tointon**
Violette Selfridge	**Hannah Tointon**
Marie de Bolotoff	**Zoë Wanamaker**
Serge de Bolotoff	**Leon Ockenden**
Nancy Webb	**Kelly Adams**
Connie Hawkins	**Sacha Parkinson**

ACKNOWLEDGEMENTS

With thanks to Jeremy Piven and all the cast of *Mr Selfridge* for giving me their time and sharing their secrets. Set designer Sonja Klaus made my task a lot easier with her huge generosity and enthusiasm, not to mention thousands of backstage images and many hours answering my queries. Many thanks also to costume designer James Keast and hair and make-up stylist Konnie Daniel for their insight into the *Mr Selfridge* look. Also art director Nic Pallace, production buyer Belinda Cusmano, set designer Rob Harris, florist Jayne Copperwaite, series advisor Juliet Gardiner and vintage car expert Michael Geary, who all proved invaluable sources of information, plus graphic designer Dan Burke, who was very helpful in providing artwork and info for the book.

Special thanks go to Lindy Woodhead – the author of *Shopping, Seduction and Mr Selfridge*, the book that inspired the television series – for her generous help and unequalled knowledge of all things Harry, and series creator Andrew Davies and lead writer Kate Brooke for their contribution. I am especially grateful to executive producer Kate Lewis for making this book possible and finding time in an impossibly busy schedule to devote to it. Thanks, too, to her lovely assistant, Jonny Richards, for his swift and useful replies to my frequent questions.

A big thank you to Shirley Patton at ITV, for seeking me out and for her encouragement and support, and to Lorna Russell for the recommendation, as well as to Mike Jones and Jo Whitford at Simon & Schuster for taking it under their wing. I owe Zoë Cridlan a huge debt for the stunning design of this book and for a lot of very hard work, along with Alex Smith and all at Smith & Gilmour.

For pictures, I would like to thank Patrick Smith and James Hilder at ITV and photographer John Rogers, Christian Black and Nicky Johnston for the on set photography.

Also the wonderful team at Selfridges archives – Michael Keep, Janet Foster and Margaret Crockett.

Finally, my thanks go to the Fergusson gallery, for kind permission to use *The Blue Hat*, and to picture agencies Bridgeman Images, Mary Evans and The Advertising Archives.

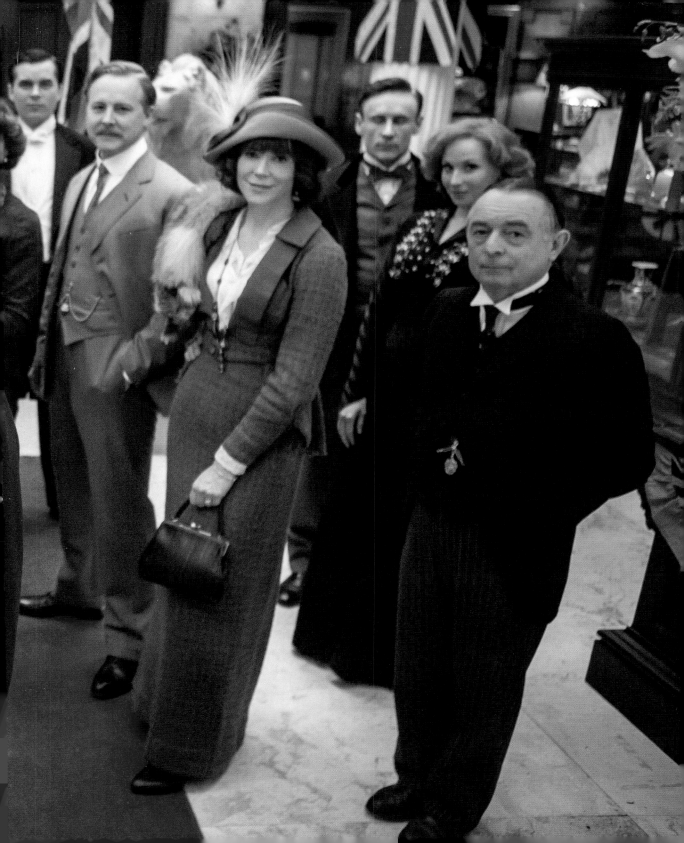

ALISON MALONEY
AUTHOR BIOGRAPHY

Alison Maloney is a journalist and author of several social history titles, including *Life Below Stairs*, *Bright Young Things: Life in the Roaring Twenties* and *The Forties: Good Times Are Just Around the Corner*. She has also written several TV tie-ins, such as the *Strictly Come Dancing Annual* and is the author of the number one bestseller, *The Mum's Book*. Alison lives in Kent with her husband and two children.